D1191788

NOT ADDED BY
UNIVERSITY OF MICHIGAN LIBRARY

GOLD OF THE GREAT STEPPE

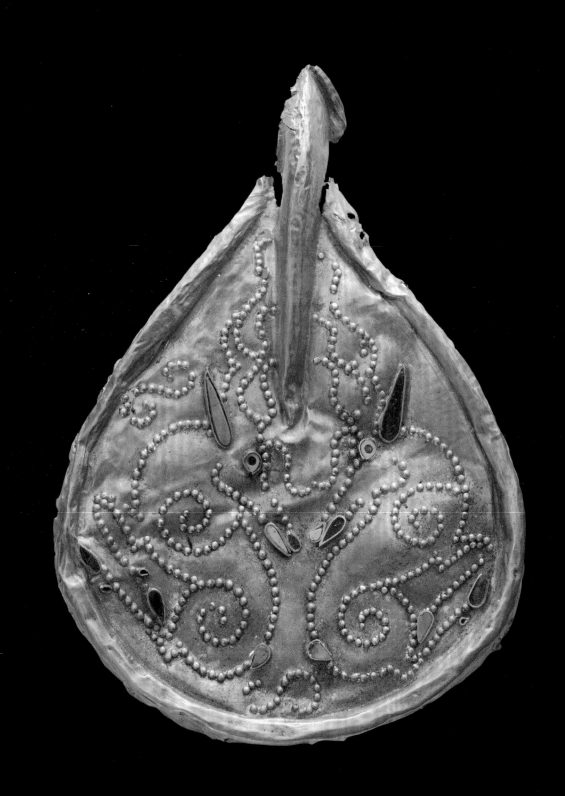

GOLD OF THE GREAT STEPPE

EDITED BY
Rebecca Roberts

CONTRIBUTIONS BY
Zainolla Samashev, Abdesh Toleubayev, Saltanat Amir,
Claudia Chang, Marcos Martinón-Torres and Laerke Recht

TRANSLATIONS BY
Joanna Dobson

THE FITZWILLIAM MUSEUM, CAMBRIDGE
EAST KAZAKHSTAN REGIONAL MUSEUM OF LOCAL HISTORY

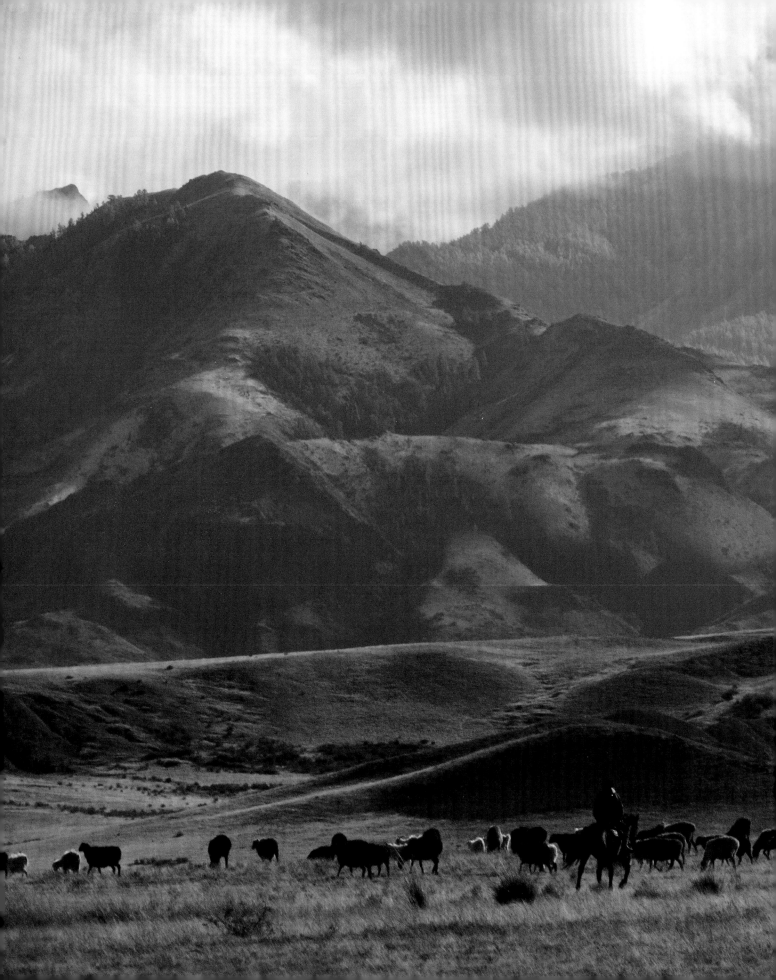

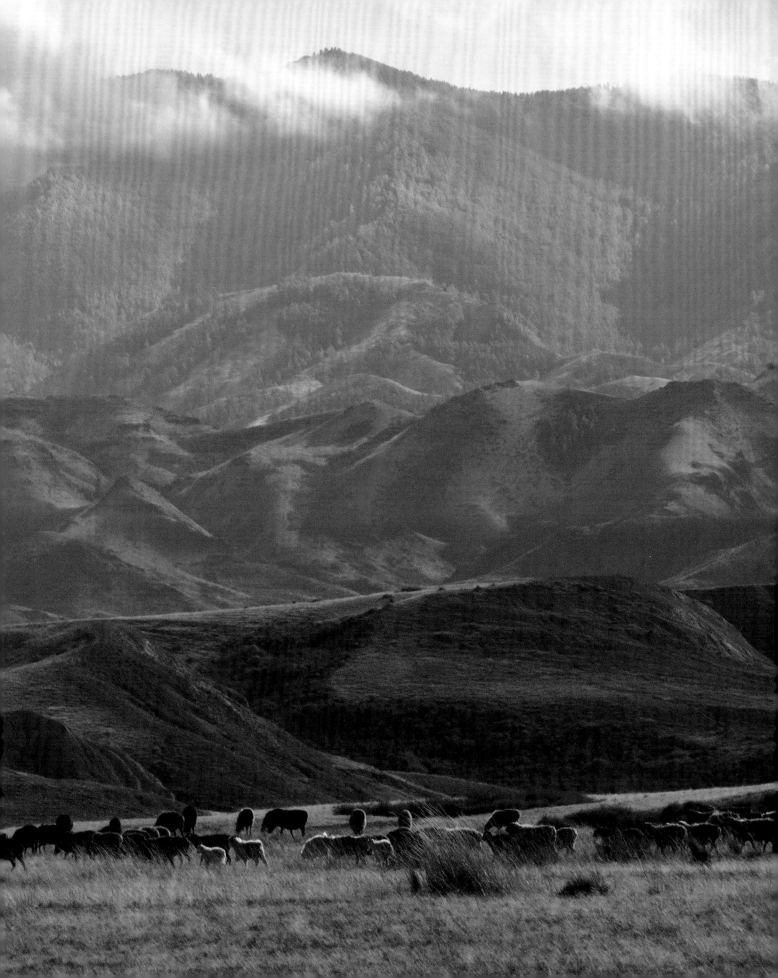

First published to accompany the exhibition

GOLD OF THE GREAT STEPPE

at the Fitzwilliam Museum, Cambridge
28 September 2021 – 30 January 2022

Text © the authors 2021

All rights reserved

No part of this book may be reproduced, stored in a retrieval system, or transmitted in any form or by any means, electronic, mechanical, photocopying, recording, or otherwise, without the written permission of the publisher, except for the purpose of research or private study, or criticism or review.

ISBN 978 1 911300 91 5

British Library Catalogue in Publishing Data

A CIP record of this publication is available from the British Library

Produced by Paul Holberton Publishing
89 Borough High St, London SE1 1NL
paulholberton.com

Designed by Laura Parker

Printed by Gomer Press, Wales

FRONT COVER Gold recumbent stag plaque with inlays of turquoise and lapis lazuli, Eleke Sazy, Group II, Kurgan 4. 8th–6th century BC

BACK COVER The Saur-Tarbagatay mountains, East Kazakhstan, by Yevgeniy Domashev

FRONTISPIECE Gold overlay of the wooden base of a gorytos (combination bow and quiver case), with heraldic design of addorsed deer rendered in granulation with inlays. Eleke Sazy, Group II, Kurgan 4. 8th–6th century BC

PAGES IV–VII, XIII, XIV The dramatic landscape of East Kazakhstan captured by Yevgeniy Domashev

CONTENTS

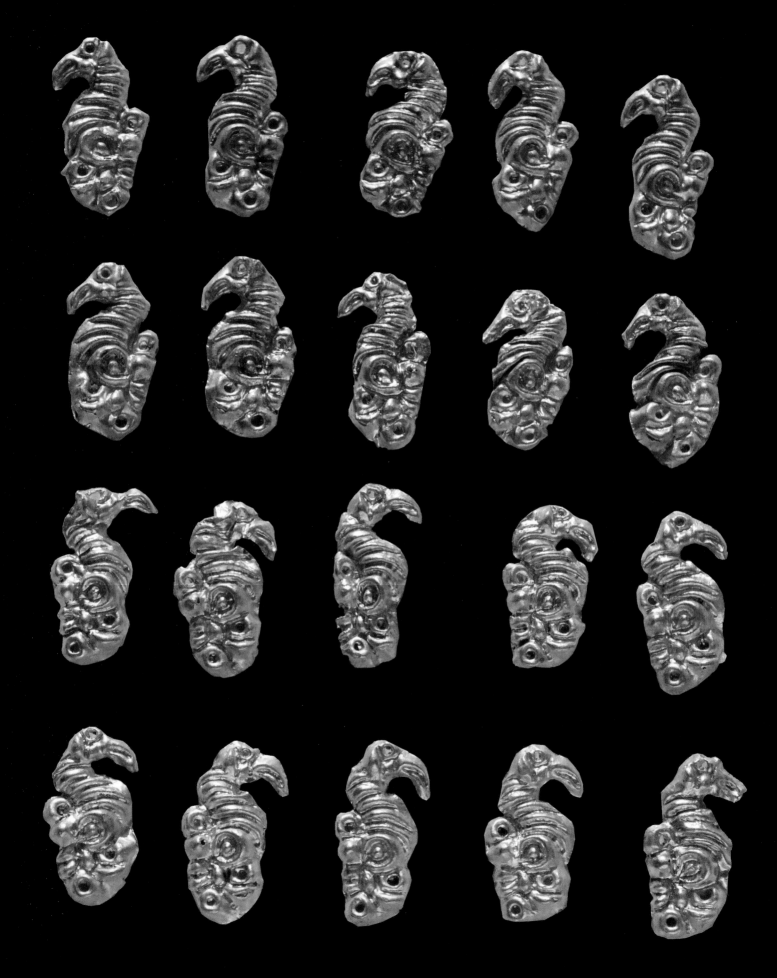

PRIME MINISTER'S PREFACE

ASKAR MAMIN, PRIME MINISTER OF THE REPUBLIC OF KAZAKHSTAN

The First President of the Republic of Kazakhstan, Elbasy Nursultan Nazarbayev, launched a number of major national projects and programmes, including 'Cultural Heritage' and 'The Nation in the Stream of History', which helped to magnify significantly research on the history of the Great Belt of Eurasian Steppes.

In his policy paper 'Independence Above All', President Kassym-Jomart Tokayev highlighted the importance of broadening our understanding of history through new academic approaches in order to facilitate the revival of the historical identity of the Kazakh nation.

Recent discoveries have shown to the whole world that our history goes back countless centuries. A significant body of previously unknown historical sources and archaeological artefacts has been brought into academic discourse.

Some truly sensational archaeological findings in Kazakhstan confirmed that ancient Turks, Huns, Saka, Sarmatians, Massagetae and other ancestors of today's Kazakhs have been able to create and maintain bright and original cultures over millennia, making a significant contribution to the development of world civilization.

Located in the heart of Eurasia – between East and West – the Great Steppe has embraced the most important technological advances and achievements in warfare, mining, metallurgy, and other arts and crafts of Antiquity and the Middle Ages.

The *Gold of the Great Steppe* exhibition showcases thousands of original pieces created by ancient masters of metal working and decorative and applied art, including magnificent pieces of jewellery made in the fabled 'animal style' of the Saka-Scythian era.

I am confident that this exhibition will help broaden understanding of the centuries-old history and unique culture of Kazakhstan among Cambridge residents and visitors.

Gold plaques depicting polymorphic creatures.
Eleke Sazy, Group VI, Great Earthen Mound
'Patsha'. c. 6th–5th century BC (fig. 2.54a, detail)

GOVERNOR'S PREFACE

DANIAL AKHMETOV, GOVERNOR OF THE EAST KAZAKHSTAN
REGION OF THE REPUBLIC OF KAZAKHSTAN

Five years ago we launched a large-scale and unique archaeological research programme in the East Kazakhstan Region of the Republic of Kazakhstan. During this time, dozens of new archaeological sites have been discovered and studied. They have enriched our knowledge about the chronological framework of prehistoric and medieval cultures, about lifeways, lifestyles, religions, worldviews and, not least, the artistic and aesthetic traditions of the Saka people. It has been proven that the Saka created truly unique jewellery masterpieces, using technological processes that were advanced for their time, constructed grandiose and exceptionally complex religious, funerary and memorial monuments, and much more.

It is no coincidence that the territory of East Kazakhstan has long been considered one of the centres of origin of ancient metallurgy in the Eurasian Mining and Metallurgical Province. Numerous discoveries by geologists and archaeologists have indicated that the exceptional diversity and richness of the subsoil, and the wide distribution of copper and tin deposits, contributed to the emergence of ancient workings, mines, tunnels, furnaces, tools and finished products within the Kalba, Narym and Tarbagatai mountain ranges (and in the Kazakh Altai in general), as well as a powerful culture of early miners.

It is believed that throughout the Bronze Age, the territory of modern-day East Kazakhstan provided a significant proportion of the Eurasian markets with raw materials and high-quality locally produced items.

According to scientists, from around the end of the second millennium BC several factors, such as global climate change and specific internal developments, led to the emergence, alongside traditional lifeways, of new economic models based on semi-nomadic and nomadic pastoralism, marking the beginning of the transition to the early Iron Age and the Saka period.

Archaeologists are certain that the latest research in East Kazakhstan allows us to trace the transformation of Bronze Age community structures, through the formation of a new economic model dominated by nomadism, and in social organization the emergence of a so-called 'military democracy', with a clear tendency towards the formation of sole royal rule.

Monumental pyramidal structures have been preserved in different parts of East Kazakhstan. These are the burial mounds (*kurgans*) of the Saka elite – Shilikti, Baigetobe, Eleke Sazy, Gerasimovka, Ekaterinovka, Markakol, Kurchum and many others. According to archaeological studies of recent years (and supported by radiocarbon analysis), they date to the 8th–6th century BC. Kurgans contained burials of nobility in extremely rich attire, decorated with gold and precious stones, and accompanied by a large number of horses in elaborate costume, all of which reflected the deep stratification of Saka society.

Kazakhstan's most outstanding archaeological discovery of recent years is the remains of the 'golden man' in one of the mounds of the Eleke Sazy cemetery, which dates to the 8th century BC. This man was named 'golden' not because of the 15,000 individual gold items found there – such finds come from other elite but heavily looted and destroyed mounds – but because his was only the second undisturbed Saka burial in Kazakhstan, the first being the Issyk mound in Zhetysu. This exceptional state of preservation allowed specialists to answer a number of anthropological and genetic questions, and, most importantly, to make the most reliable reconstruction of the ceremonial funeral costume and weapons of the royal youth in the shortest possible time. Finding *in situ* costume embellishments and weapons in this mound opened up new opportunities for scientists to study the religion, worldview and funeral rites of the Early Saka people.

Significant finds have also been made in several looted mounds of the Shilikti valley, where representatives of Early Saka society were buried. A considerable number of gold embellishments, including all-cast ones, remained preserved in the central log chambers of the mounds despite severe destruction by ancient robbers, and allowed scientists to propose a hypothetical reconstruction of the ceremonial costume of the Shilikti 'king'.

In 2020 another treasure trove of 830 gold artefacts was found. At the foot of a large mound, under the protective 'shell' of stones that completely covered its surface, gold items were laid in the form of a funeral and memorial gift – an offering to the ruler. The treasure belongs to the Middle Saka time, 5th–4th century BC.

We thank the University of Cambridge and the Fitzwilliam Museum for their joint efforts to host the *Gold of the Great Steppe* exhibition. We are confident that the exhibition, and the research carried out around it, will open to the public new pages in the history both of the East Kazakhstan Region and of all humankind.

The Saur-Tarbagatay mountain range

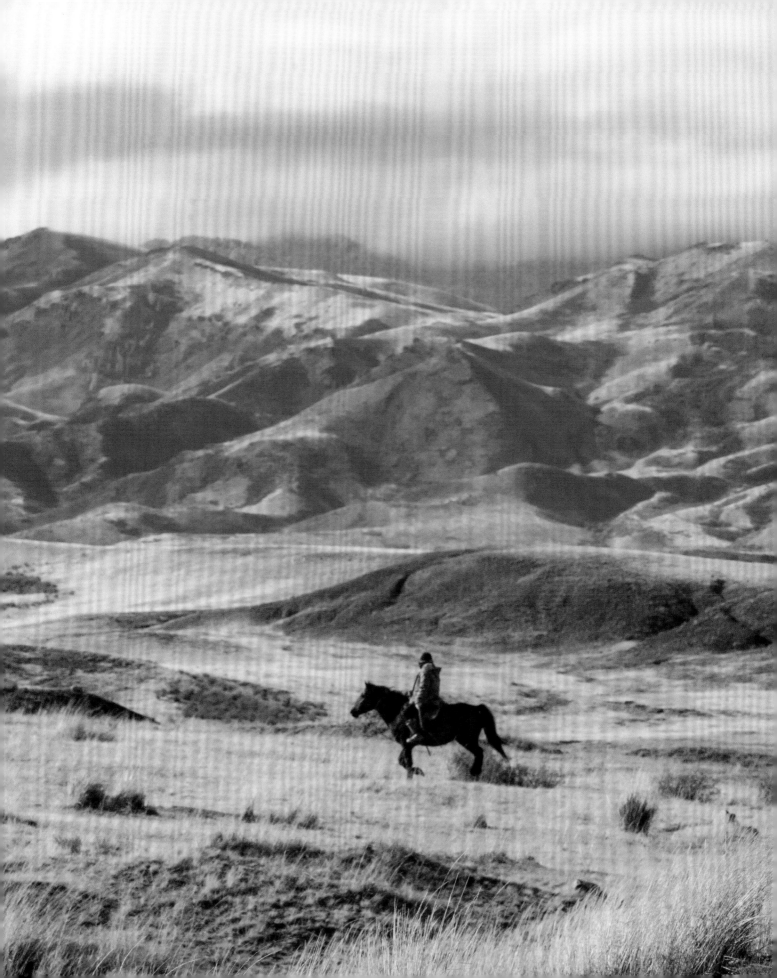

AMBASSADOR'S PREFACE

H.E. ERLAN IDRISSOV, AMBASSADOR OF THE REPUBLIC
OF KAZAKHSTAN TO THE UNITED KINGDOM

In 2021 and 2022 we are celebrating a number of important milestones, including the 30th Anniversary of Kazakhstan's Independence and the 30th Anniversary of the establishment of a diplomatic relationship between Kazakhstan and the United Kingdom. I find it very timely and appropriate that the Gold of the Great Steppe exhibition is coming to one of the best UK museums at such an auspicious time.

I am delighted that the British public will have an opportunity to immerse themselves into unique culture and history of our politically young and historically ancient nation. The time-tested strategic partnership that so happily exists between Kazakhstan and the United Kingdom is based on the solid foundation of friendly people-to-people ties and an intensive cultural exchange. I cannot stress enough how important it is to continue supporting mutual understanding and interest in history and culture of our two nations.

I applaud the University of Cambridge and the Fitzwilliam Museum for their prodigious effort to bring Kazakhstan and the Kazakh culture in the focus of the attention of British and global audiences. I am immensely grateful to all organisations and individuals who contributed to the exhibition and helped strengthen further the bonds of friendship between Kazakhstan and the United Kingdom.

A herd of horses in the rich pastures of the Saur-Tarbagatay mountains. Horses are an important part of Kazakh culture, providing transport, milk and meat

DIRECTOR'S PREFACE

LUKE SYSON, DIRECTOR OF THE FITZWILLIAM MUSEUM

A beauty as of the sea, of boundless expanse and freedom
—Charles Kingsley, *Hereward the Wake*, 1866

This description of the Cambridgeshire fenland was written by Charles Kingsley during his time as Regius Professor of Modern History at Cambridge, and it evokes the open skies and open lands found on our doorstep here in Cambridge. Imagined on a much grander scale it can also be applied to the Great Steppe, which stretches across the vast expanse of central Eurasia – a landscape of possibility and openness, variety and contrast, 'boundless expanse and freedom'. Nowhere is this more evident than in East Kazakhstan, where mountains and grasslands meet rivers and lakes in a glorious mosaic, providing endless possibilities for movement, interaction and creativity, harbouring valuable gold deposits beneath the surface.

The *Gold of the Great Steppe* exhibition and this accompanying publication will present artefacts from the extraordinary burial mounds of the Saka-Scythian people of East Kazakhstan. Recent excavations and analyses led by archaeologists from Kazakhstan have helped us understand much better how the Saka-Scythians lived and travelled, the things they made and what they believed in. They have revealed a distinctive, advanced society, which is still being uncovered as modern archaeological methods enable scholars and scientists to find and analyse not only burial mounds but also the remnants of settlements. Known as fierce warriors, they were also skilled craftspeople, producing intricate gold work. Their artistic language indicates their deep respect for the animals around them – both real and imagined. They dominated their landscapes with huge burial mounds of ambitious construction, burying elite members of their society with their horses.

The majority of the gold pieces in the *Gold of the Great Steppe* exhibition were made to be attached to clothing and accessories – both human and equine. These intricate pieces, each individually astounding and yet produced in multiple copies, are, like the huge burial mounds in which they were found, both monuments to the status of the dead, and testaments to the labour of the living. The pieces speak across time and space through their beauty and craftsmanship, and yet the true depth of their meaning remains unknowable. As we observe and study them as outsiders to the Saka-Scythian world, brilliant flashes of insight are revealed to us, and yet so much of their appeal lies in the enigma. Novice or expert, scientist or art historian, we are all levelled before them – we cannot read the true meaning behind the imagery, and yet we can appreciate the power of the message.

We are indebted to the openness and generosity of the Regional Government of East Kazakhstan for proposing and making possible this collaboration from both sides of the Great Steppe.

Gold roundels. Eleke Sazy, Group II, Kurgan 4 hoard. Saka period (fig. 3.10a, detail)

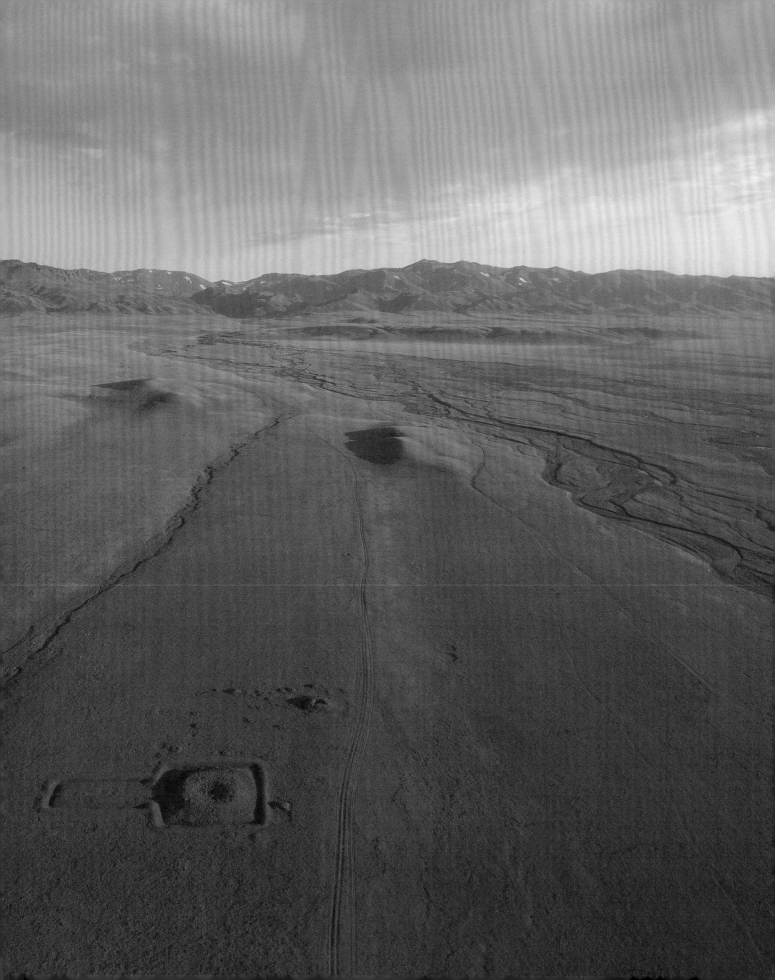

ACKNOWLEDGEMENTS

Gold of the Great Steppe is a project born from true collaboration in the face of the COVID-19 pandemic, made possible by many forms of generosity from those involved. The initiative for the project, and support for the archaeological research behind its inception, comes from Governor Danial Akhmetov, Regional Governor of East Kazakhstan. His foresight and vision mean that the priceless artefacts and rich history of East Kazakhstan will be preserved for future generations of Kazakhstanis to appreciate and study. In the immediate term these treasures will delight and educate members of the public in the United Kingdom. This international effort is made possible through diplomatic support from the Embassy of Kazakhstan in the United Kingdom, led by His Excellency Erlan Idrissov, Ambassador Extraordinary and Plenipotentiary of the Republic of Kazakhstan to the United Kingdom, who is supported by his excellent team, of whom particular thanks to Aigerim Seisembayeva, Third Secretary, Embassy of Kazakhstan in the United Kingdom.

A delegation from Cambridge were grateful to be welcomed to East Kazakhstan by Alisher Markhabat, Deputy Governor of the East Kazakhstan Region, and Miras Zhumagulov and Raushan Nurmukhanova, Deputy Heads, Department of Culture, Archives and Documentation of the East Kazakhstan Region. While in Kazakhstan, the Cambridge team spent their time working at the East Kazakhstan Regional Museum of Local History in Ust'-Kamengogorsk. Generous and complete access to artefacts was arranged by the Museum's director Dr Svetlana Nurgazieva. The Cambridge delegation are grateful for the significant levels of support offered by all members of staff at the museum, including Dr Galina Kush, Natalya Kosenkova, and Alexandra Motrich.

The Cambridge team were delighted and humbled to be introduced to the artefacts by the archaeologists who excavated them: Prof Zainolla Samashev (Nazarbayev University) and Prof Abdesh Toleubayev (Al-Farabi Kazakh National University), whose tireless and meticulous work over many years has produced a wealth of material and written information. We are also grateful to the East Kazakhstan Regional Architectural, Ethnographic and Natural Landscape Musuem-Reserve, Ust'-Kamenogorsk, and the State Historical and Cultural Reserve Museum, Berel for providing additional material. Many thanks to Qazaq TV for providing access to their excellent video coverage of the excavations.

Heartfelt thanks and admiration are extended to Yevgeniy Domashev for providing his atmospheric and beautiful photographs of East Kazakhstan with such generosity and openness.

Advice and guidance about how best to present the material to a UK audience has been generously provided by colleagues who are leaders in their respective fields: at University College London Dr Miljana Radivojevic, Prof Tim Williams, and Dr Gai Jorayev; Dr Prajakti Kalra (Cambridge Central Asia Forum); Prof Emerita Claudia Chang; Dr Laerke Recht (University of Graz); Prof Peter Stewart (University of Oxford); Dr Tamasin O'Connell, Prof Matthew Collins, and Prof Marcos Martinón-Torres (University of Cambridge) have all provided invaluable input. Under the skilful guidance of Heritage Consultant Lisa Keys, this remarkable group of individuals brought energy and clarity to the project.

In Cambridge, the whole project is enabled by many talented individuals, who have worked patiently with us in extraordinary circumstances. Rebecca Roberts would like to extend particular thanks to Dr Orietta Da Rold, Prof Raphael Lyne, Marina Ballard, and Vicky Aldred at the Faculty of English, and Dr Cameron Petrie at the McDonald Institute for Archaeological Research for affording her the flexibility in her other work commitments to dedicate time to this project. At the Fitzwilliam Museum grateful thanks is extended to the many skilled individuals who pulled together to make the project possible, including, but not limited to, those working in conservation, digital content, photography, graphic design, security, contracts, finance, HR, learning and outreach, development, communications, and exhibitions delivery. We are grateful to Catherine Kneale at the McDonald Institute for Archaeological Research for her assistance in the calibration of the pXRF instrument, to Ian Freestone and Thilo Rehren (UCL) for their thoughts on the possible enamel, and to Umberto Veronesi for producing the ternary colour diagram in Chapter 6.

The team who contributed to this volume from both sides of the Great Steppe has from the very beginning displayed exceptional teamwork, perseverance, and good humour in the face of unprecedented pandemic conditions. Prof Zainolla Samashev, Prof Abdesh Toleubaev, Prof Claudia Chang, Prof Marcos Martinón-Torres, Dr Laerke Recht, and Saltanat Amir skilfully crossed disciplines to compose and refine the content of the book. Joanna Dobson, bringing a unique skillset of translation, authorship, and extensive knowledge of the Altai region, worked tirelessly to produce high quality translations, as well as facilitating discussion while in Kazakhstan. Each word has been crafted with care and attention, but any errors rest on the shoulders of the editor. Final and emphatic thanks must be given to Saltanat Amir, David Evans and Erica Emond, who made the entire project possible in the face of seemingly impossible circumstances.

Eleke Sazy valley contains hundreds of funerary monuments dating from the Early Saka period onwards

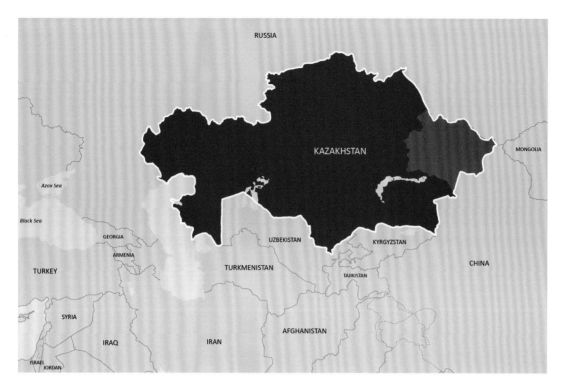

Map 1

Central Eurasia, showing modern political boundaries.
The East Kazakhstan region is highlighted in red

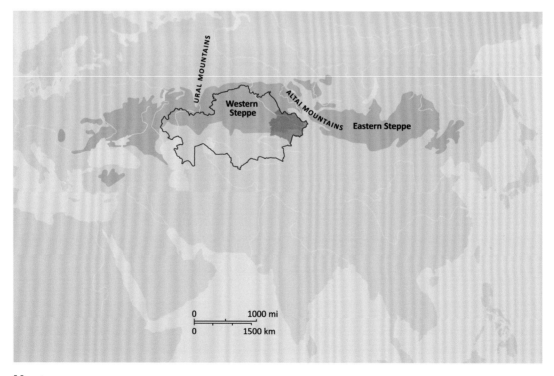

Map 2

Central Eurasia, showing the full extent of the Great Steppe

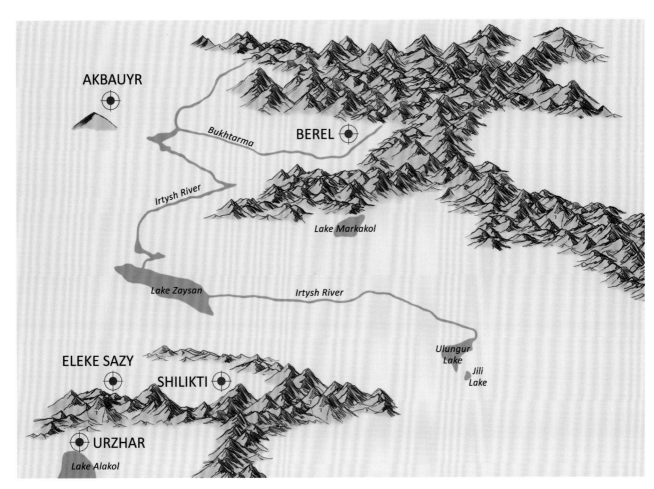

Map 3

East Kazakhstan, showing location of sites
presented in *Gold of the Great Steppe*

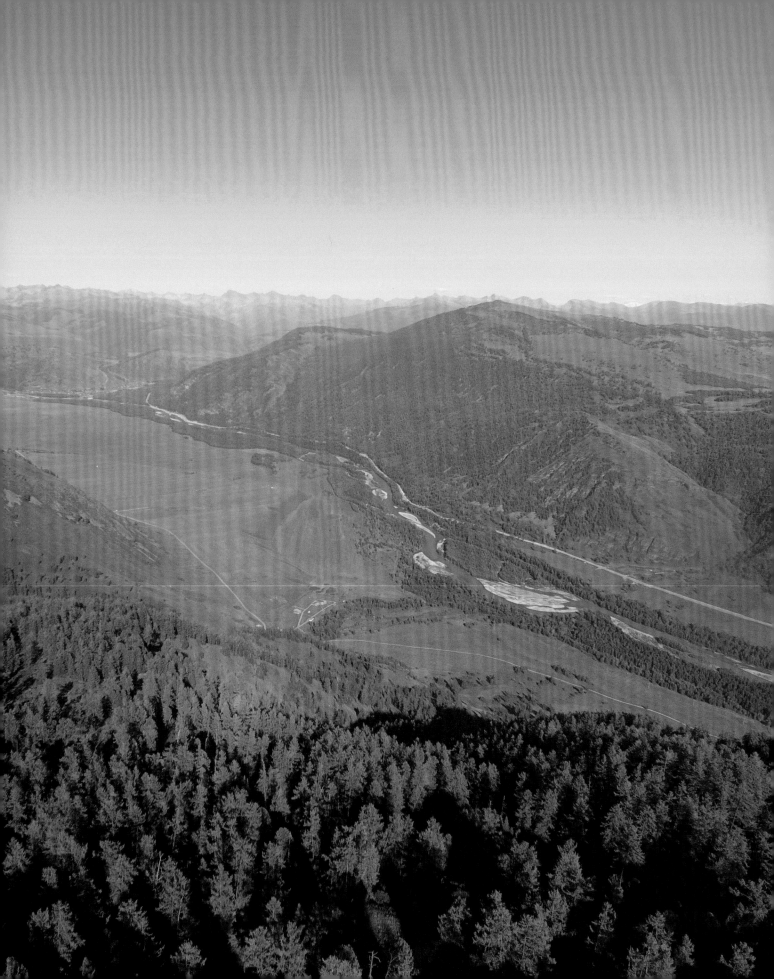

1. INTRODUCTION

CLAUDIA CHANG AND
REBECCA ROBERTS

The exhibition *Gold of the Great Steppe* features the most recent artefacts found from the necropoles and settlements built in the first millennium BC by the Saka-Scythian nomadic confederacies of eastern Kazakhstan. These peoples were part of the pan-Scythian cultural sphere, which occupied the 'Great Steppe' – the vast Eurasian steppe zone extending from the Black Sea in the West to the glacier-covered Altai-Sayan mountains in the East (Maps 1–3). Spanning the borders of Kazakhstan, China and Mongolia, the mountains of this region are dominant (fig. 1.1); however there is also an equally striking human-made landscape of burial mounds (called *kurgans*), settlements and petroglyphs, spanning the late Bronze Age (c. 1100 BC) to the medieval period and into the recent nomadic history of the contemporary Kazakh people. In the second half of the 19th century and throughout the 20th and early 21st centuries, archaeologists have investigated the splendid finds of the elite aristocratic burial mounds of the Shilikti and Pazyryk cultures of the first millennium BC. Since 1998 a group of leading Kazakh archaeologists has excavated Iron Age necropoles (Berel, Eleke Sazy, Shilikti) and also late Bronze/Early Iron Age settlements (Akbauyr, Trushnikovo, Novoshulbinskoe) of these nomadic and semi-nomadic peoples (Map 3). Furthermore, there is now evidence for the continued construction of kurgans into the early Turkic periods of the 3rd–4th century AD at Berel, also yielding important artefacts, and human and horse burials.

These activities represent a vast array of scientific work, including particular methods of excavation to determine construction techniques, the recovery of delicate artefacts made from leather, plants, textiles, wood, bone and metal, their conservation and material analyses. Some of this work is presented in the chapters of this book, and is highlighted

1.1

Aerial view of Berel necropolis (centre) located in the natural 'amphitheatre' of the Altai mountains

in the present exhibition. Each artefact excavated has its own unique life post-excavation, designed to uncover aspects of its pre-depositional history. Each object has a story to tell, which various analytical methods can begin to extract. Some artefacts, such as those made from organic materials such as fur, wood, plant fibres and textiles proved too fragile to travel for an international exhibition (figs. 1.2–7). Their very existence, over two millennia after they were buried, speaks to a rare level of preservation, facilitated through the formation of permafrost in the kurgans. Their scientific value is equal to that of the gold objects, and as part of the preparations for the exhibition new analyses have been carried out on these artefacts, which further enrich our understanding of the Saka-Scythians.

What sort of lives did the people who built and are buried in these necropoles and settlements have? For archaeologists this has always been a particularly thorny question. In Chapter 2, Zainolla Samashev demonstrates that from the vast scientific information gathered from the most recent excavations at Eleke Sazy and Berel, a chronology for the Saka-Scythian elite burials now spans the early period at Eleke Sazy (9th–7th century BC) and the later classical Saka period (eastern Scythian populations; 4th–3rd century BC) which are consistent with the Pazyryk culture, to which the Berel mounds are assigned. The splendid gold finds of jewellery, headdresses, plaques on clothing of the interred, and horse burials with wooden and leather masks of ibex, and of other, mythological beasts, give specific insight into the symbolic worlds of these ancient nomadic groups as well as their ritual practices.

Yet archaeologists also construct narratives of the subsistence life of semi-nomadic people who travelled from winter pastures in the lowlands to upland pastures in the spring. Where did these people pasture their flocks and herds of sheep, goats, cattle and horses? And what sort of resources did they exploit, such as fish, wild plants, and even the possible cultivation of grains such as millet, to supplement the diet of meat and milk? To discover the answers to such mundane questions, archaeologists must turn to the scientific excavations at Akbauyr, an early settlement site at the cusp of the Bronze and Iron Ages. Finds at this early settlement include the stone foundations of dwellings, stone artefacts such as grinding stones, pestles, hoes and axes – indicating that grain may have been cultivated – as well as ceramic vessel fragments and evidence of craft production such as spindle whorls and crucibles.[1]

The vast burial mound complexes of Berel (over 70 kurgans) and Eleke Sazy (over 300 kurgans) demonstrate that the ancient peoples of the first millennium BC were socially and economically stratified. This has long been a debate in Western social anthropology – whether nomadic cultures were fiercely independent and egalitarian, or whether they were hierarchical and unequal.[2] Females and males buried in the largest kurgans, sometimes in tombs that were reflections of the sod and

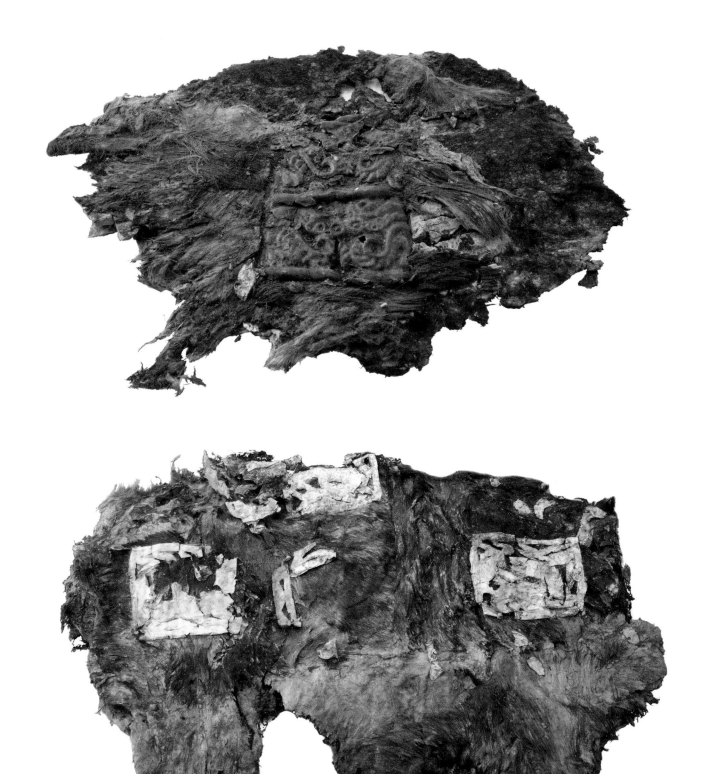

1.4

Red textile fragments. Berel Kurgan 11.
TEXTILE. Late 4th–early 3rd century BC

1.5

Pieces of twine. Berel Kurgan 11. MATERIAL
UNKNOWN. Late 4th–early 3rd century BC

timber constructions of dwellings[3] – with gold, silver, inlaid stones and interred horse burials – have been identified as the aristocrats of clans or confederacies. What group of people built these carefully constructed tombs, perhaps meant to preserve bodies in the permafrost? From the intricate production of thousands of millimetre-small gold beads to the construction of metres-high kurgans formed of large, imposing rock slabs placed over the tomb chambers, and the careful alternating layers of gravel, rubble and sods enclosing the mound itself – all this suggests that many people's time, strength and labour were commandeered through means unknown to produce these incredible monuments. Such hints at the nature of nomadic power structure are tantalizing, and each artefact speaks to a certain interplay between or among social strata within a highly complex society.

Nomadic culture during the first millennium BC depended upon the mobile lifestyle of short-distance seasonal vertical movement between uplands and lowlands or alternatively long-distance movement across north-south latitudes.[4] The Berel necropolis is situated on a large terrace about 1120 m above sea level, on the third terrace of the Bukhtarma River. The landscape of this necropolis suggests a territory rich in wild animals in the alpine regions (including the predator felines, wild sheep and ibex) and also, below, the importance of fish and timber resources. How did these burial mounds, of varying size and contents, mark territory for a clan or group of clans? And was this burial landscape marking the territory of winter pastures?

The exhibition highlights the process by which these spectacular mounds have been excavated in order to discover the tombs of the ancient elite, through the example of Kurgan 4 of the Eleke Sazy cemetery, in Chapter 3 of this volume. Kazakh archaeologists and specialists from over twenty different nations have participated in the hard work of removing large stone slab coverings, and carefully removing the soil matrix from the tombs themselves, which contain both human and horse skeletal

remains, often decorated or clothed in splendid costumes, where all that remains are the plaques, buckles, jewellery or headdresses. As well as the bronze, silver and gold artefacts are fragments of leather, fabric and wood that must be carefully conserved. In one case, at the burial mound of Eleke Sazy Kurgan 4, a treasure hoard was found below the stone cap which included bronze and gold plaques, some with stylized animal motifs, pendants and many tubular gold beads, as well as beads of semi-precious stones. Samashev notes that such finds could be part of a post-funerary ritual in which the precious vestments and ownership items of the deceased were re-circulated, citing a custom of transformation among contemporary Kazakhs, where such items of the deceased are re-distributed in a rite of passage after the funeral.[5]

A burial mound constructed to mark a territory, either by ownership or, more loosely, possession, is also an encapsulation of custom, tradition and practice. Here, the context of the mound itself, how it was built, what purpose or function it served, and its embodiment of ritual, mythology, beliefs and aesthetics, can be employed to make inferences about such past practices. So often the warrior status, especially as it pertains to males, is important for the interpretation of steppe culture. At Eleke Sazy Kurgan 4, a young male was buried with a dagger and a scabbard, along with a bow case and quiver. The scabbard has gold overlays consisting of an upper register of grazing animals without horns or antlers and a feline predator in a sudden halted position, with inlaid stones for facial features and ears, and a lower part of deer with extended antlers and S-shaped stylized tines. It takes the fine work of art historians and others to unwind these narratives, which are neither Persian nor Chinese in composition, but undeniably steppe features of a world divided between prey and predator, juxtaposed. Here the clues are endless, yet they require careful reading by those steeped in the analysis and interpretations of 'animal-style' art. Why does a scabbard, obviously military protective gear, display such beasts, and what might this mean in terms of war, funerary practice, and manliness? Even more curious since the male in question is barely a man – aged around seventeen years at the time of his death. Unanswered questions are as much a part of archaeology as detailed analysis. The female burial from the same grave was robbed in antiquity, and we will never know whether she, too, bore weapons.

The 'animal-style' objects found at Eleke Sazy and Berel represent both symbolic and semantic markers of Eurasian steppe culture. New art-historical interpretation of first millennium BC zoomorphic imagery stresses the placement of such objects on dress, ornamentation and the body as well as the spatial location of these objects in the tomb itself.[6] What the funerary interment of both horses and humans at Berel and Eleke Sazy provides is a large canvas by which to test an entire visual repertoire and framework of mythological narratives.

OVERLEAF
Eleke Sazy valley, Tarbagatay mountain range. The mountains and rivers of the Altai region are rich in gold deposits

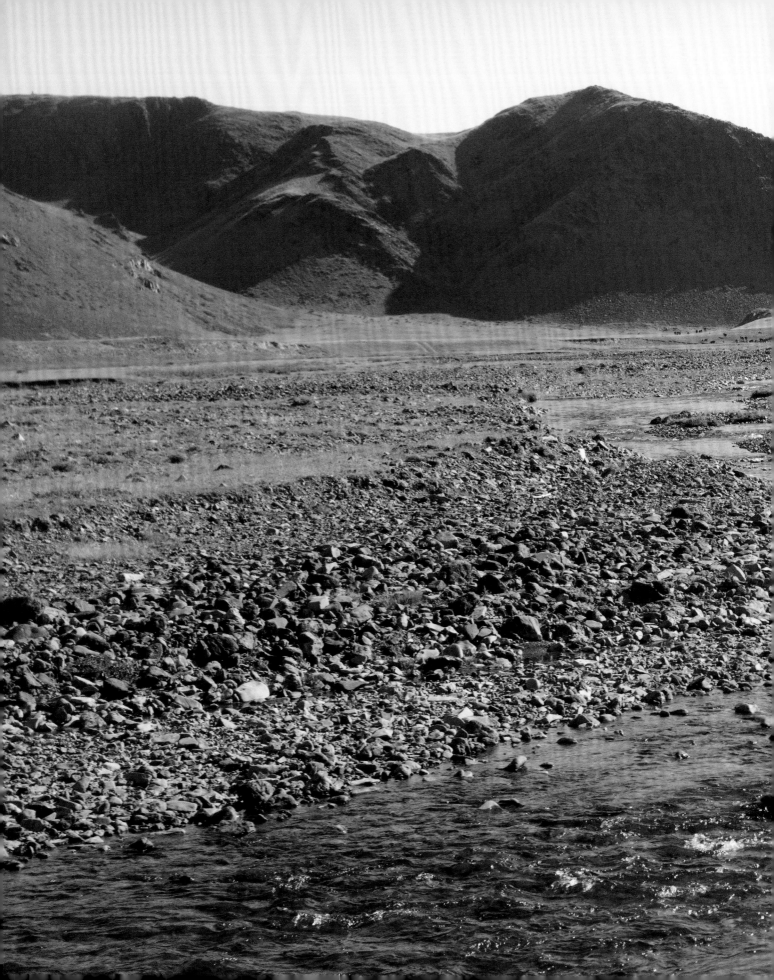

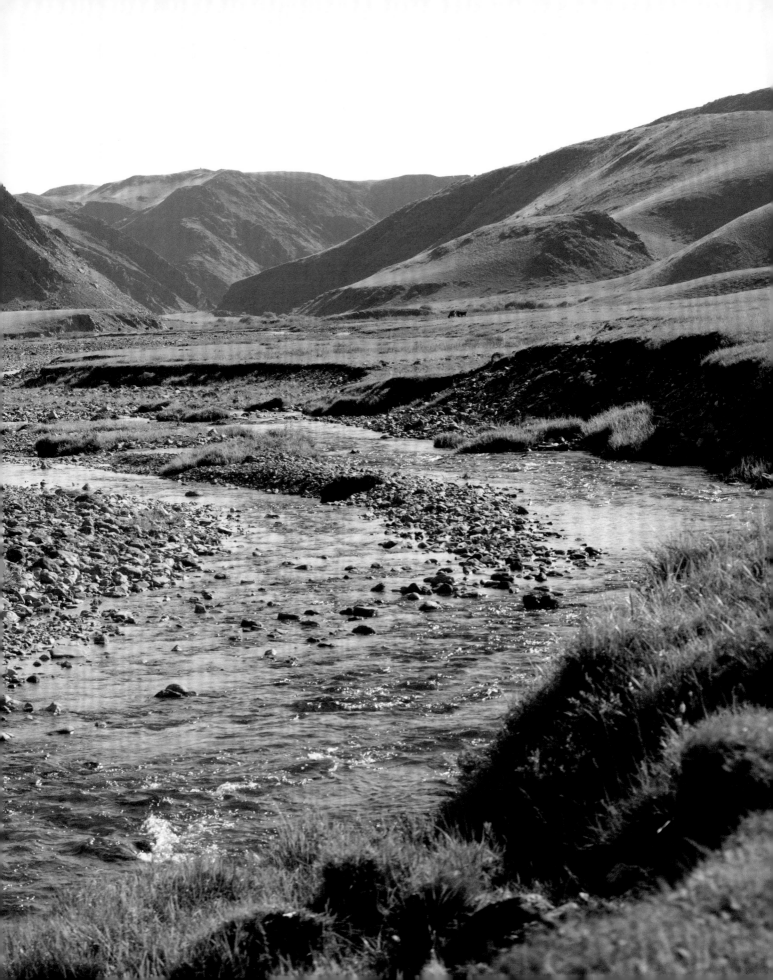

1.6

Three-dimensional decorative plaque with sewing holes. Figure of horse/sheep. Made from two articulated pieces. Berel Kurgan 5. WOOD WITH GOLD OVERLAY. Late 4th–early 3rd century BC

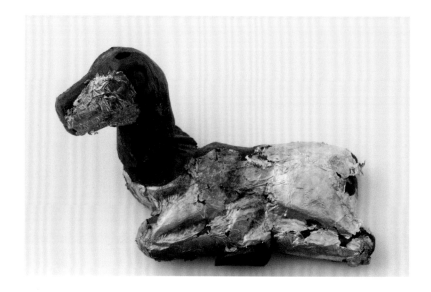

We observe the symmetrical fields of both the objects themselves and their subject matter, from the curved, S-shaped tines of the Shilikti and Eleke Sazy golden deer plaques and the unique three-dimensional gold argali – wild mountain sheep – set on a platform of lobed roundels and noted by Samashev as floating on clouds,[7] to their symbolic counterpart predators such as the curled feline plaques of both Shilikti and Eleke Sazy. We may ask ourselves, why such depictions of mountain animals and their predators, on both a practical and aesthetic level? If indeed the steppe world is a multi-layered world of underground, landscape and sky, do high-mountain animals – both predator (felines, bears and mythical griffins) and prey – represent a hunting tradition and also the verticality of a dramatic landscape, reflecting mythological spirit worlds?

Samashev in Chapter 2 presents a clear chronological sequence for placing the smaller excavated burial mounds in a chronological framework of later Hun-Xianbei culture groups (early Turkic period groups, c. 3rd–5th century AD). These later burial mounds also indicate a continuation of mortuary practice and burial tradition incorporating both horse and human interment. The use of ethnic identities to render chronological periods and culture areas emerges from the Soviet and post-Soviet archaeological and historical traditions of identifying style, artefact type and burial attributes with geographical clusters, often given ethnic identities or archaeological culture designations.[8] The continuity of steppe tradition, sometimes boldly referred to as 'nomadic civilization', is documented archaeologically through various culture groups of the Altai-Sayan region who relied upon social stratification apparent from the elite mounds, the display of power and prestige of warriors, mythological motifs of predator-prey, and an aesthetic rendering of the spiritual aspects of both human and animal.

1.7

Three-dimensional decorative plaque with sewing holes. Figure of horse/sheep. Made from two articulated pieces. Berel Kurgan 5. WOOD WITH GOLD OVERLAY. Late 4th–early 3rd century BC

There is indeed another way to utilize these 'archaeological culture' designations, and this is characterized in Chapter 4 by Abdesh Toleubayev, who draws direct parallels between tradition and customs of historic and contemporary Kazakh nomadic people today and the ancient Saka-Scythian traditions present in the funerary contexts of the first millennium BC. In the cultural evolutionary schema of the late 19th century, E.B. Tylor discussed "the survivals" of ancient practices seen in tribal cultures,[9] whereas Toleubayev asserts another approach. As part of a process of decolonizing the interpretation of the archaeological culture of the Saka-Scythians, so long dominated by Soviet interpretive frameworks, he draws parallels between what happened as far back as the first millennium BC (at sites including Berel, Shilikti and Pazyryk) and ritual custom and practice among Kazakh and other nomadic cultures. When such a rich ethnographic record for historic and contemporary Kazakhs exists, archaeologists can avail themselves of ethnographic descriptions of rituals and practice to build interpretive frameworks for ancient rituals and practice.

Western archaeologists using ethnography refer to this set of practices as 'ethnographic analogy'. Recently the use of ethnographic description for archaeological interpretation has been revised to embrace its usefulness because its rich contextual details (such as mortuary practice) can flesh out the fragmentary nature of archaeological materials.[10] Toluebaev compares ancient Saka-Scythian female burials at Pazyryk, where silk pouches with nail clippings and the upper part of hair plaits were identified, with the Kazakh ritual practice of women collecting hair, clipped nails and lost teeth throughout their lifetimes, then later requesting to be buried with objects such as the 'cut-braid'. He also describes the gendered and hierarchical relations of Kazakh seating in a

yurt and how the same use of right side of a tomb is reserved for females, while the left side is for males in ancient Saka-Scythian and Hunnic tombs. These comparisons or parallel features speak to a more rigorous interpretive framework for the invisible aspects of ritual, ceremony and mortuary practice often unavailable to archaeologists except through historic or ethnographic description.

Perhaps one of the strongest affinities between modern-day Kazakhs and their geographic predecessors is the close bond between people and horses. Bearing witness to a long tradition of pastoral nomadism, horse milk and meat are a delicacy in even the most urban parts of present-day Kazakhstan, and Toleubayev discusses the historic Kazakh custom of cutting the mane and tail of a deceased person's mount.[11] No discussion of the Saka-Scythians is complete without exploring the close and complex relationship between people and horses, and from an archaeological perspective horses bear important witness to Saka-Scythian life and death, since they were companions in both. To this end, in Chapter 5 Laerke Recht draws on data from Berel and other necropoles to discuss how the numerous horses buried in kurgans have been analysed to reveal their life histories, manner of death and treatment post-mortem, and what these results can tell us about economic, social and symbolic practices in the past. As we see in the human burials, horses were carefully arranged in spectacular funerary outfits, indicating that they, too, played a part in the expression of power and status. At Berel, the horses, placed in close but separate chambers from the human interments, are dressed in face masks, horns and other decorative elements that transform them into mythological creatures and suggest a special spiritual bond with the interred humans. The placement of horses in kurgans in positions which echo (or are echoed by) the 'animal style' speaks to their symbolic power. The horses buried in Berel are all male, and, if similar to those from Pazyryk (where exceptional preservation allowed for such identification), they were most likely also geldings. This hints at a high level of technical knowledge about animal husbandry, and a sophisticated strategy in the management of horse herds. This level of organization reflects the evidence we see in the production of thousands of gold artefacts, and the building of highly structured burial mounds, all of which demonstrate that the elite strata of Saka-Scythian society in East Kazakhstan commanded sufficient power and status to coordinate these activities.

Underlying these grand themes of power, mythology, symbolism and structure is a hidden world of individual skill, time investment and technical knowledge, which can be accessed only through painstaking scientific analyses. This is clearly demonstrated in Chapter 6, where Saltanat Amirova and Marcos Martinón-Torres present new archaeometallurgical analyses of the gold artefacts from Eleke Sazy Kurgan 4 and Kurgan 7. Combining data from x-ray fluorescence (XRF)

and high magnification imagery, they reveal details unseen to the naked eye, which speak to the incredible technical skill of the Saka-Scythian craftspeople, as well as their knowledge of gold mining and extraction. The deer plaques from the two different kurgans have the same chemical signatures, implying a single, possibly local, gold source. However, they differ in chemical composition from the gold clothing ornaments from the hoard found in Kurgan 4, which may imply that this hoard was deposited at a different time, or was made by different craftspeople. Thousands of tiny gold beads, 1 mm in size and thought to have been sewn onto clothing and shoes, were found in two different locations within Kurgan 4. At first glance both groups of beads appear to be the same; however XRF analysis shows that the composition of the gold is different, indicating different sources of raw material. Further to this, high magnification images reveal that these groups of beads were in fact produced using two quite different techniques. This raises questions about who created them, how, where and when. How was technical knowledge shared? Who had access to particular gold sources? Was gold mining and production protected and regulated by the "griffins which guard the gold"[12] in the same complex ways indicated in other parts of their lives? Were the two groups of gold beads deposited at the same time but from two different makers, or is there a temporal gap between these two deposits?

As an international exhibition, *Gold of the Great Steppe* has benefited from the cross-fertilization of techniques, methods, and modes of analyses and interpretation used by the Republic of Kazakhstan and by institutions of archaeological researches in the United Kingdom. Leading metallurgical experts, archaeological chemistry and material sciences experts, art historians and ancient plant specialists have added technical and scientific dimensions to the objects displayed and what we can learn about these objects. Each expert's contribution is described with two particular goals in mind – (1) how this particular piece of scientific evidence, discovery or technique adds to a larger context for interpreting the art and craft of such objects; and (2) how we may foster those international institutional connections and networks to develop new and better paradigms for interpreting and preserving the past for future generations.

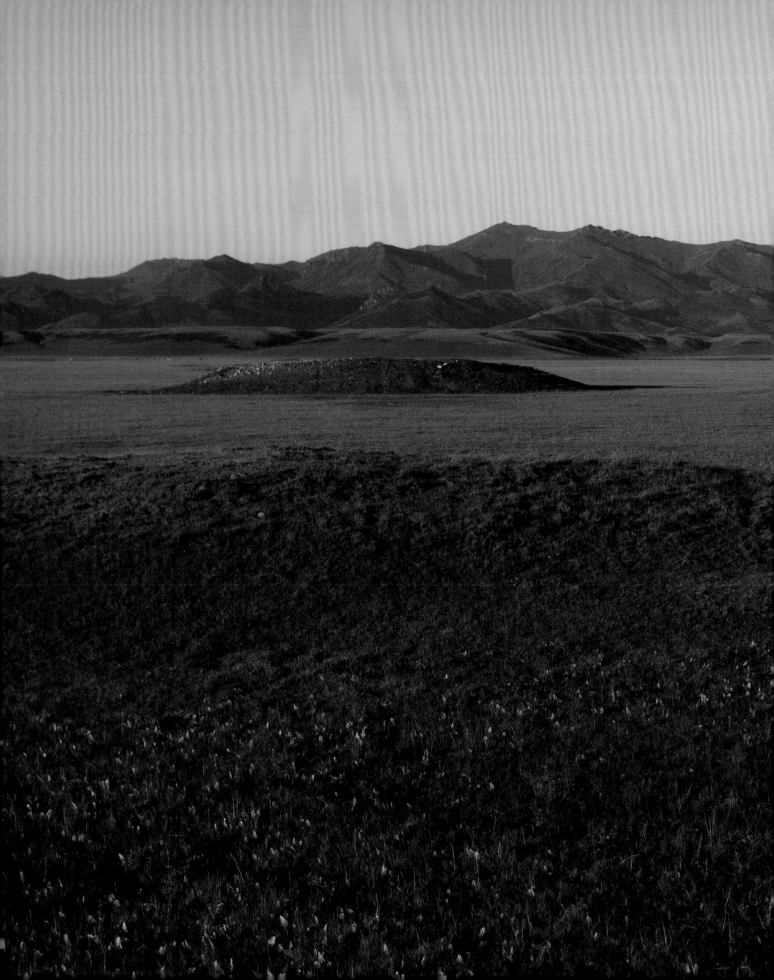

2. THE ILLUSTRIOUS CULTURE OF THE EARLY NOMADS IN THE KAZAKH ALTAI

ZAINOLLA SAMASHEV

TRANSLATED BY
JOANNA DOBSON

Modern-day Kazakhstan lies at the heart of the Eurasian steppe belt, where throughout the first millennium BC, a complex series of historical events would significantly shape the cultural space of this entire geographical area and adjacent territories. Bordered by expanses of forest and taiga (boreal forest) to the north, mountain ranges and desert to the south, the conditions of the steppe zone provided opportunity for the east–west lateral expansion of the ancient peoples of Eurasia (Map 2).

The period spanning roughly the end of the second millennium BC and the early first millennium BC marks the transition to the Early Iron Age (currently believed to have lasted up until the 3rd–4th century AD), and with it emerge practices of nomadic pastoralism. It is at this time that stockbreeding is established as the main subsistence strategy for a significant portion of the population of the Eurasian steppe belt.

Throughout this vast historical milieu, more efficient economic strategies emerge, centred primarily around mobile forms of animal husbandry, which are developed and mastered as the early nomads adapt to the changing ecological landscape. At the same time, aesthetic values, philosophical ideas and social and political institutions evolve, which, although differing in form, are surprisingly similar at their core.

The area of land that stretches from the Urals eastward as far as Mongolia offers highly favourable conditions for the practice of mobile animal husbandry. An innovative development at the time, this efficient herding system, so well-suited to the conditions of the steppe region, is still practised today among many of the steppe peoples of Eurasia. Depending on local conditions, the range of pastoral migrations varied from 30 km to as much as 1,500 km.

2.1

The Saka cemetery of Eleke Sazy, Tarbagatay region

These circumstances provided the steppe peoples with new opportunities for prosperity, which led to cultural blossoming, and stimulated processes of social stratification and the development of new power structures. Numerous nomadic cultures of the Saka type appear in the steppe zone, the early stages of which can now be dated to the 9th century BC, as will be argued in this chapter.

These changes were brought about on account of a powerful economic and cultural substrate that existed in the area at the end of the third and beginning of the second millennia BC. The cultures of this time had their foundations in highly developed technologies for the processing of raw materials (including non-ferrous metals, bronze, gold and precious gemstones) and a sustainable system of nomadic animal husbandry, as well as an effective military and weaponry.

However, across the diverse natural and climatic zones of the Kazakh Steppe and the Eurasian steppe belt as a whole, the 'transition' to the Early Iron Age developed at different rates, displaying varying social, economic, and technological characteristics at any one time.

Under the conditions of this 'transition', the picture of many cultures begins to change: optimal subsistence strategies are developed (vertical or year-round pastoral migration and herding domestic animals capable of foraging for grass beneath the winter snow cover); more portable types of dwelling and utensils are created; clothing types change; exploitation of the horse as a form of mounted transport triggers the invention of more efficient types of reins and harness equipment, as well as specialized weaponry for mounted riders.

These developments spread relatively quickly throughout the cultures of the steppe, forming a kind of 'cultural horizon' linked to previous mobile cultures of the Bronze Age, where horse-riding skills as well as two-horse military chariots and quadrigae were already in existence along with corresponding horse trappings (disc-shaped and other types of psalia and reins etc. are recorded). Due to significant progress in horse breeding and the production of large series of bridle sets in bronze, the rider comes to the fore in early nomadic society.

Innovations emerged not only in response to significant fluctuations in climate, among other external factors, but perhaps to an even larger degree, as a result of long-standing economic, social and political developments taking place within the steppe communities themselves. That said, some researchers also look to additional external cultural 'influences' resulting from migrations and military campaigns, to say nothing of the influence of palaeoecological conditions towards the end of the second millennium BC and the first half of the first millennium BC.

It is logical that a transitional period or phase should have existed between the late Bronze Age and the Early Saka period which would have been characterized by innovative mechanisms of adaptation to natural and ecological niches of the steppe space emerging alongside

previously established and developing economic and cultural types. Some researchers consider this transition a historical period in its own right with characteristic types of economic activities, tool sets and weaponry,[1] suggesting that it be referred to as the Ferraaeneum or Bimetallicum.[2]

The study of palaeogeographic conditions and palaeoclimatic events in the context of the cultural and historical processes unfolding in the Kazakh Steppe is also highly relevant. According to recent research carried out in southern Siberia and the adjacent territories of Central Asia, whereas some cultures of the Late Bronze Age, such as the Karasuk culture (1460–900 BC), developed in warm and moderately dry climatic conditions, around 850 BC the area begins to experience a drop in temperature and increased humidity levels, providing favourable conditions for the expansion of pasturelands and the development of nomadic cultures.[3]

In the early Iron Age, three cultural modes of occupation developed and became integrated – livestock breeding, agropastoralism and craftsmanship – while institutions of leadership and a military-priestly aristocracy were created. These shifts in early nomadic society necessitated the adoption of complex religious systems, the attribution and consolidation of status through funerary rites, a strict iconographic template applied in weapon-making and plastic arts, and the creation of epic tales and an integrated system of mythology and belief.

The era of the early nomads coincided with the crucial step on the path of progress for all humanity – the advent of the widespread use of iron in the production of tools and weapons.

Very recent discoveries of ironworking furnaces recorded at the Bronze Age Alat settlement in the eastern Saryarka area date the onset of iron production in the Kazakh Steppe to the turn of the second–first millennia BC. According to archaeometallurgist S. Zhauymbaev, four ironworking furnaces, ore, slag and production sites have been recorded at the settlement, where iron was worked using an especially sophisticated technology.[4] In the Kazakh Altai, single artefacts made of iron have been recorded in Early Saka mounds at the Eleke Sazy necropolis dating to no later than the 8th–7th century BC.

As K. Akishev has noted, however paradoxical, the 'mass production' of bronze artefacts also underwent rapid development in the Saka period.[5] Other researchers have noted the same phenomenon, referring to the artistic bronze of nomadic cultures (objects of horse harness and trappings, weapons, temple artefacts, etc.), the widespread distribution of which is especially noticeable in the first half to the mid-first millennium BC.[6] Nevertheless, the use of iron in all spheres of activity was more economical and more efficient than bronze and had great advantages.

In this period, grandiose funerary structures, pyramids and huge necropoles appear in the expanses of the steppe, erected in honour of

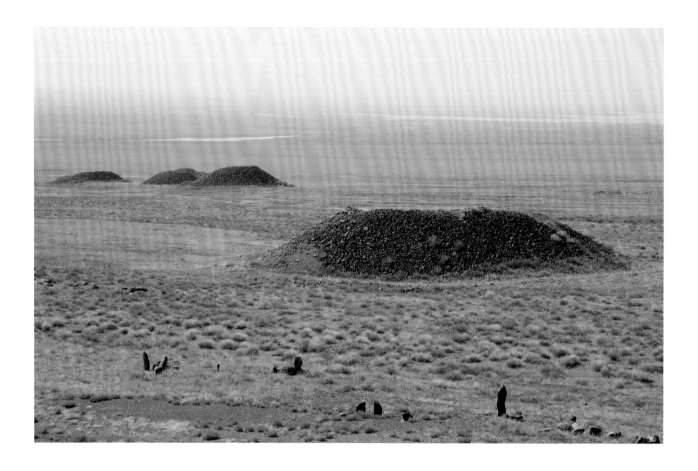

2.2

Besshatyr, Zhetysu, south-east Kazakhstan,
6th century BC

leaders, members of the elite and nomadic aristocracy. These funerary monuments reflect the profound social and political processes taking place in society at the time. The largest kurgans containing the burials of early Iron Age leaders are located at Gordion in modern Turkey, at Sakmara, and in the Kazakh Steppe at Zhuantobe cemetery near Kegeny, Asy Saga and Besshatyr in Zhetysu,[7] as well as Shilikti in the Tarbagatay area, and Kyryk Oba in the West Kazakhstan region (fig. 2.2).

Historical sources

According to written sources, the northern nomads grazed large herds, were brave and impressive horsemen skilled in archery and in wielding the akinakes (Saka short sword), and posed a real threat to agricultural civilizations. Herodotus wrote that there were "twenty-eight years of Scythian supremacy in Asia".[8] We know of various other forms of contact between the steppe peoples and the Western Asian states (Assyria and Media). The Saka peoples are described in Western Asian cuneiform inscriptions, are mentioned in the writings of ancient authors, and in

Chinese chronicles, which place them between the Amu Darya (Oxus) and the Murghab Rivers.[9] It is believed that the name of the Sakas (also called sagas in ancient texts) is associated with the word 'saka' (saga) meaning 'deer', tracing back to the name of a tribal totem-protector.

Ancient Persian sources use the word Saka to refer to the nomads of the northern Black Sea area, whom Herodotus calls Scythians. And often, ancient authors used the term Scythians or Sakas simply to refer to the northern nomads. The earliest mention of the early nomads who inhabited the modern-day Kazakh Steppe is thought to date to the 7th century BC and occurs in the chronicles of Ashurbanipal (668–626 BC), Cylinder B (648 BC), column IV, l.14, "... Sharati, Parihia, sons of Gagi, chieftan of the land of Sahi, who had thrown off the yoke of my dominion, 75 of their strong cities I captured and carried off their spoil. Them I seized alive with my own hands and brought to Nineveh, my royal city".[10] In his commentary on the text, V. Latyshev believes the Sahi might correspond to the Saka mentioned by Herodotus and the Achaemenid texts.[11]

Scholarly studies on this issue mainly use data from the Behistun inscription in honour of the military victories of Darius I (6th century BC), reconstructed by V.V. Struve. Of immense significance to us is the fact that among the images of noble prisoners of war that accompany the Behistun inscription is a representation of Skunkha (with the epithet 'This is Skunkha-sak') – leader (King) of the Saka, who appeared before his enemy after his failed battle against the troops of Persian King Darius I in 519 BC.[12] This monument provides us with the proper name of a historical figure, the Saka king Skunkha, who wore high headgear and who occupied the Aral Sea region (fig. 2.3). Among the countries and peoples conquered by the Persians, the Naqsh-e Rostam inscription mentions both the Haumawarga Saka (haoma-consuming Saka)[13] and the Tigrakhauda Saka (Saka with pointed hats), who are also depicted on the Eastern Staircase of the Apadana, Persepolis (fig. 2.4).

Many researchers negated the likelihood that the steppe peoples could have their own written language, although the runic-like inscription inscribed on a silver bowl from the Issyk kurgan indicates the existence of a written alphabet among the Saka, at least by the middle of the first millennium BC. Likewise, it is curious to note the visual similarity between some of the letters in the Issyk text (fig. 2.5) and signs inscribed on ceramics and other artefacts (fig. 2.6) from the Gordion archaeological complex on the Sakmara River in Turkey, which date to a much earlier period.[14]

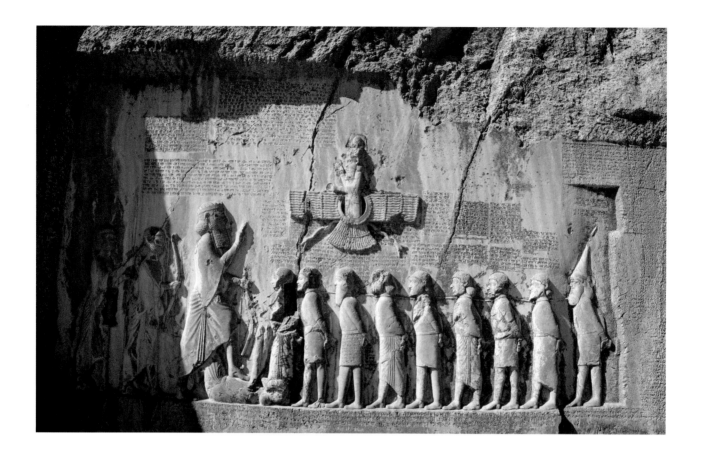

2.3

Behistun relief. The Behistun inscription records battles waged by Darius I in the 6th century BC, and is written in Elamite, Babylonian and Old Persian. The relief depicts nine captured kings who joined Gaumata (shown here under the boot of Darius) in an attempt on the throne. The figure on the far right of the composition is identified as Skunkha, king of the Tigrakhauda Saka (Saka with pointed hats), who was captured in 519 BC. Located 100 m up a limestone cliff, H: 15 m, W: 25 m. Mount Behistun, Kermanshah Province, Iran. Darius I. 522–486 BC

2.4

Delegation of Tigrakhauda Saka in traditional clothes and armed with *akinakes*, bringing gifts to the Achaemenid king Darius I. STONE. Persepolis, Apadana stairway, section three of panorama of middle register on left. Iran. 6th century BC. P. 28994/N. 15264

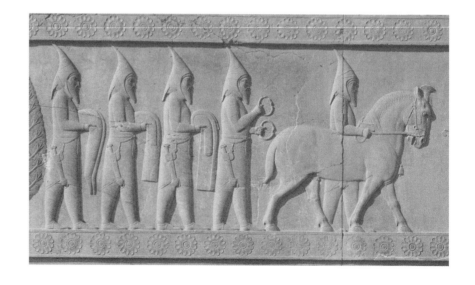

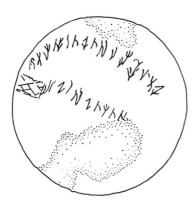

2.5

Inscription on a silver bowl from the Issyk kurgan containing the 'Golden Man'. SILVER. c. 4th century BC. (after Akishev, 1978)

2.6

Phrygian graffiti inscribed on ceramic sherds excavated from the Gordion archaeological complex. CERAMIC. Gordion citadel mound, Turkey. 6th–4th century BC. Gordion Museum, Turkey

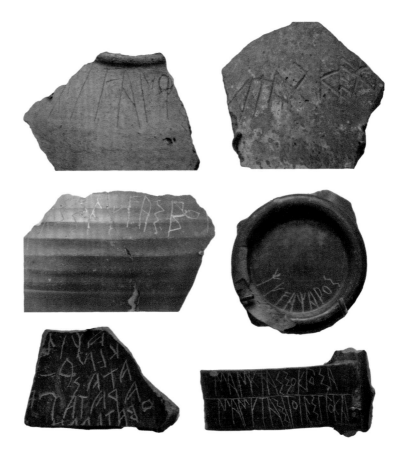

Archaeological material

The archaeological cultures of Kazakhstan in the Saka period are of great significance. Not only do they connect the cultures of Europe and Central Asia, but also in many aspects they may emerge from the cultures of the Bronze Age, such as the Begazy-Dandybaev culture.

A connection has long been established between late Bronze Age funerary monuments and artefacts from northern Tagisken and the Saka burial grounds of the Aral Sea region. There is, therefore, every reason to associate the origin of the main components of the early nomadic cultural complex with the territory of modern-day Kazakhstan, with its vast steppe spaces and mountain landscapes of the Altai-Sayan and Northern Tien Shan mountain ranges. However, in order to find a satisfactory solution to issues of cultural evolutionary development, it is insufficient to rely solely on data gathered from burial and funerary monuments.

Some of the most striking archaeological monuments dating to this period are the so-called 'deer stones'. These commemorative monuments bear numerous images of animals, mainly recumbent deer

2.7

Deer stones are ancient megaliths carved with deer and other images and symbols. They are found in Siberia and the Altai regions of Russia, Kazakhstan, Mongolia and China. Mostly carved from granite, of varying heights. STONE. Tarbagatay, East Kazakhstan. Bronze and Early Iron Age

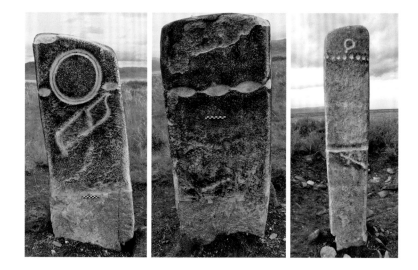

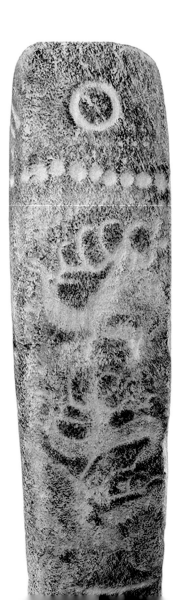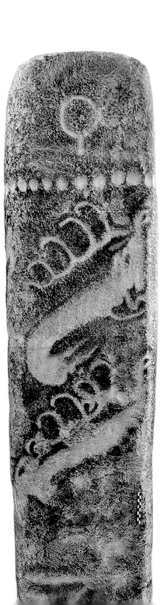

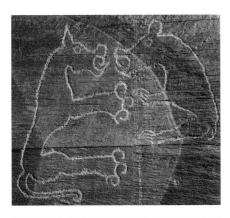

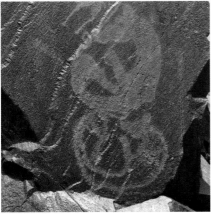

2.8
Petroglyph of a mythical scene of a bear and a predator. STONE. Sauyskandyk, Greater Karatau Ridge, South Kazakhstan. Iron Age

2.9
Petroglyph depicting coiled predators. STONE. Greater Karatau Ridge, South Kazakhstan. Iron Age

2.10
Petroglyph of a battle scene depicting warriors with bows by their sides engaged in combat on foot with battle axes (sagaris). STONE. Sagyr Tract, East Kazakhstan. Early Saka period

(sometimes stylized versions lacking legs). They also occur in simplified form with earring hoops, necklaces, belts and oblique lines carved onto the front side of the stone. Analogues to the classical deer stone type, such as the Uushigiin Uver stones in Mongolia, have been recorded in Tarbagatay and in north-eastern Kazakhstan (fig. 2.7). Unfortunately, no single ritual-memorial complex including deer stones has been comprehensively studied, and the majority of monuments recorded have been removed from their original location.

In terms of studying ways in which knowledge was preserved and transmitted throughout the communication system that existed in the Iron Age steppe, petroglyphs are likewise of great interest, especially those recorded in various regions of Kazakhstan that date to the transitional and Early Saka periods (figs. 2.8–10).

Settlements

When it comes to shedding light on the ancient economic characteristics of the subsistence strategy practised by the early nomads, of particular importance to archaeologists are materials originating at settlements dating to the late Bronze Age and transitional period as well as a small number of Early Saka settlements recorded to date in East Kazakhstan. Of more than thirty Bronze Age settlements currently researched in East Kazakhstan,[15] Trushnikovo, Novoshulbinskoe and Akbauyr are most relevant to the topic that concerns us here.

SETTLEMENT AT TRUSHNIKOVO VILLAGE
In the mid-1950s, on the bank of the Irtysh River, several sites were studied at Trushnikovo including a number of damaged pit dwellings, rectangular at base with rounded corners. The dwellings contained the remains of post-holes from various vertical structures – hearth fires, utility and waste pits, and even a deep well shaft. The finds recorded here include a large number of animal bones (sheep, goats, cattle and

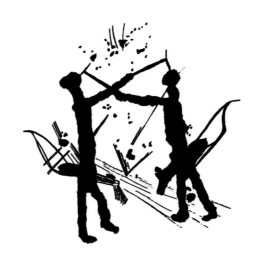

horse, etc.), fragments of ceramic dishes, bronze items resembling bullet-shaped arrowheads with barbed hook and socketed shaft, bone arrowheads, quern stones, pestles and pigment grinders, pieces of copper ore and other artefacts made of stone, bronze and bone.[16]

The size of the pit dwellings, the large number of horse, sheep and goat bones, the fragments of plain ceramic ware, and especially the bronze arrowheads of pre-Saka and Early Saka appearance clearly illustrate that new components of livelihood were emerging in the mobile lifeways of the population during the historical period in question.

AKBAUYR

The Akbauyr monument is located 20 km east of the city of Ust'-Kamenogorsk on a level area situated between two folded outcrops of granite rock, at the foot of a hill also called 'Akbauyr'.

In the far north-western portion of the site, there stands a row of six large, shallow-dug granite slabs (figs. 2.11a,b). Directly beneath the ground surface, ceramic sherds, quern stones, pigment grinding stones, crucibles, socketed axe heads, a spindle whorl and the bones of various types of animals were recorded in the area around these slabs, mostly to the south. Some of the stones are grouped so as to suggest that they represent the remains of dwelling foundations and other structures. A preliminary analysis of the materials obtained indicates that this settlement dates to the Early Saka period.

1,472 ceramic fragments were recorded at the Akbauyr settlement during initial excavation (fig. 2.12a). These comprised 59 rim fragments, 25 base fragments and 1,363 body fragments. Of the total number, 16 were decorated with impressions of tooth-comb stamping. Six other artefacts included four spindle whorls and two fragments of a ceramic crucible. In addition, three spindle whorl blanks were recorded.

Stone tools recorded at different layers of Akbauyr settlement include hoes and grinding stones (figs. 2.12b–c), and are of interest to archaeologists, first and foremost, for their ability to shed light on the ancient economy, processing technologies, and other spheres of activity in which the population of this region was engaged during the transition from the Bronze Age to the Iron Age and, especially, in light of studies related to the Early Saka culture.

The materials recorded, of which ceramics are only one component, reveal signs characteristic of the late Bronze Age and early Iron Age. Archaeological investigations at Akbauyr are at an early stage.

2.11a,b

Akbauyr settlement. Upper cultural layer.
Akbauyr, East Kazakhstan

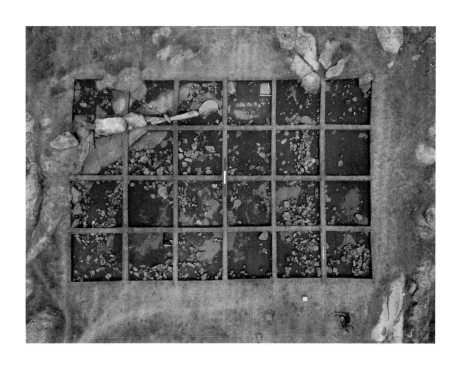

 Boulder

 Stone, coarse granite

 Stone, slate slabs

 Sector number

Fragments of ceramics

■ Wall

▾ Rim

▲ Base

▱ /▱ Animal bone

● /● Stone tools, fragments

East Kazakhstan Archaeological Expedition 2019. Settlement Akbauyr-1. Horizon 2.

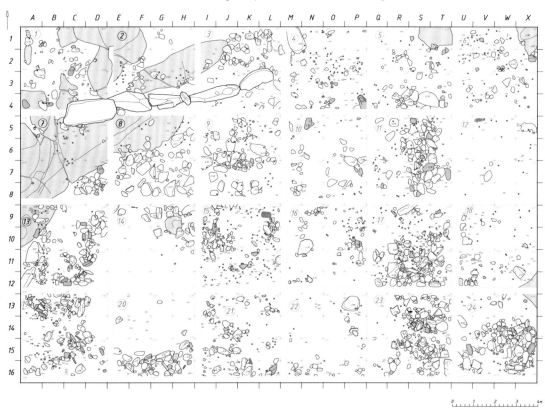

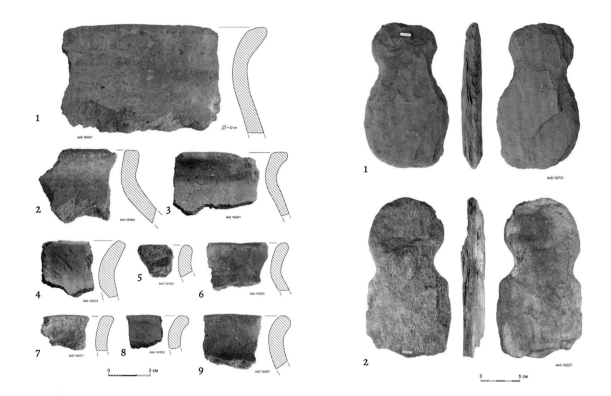

2.12a

Rims of non-ornamented ceramic vessels.
CERAMIC. Akbauyr settlement, East
Kazakhstan. Early Iron Age

2.12b

Stone hoes. STONE. Akbauyr settlement,
East Kazakhstan. Early Iron Age

NOVAYA SHULBA SETTLEMENT

This settlement is situated 2 km to the south-south-east of Novaya
Shulba Village on the promontory of the left Shulbinka River bank. Here,
archaeologists investigated approximately 108 square metres of cultural
deposits covering three dwellings. Remains of post-holes from timber
structures and a site revealing traces of a copper-smelting furnace were
recorded. According to data provided by A. Ermolaeva and L. Ermolenko,
a pit for crucible smelting and the refining of finished products was
recorded next to the pit-furnace, and at this metallurgical production
site archaeologists recorded over 115 kg of slag, 4.4 kg of copper ore
and bronze ingots, as well as stone ore-grinding tools, crucibles and a
fragment of a ceramic *tuyere*.[17] One may determine the type of object
being cast from the casting moulds recorded – adze or hoe-like tools, and
knives with the type of pommel referred to as 'corbel-head arc'. According
to current typological classification, knives of this type date to the end
of the 9th to the early 7th century BC. This period determines the upper
horizon of the cultural layer at Novaya Shulba. Analyses of the artefact
forms and production technology of the ceramic finds recorded here also
support this historical timeframe as the period during which the site
functioned as a metal-working and pastoralist settlement.

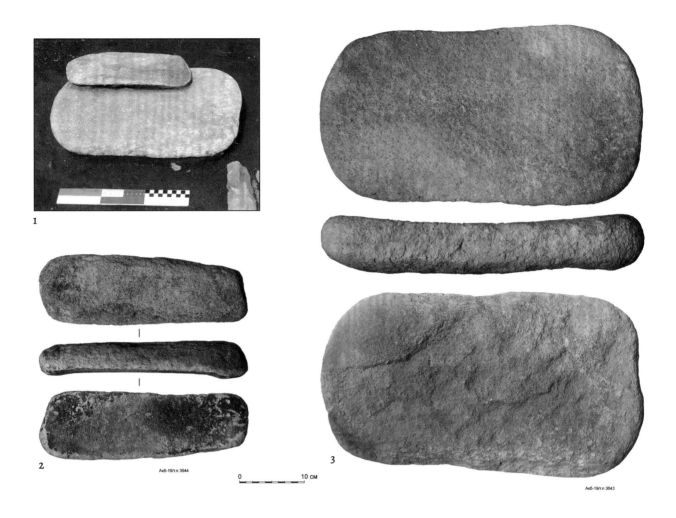

2.12c

Saddle quern and handstone. STONE. Akbauyr settlememt, East Kazakhstan. Early Iron Age

Funerary monuments

Kurgans represent the most widespread type of archaeological site found throughout the entire steppe zone. Chronological attribution – procedures for cultural and historical reconstruction – just as with the designation of archaeological cultures, is based largely on analyses of the furnishings and assemblages contained within these monuments. However, unlike the monument erected at any given site, the artefacts found therein have the quality of being portable, and may be indicative of outside cultural/ethnic influences, thereby signifying variations from the original forms, symbolic meaning, structure and chemical composition. Consequently, the study of these artefacts requires archaeologists to carry out additional procedures and analysis.

For this reason, great attention is paid to the architectural components of funerary structures, which subsequently inform

The Stone Kurgan during the process of excavation to investigate its above-ground structure. Eleke Sazy, Group II, Stone Kurgan. Early Iron Age

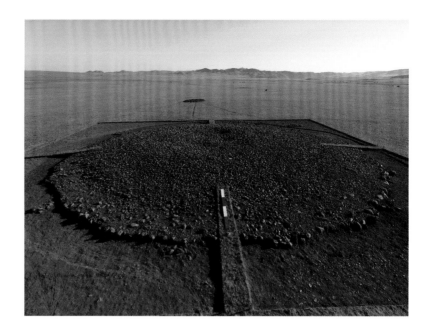

archaeologists as to the identification of cultural and chronological horizons, ethnic attribution, the details of funerary rites and memorial customs, religion and worldview, etc.

Until now, it was thought that kurgan-enclosure 3 at Kurty II burial ground in the area of the Bukhtarma River was the single known example of the earliest type of funerary monument dating to the Saka period in modern-day Kazakhstan. Here an oval arrangement of large, rounded stones was found in the vicinity of a burial containing a skeleton in tight, foetal position placed on the left side, head to the north-north-west. The oval arrangement of stones contained a horse burial in which two three-hole psalia made of horn were recorded and dated to the 9th–8th century BC.[18]

However, the Stone Kurgan belonging to monument Group II at Eleke Sazy necropolis in East Kazakhstan investigated by our team in 2019 yielded conetmporary, if not older, material.[19] The Stone Kurgan is circular at the base, composed of several layers of mainly rounded large and medium-sized stones, and stands out from the other kurgans at the same site in that the raised mound lacks a grassy-earthy layer (fig. 2.13). In this case, only the very periphery of the above-ground structure was covered in a turf layer. The kurgan itself measured 1.2 m in height and 32.6 by 32.15 m in diameter; the entire stone structure was held in place by a powerful crepidoma consisting of large rounded stones.

In the central part of the ground structure at the level of the ancient horizon, a construction of horizontally arranged slabs could be made out. In places, the slabs were stacked in several layers. The general configuration of the slabs resembles an early type of nomadic burial

Collapsed burial chamber of the Stone Kurgan
with the remains of horse burials. Eleke Sazy,
Group II, Stone Kurgan. Early Iron Age

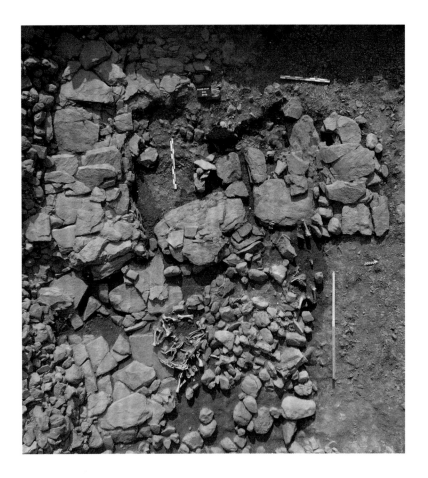

chamber, familiar in the archaeological record, which is rectangular at the base and joined by a dromos on the eastern side (fig. 2.14).

The southern portion of the burial chamber revealed the scattered bones of an adult and at the same level, closer to the northern wall, the long bones of the legs of the interred. Judging by the position of the bones, the body was laid with the head to the west facing south. Given the size of the large rectangular chamber comprised of horizontally arranged slabs, it was supposed that two individuals were once interred within.

On the eastern side of the chamber, the bones of two horses were recorded among disturbed stones, as if placed between the walls of the dromos. Their heads were placed to the north and slightly turned to face the east (fig. 2.15).

Psalia made from maral deer tines were found *in situ* on both sides of the skull of one horse (figs. 2.16, 2.18). The psalia take the form of a curved rod with pointed terminals and three holes for attaching straps at different angles (fig. 2.16). The second psalia was found in a poor state of preservation. It is interesting to note that these finds so far define the earliest period in Early Saka monuments both in this region and adjacent territories. The type of psalia recorded here is characteristic of the late

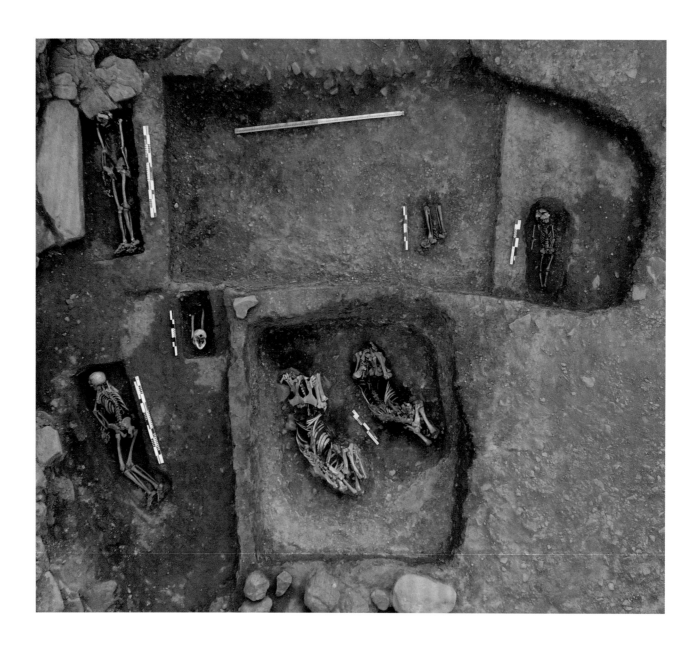

Burials of people and horses in the lower
level of the collapsed burial chamber of
the Stone Kurgan. Eleke Sazy, Group II.
Early Iron Age

Bronze Age and has analogues in various monuments in Central Asia
dating to the 10th–9th century BC. A number of three-hole horn psalia
have also been recorded in the Altai region.[20] Several bone strap adjusters
and beads filed from long bones were also recorded among the grave
goods (fig. 2.17).

Beneath the two horses mentioned above, the skeletons of two more
horses were discovered in a shallow rectangular-shaped pit. In both
cases, the skull of the animal was missing. The skeletons were placed in
parallel, legs tucked beneath the body, front part to the east-north-east.
A bone strap adjuster was found between the ribs of one of the horses.

2.16

Psalia and reverse view. DEER TINE (ANTLER)(?), L: 14.5 cm. Diameter at the top - 1.7 cm. Eleke Sazy, Group II, Stone Kurgan. КПО94–38976. Early Iron Age

2.17

Strap adjusters from horse tack, and reverse view. BONE(?), H: 1–1.2 cm. Diameter: 2.2–2.3 cm. Eleke Sazy, Group II, Stone Kurgan. КПО94–38979, КПО94–38981, КПО94–38982, КПО94–38983. Early Iron Age

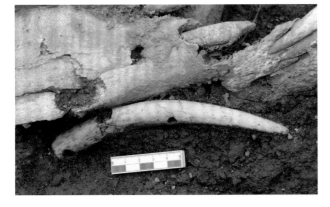

2.18

Psalia made from deer tine near horse skull during excavation. DEER TINE (ANTLER)(?), L: 14.5 cm. Diameter at the top - 1. 7 cm. Eleke Sazy, Group II, Stone Kurgan. КПО94–38976. Early Iron Age

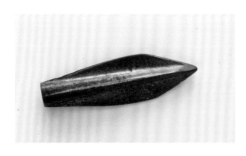

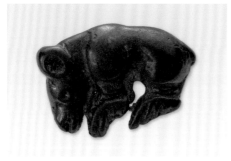

2.19

Bronze arrowhead. BRONZE, L: 4.5 cm. Eleke Sazy, Group II, Stone Kurgan. КПО94–38988. Early Iron Age

2.20

Bronze bear figurine from horse tack. BRONZE, L: 3 cm, W: 2 cm. Eleke Sazy, Group II, Stone Kurgan. КПО94–38989. Early Iron Age

A number of pits were arranged around the main burial chamber containing the two human burials and horse burials. The pits contained the burials of another four personages. The heads of the interred were positioned to the west and the west-south-west (fig. 2.15). These burials have no grave inventory. Nonetheless, they may shed light on social and demographic dynamics within nomadic society through anthropological studies describing the sex, age, and morphological and genetic characteristics of those interred in this and other mounds at Eleke Sazy necropolis.

In addition to the *in situ* finds already described above, of particular interest are two bronze items – a bear-shaped harness detail and an arrowhead. Both were found in a looter's tunnel and yet relatively close to this kurgan's huge burial chamber.

Bronze arrowhead (fig. 2.19)
The bronze bilobate, socketed arrowhead, 4.5 cm in length, represents a fairly widespread type. The proportions of the arrowhead are comparatively large. The asymmetric-rhombic leaf-shaped blade measures 1.4 cm at the widest part in the upper part of the arrowhead. In the lower part, the lobes extend to the very base of the socket, which measures 0.7 mm wide. There is a hole in the lower part of the socket. A raised rib runs the full length of the socket on both sides. The colour is silvery-grey.

The earliest arrowheads of this type (with slight differences in proportions and socket length) are recorded at Arzhan-1[21] and a number of other monuments in Tuva,[22] Shilikti Kurgan 5, Maiemir, Gerasimovka, etc., as well as among numerous chance finds recorded in East Kazakhstan.

Bronze bear figurine (fig.2.20)
The beast is depicted with lowered head and an oval ear of exaggerated proportions with a depression at the centre. The eye is highlighted by a raised rim, which adds expressiveness and an impression of volume, while the slightly narrowed muzzle, accentuated mouth and bared teeth convey an impression of dynamic tension. The ancient artist emphasized the paws and long claws characteristic of this predator in which the beast's power and energy are concentrated, perhaps believing that these and other bear-like qualities would be transferred magically to the individual, thereby augmenting the strength of horse and rider as they transitioned into the other world.

A large transverse loop on the plaque's reverse side suggests that the figurine was positioned on the vertical strap of an equestrian headband.

Based on the architectural features and accompanying burial assemblage of the Stone Kurgan in the second group of monuments at Eleke Sazy, this monument dates to no later than the mid-9th century BC,

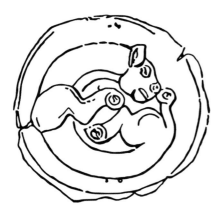

2.21

Drawing of a gold clothing plaque in the form of a curled feline predator. From Maiemir (after M.P. Gryaznov). Chance find. Maiemir steppe. Kazakh Altai

2.22

Maiemir. Section of an Early Saka kurgan. Maiemir steppe. Kazakh Altai

which predates the elite kurgan Arzhan-1, Tuva, and positions it chronologically within the earliest phase in the formation of the Saka culture in Central Asia.

Fascinating material dated to the Early Saka period was also recorded at Eleke Sazy Kurgan 4, and this is described in detail in Chapter 3 in this volume.[23] A trapezoidal burial chamber was discovered at the centre of Kurgan 4. Here a double burial was discovered, constructed, as with a number of elite Early Saka kurgans, at the level of the ancient land surface. This characteristic distinguishes Eleke Sazy Kurgan 4 from Arzhan-2, Tuva, the most striking monument of the Early Saka culture recorded in Central Asia, in which the royal burial (grave 5) was built at a depth of 3 m below the present land surface.

In terms of design features, Kurgan 4 at Eleke Sazy in the Tarbagatay area has much in common, first and foremost, with well-known burial structures in East Kazakhstan, the Shilikti kurgans including Baigetobe investigated by S. Chernikov and A. Toleubayev, as well as Maiemir, Saryarka and Taldy 2.[24] In terms of grave goods, more extensive parallels may be drawn with the Early Saka monuments of Zhetysu (Zhalauly treasure), Sayan-Altai (Arzhan-2) and Xinjiang.

In addition to data gathered from the kurgan at the burial ground Kurty II mentioned earlier, the early period of the development of the Saka culture in the Kazakh Altai is illustrated by materials recorded at Zevakinsky burial ground, where one finds fascinating burials (predominantly collective) in shallow pits as well as grave goods in the form of bronze knives with corbel arc.[25] Materials from the Izmailov archaeological complex (8th–7th century BC) are also dated to the 'transitional period'.[26]

Maiemir artefacts from East Kazakhstan dating to the Early Saka period are often referenced for the purposes of chronological attribution and cultural historical reconstruction.[27] In particular, gold clothing plaques in the form of feline predators curled into a ring characterize the

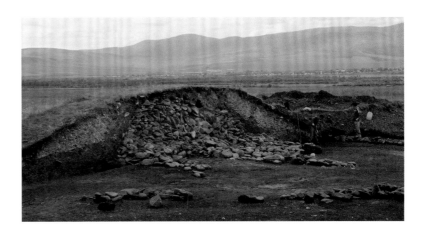

2.23
Early Saka arrowheads. BRONZE. Maiemir steppe. Kazakh Altai. Early Iron Age

2.24
Female necklace and earrings. SEMI-PRECIOUS STONES, GOLD. Maemir steppe, Kazakh Altai. Early Saka Period

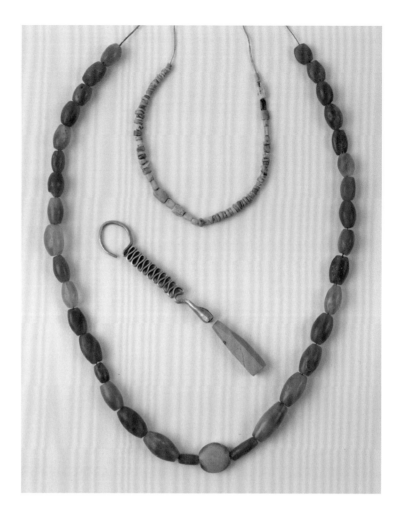

sophistication of the artistic culture, mobility and warrior-like dynamism of Early Saka nomadic society (fig. 2.21).

In 2009 we excavated a number of kurgans located in the Maemir Steppe, which are characteristic of the Early Saka period in terms of both construction and the artefacts recorded there (fig. 2.24). In one kurgan, for example, the mound was erected at the level of the ancient land surface and consisted of a trapezoidal burial chamber with dromos, crepidoma and enclosure. The burial chamber and dromos on the eastern side were encased by a round structure consisting of successive layers of carefully cut sod slabs and rolls and other earthen materials. The entire structure was covered with a dense 'protective shell' of river stones. Regardless of size, this architectural design is characteristic of kurgan construction in the Early Saka period of the Kazakh Altai (fig. 2.22).

In another monument, Maiemir II, which we investigated in 1997, the original ground structure consisted of two rings of large slabs with the spaces in between covered with 2 or 3 layers of gravel. A stone arrangement and slab cover were recorded at the centre of the surface

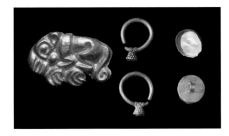

2.25

Gold artefacts from the Early Saka kurgan with lateral niche. GOLD. Tarasu. Early Iron Age

2.26

Gold artefacts from kurgans at Shilikti cemetery. From top left: plaque of two addorsed deer heads. Shilikti Kurgan 16; two plaques depicting an eagle-griffin clutching a snake in its talons, which in turn forms part of the bird's body, Shilikti Kurgan 16; earring made from rings, beads, and leaf-arrow shaped pendant, Shilikti 5, Kurgan 4; plaque depicting eagle-griffin, Shilikti Kurgan 16; plaques of predator curled up in a ring, Shilikti Kurgan 16; plaque of 'Snow Leopard Mask', 153 found. The overall composition appears as a 'mask' of a snow leopard, formed by two ibex protomes nose-to-nose. The lower portion of the composition also depicts a flying bird when viewed from above and in profile, Shilikti 3, Baigetobe Kurgan. GOLD, TURQUOISE, PRECIOUS STONES. Dates range from 8th–3rd century BC

Shown at actual size (approx.)

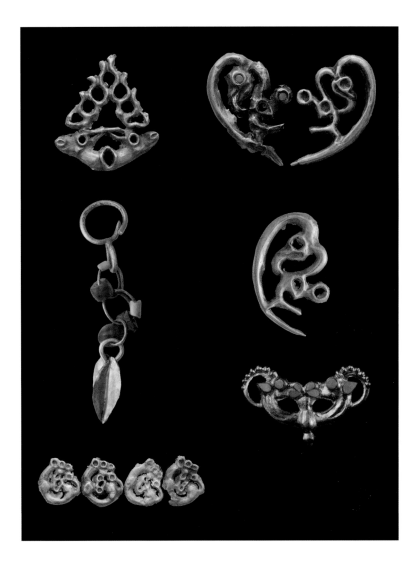

structure. Below, a grave pit was discovered with a lateral niche in the northern wall containing the remains of a woman of mature years. The accompanying assemblage of grave goods consisted of two bone quiver-strap details, as well as one bone arrowhead and six bronze arrowheads dating to the 8th–7th century BC (fig. 2.23).[28]

In 1998 excavators unearthed another kurgan at the Tarasu burial ground on the Bukhtarma River terrace, which illustrates a continuation of Early Saka funeral rites in which burials are found in a lateral niche cut into the wall of the grave pit. The finds here included female clothing adornments, plaques depicting predator figures, cone-shaped earrings with granulation, beads, a bronze mirror and a bronze knife held in a leather sheath (fig. 2.25).

Based on a number of characteristics, but particularly in relation to vivid works of figurative art (fig. 2.26), the Shilikti kurgans of East

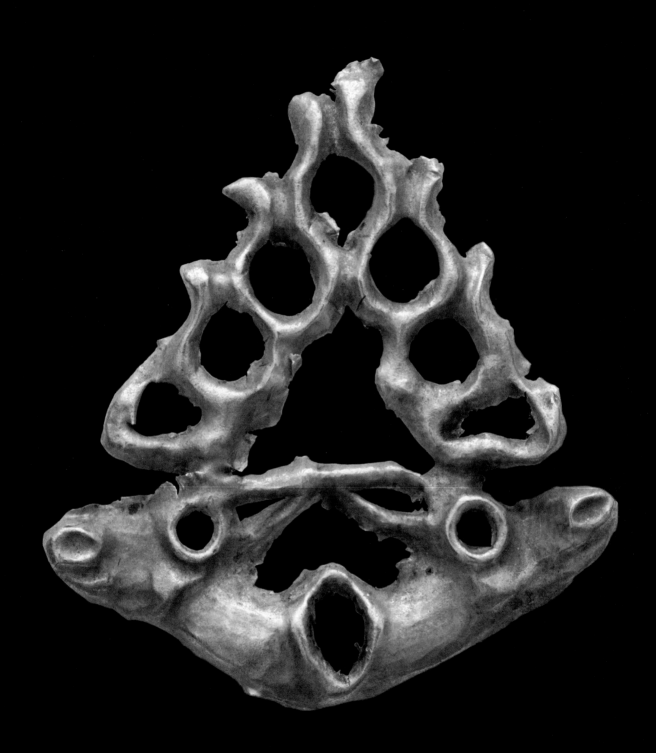

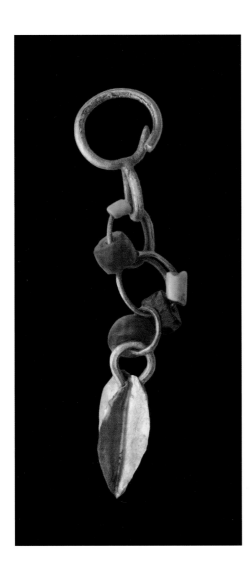

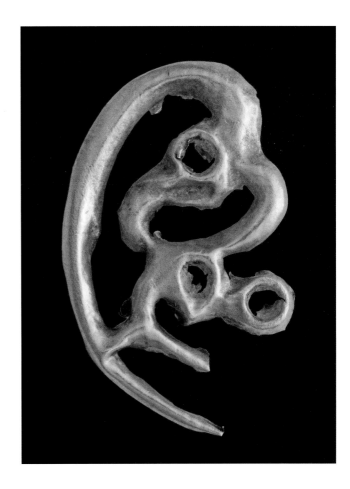

2.26b

Gold earring made from rings, beads, and leaf-arrrow shaped pendant. Shilikti 5, Kurgan 4. GOLD, PRECIOUS STONES. 5th–3rd century BC

2.26c

Plaque depicting eagle-griffin clutching a snake in its talons, which in turn forms part of the bird's body. GOLD AND TURQUOISE. Shilikty, Kurgan 16. 8th–5th century BC. Similar plaques were found in Shilikty 3, Baigetobe Kurgan

2.26a

Plaque of two addorsed deer heads. Shilikti Kurgan 16. Similar plaques with turquoise eyes were found in Shilikti 3, Baigetobe Kurgan. GOLD, TURQUOISE. 8th–5th century BC

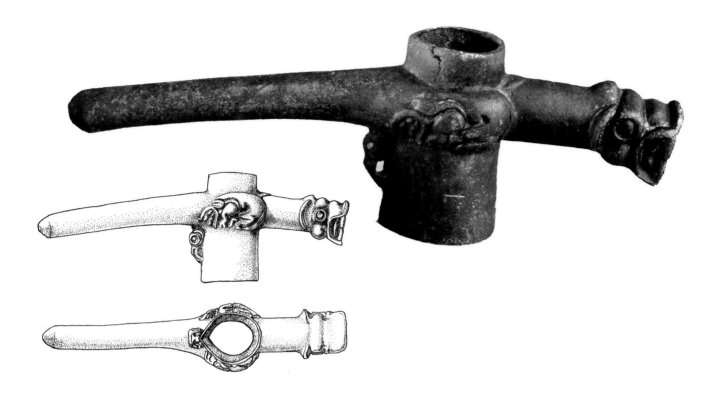

2.27a,b

(a) Bronze sagaris with zoomorphological decorations. (b) drawings showing side and top of sagaris. Chance find. BRONZE. East Kazakhstan

2.28

Bronze harness-strap detail with image of a beast. Chance find. BRONZE. East Kazakhstan

Kazakhstan, including Baigetobe, have already been established as the type sites of the Early Saka cultural complex and as such are widely referenced in academic literature.[29]

Chance finds

The culture of the region's population during the early period is also characterized by chance finds from various regions of East Kazakhstan, which include horse harness and trappings (see figs. 5.6–7), as well as decorative ornaments in bronze and other materials executed in the so-called Early Saka 'animal style'.

Although these chance finds lack context, they are of value to archaeologists in that they shed light on issues surrounding the formation and transformation of the Early Saka period in East Kazakhstan and adjacent areas. Several of these artefacts have been previously documented in archaeological literature.[30]

Among recent chance finds, of particular interest is a thick bronze *sagaris* with blunt pick and poll in the shape of the head of a feline predator depicted with mouth bared, large round eyes and faintly outlined ears (figs. 2.27a,b). On the lug, at the intersection of the shaft and head is an embossed zoomorphic image depicting a crouched feline predator in which the representation of the head, shown in profile, and especially the contours of the mouth, with accentuated lips in high relief,

2.29

Mirror with stags and an ibex. Chance
find, Altai Region, Bukhtarma River basin,
near Berel, East Kazakhstan. BRONZE,
Diameter: 13.7 cm. 8th–7th century BC.
The State Hermitage Museum,
St. Petersburg, 1122-54

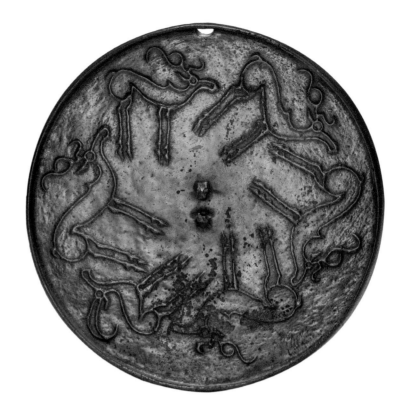

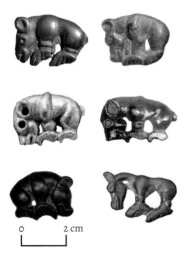

2.30

Bear figurines from East Kazakhstan. Top
left: see fig. 2.19; centre right: Shilikti 3,
Baigetobe Kurgan, c. 730–690 BC.
GOLD, TURQUOISE; other objects: chance
finds. BRONZE. East Kazakhstan

are most unusual. A similar example of this treatment of the mouth can
be seen in a beast depicted on the surface of a bronze harness-strap detail
found in East Kazakhstan (fig. 2.28). It is natural that the surface of this
item, like all details of horse harness and trappings intended to be used
in a rite of passage, should be decorated with expressive representations
of predators, an element clearly integrated into the mythological and
ritual concepts of the Early Saka culture. As prestigious items, these
artefacts are often found in elite burials.[31]

A bronze mirror found in the Bukhtarma area is decorated with the
contoured images of six deer and one mountain goat shown standing
on 'tiptoes'. These images are executed in Early Saka 'animal style' of
which this artefact may be considered a reference piece (fig. 2.29). This
type of image is now well cited in archaeological literature. Doubtless,
the animals which are arranged towards the outer rim and rotated
around a vaulted loop at the centre (not preserved), reflect archaic Saka
perceptions of mythological space-time.

In addition to the bear plaques recorded at Eleke Sazy and the gold
plaques from the Baigetobe kurgan,[32] in recent years several other
examples of the bear figurine serving as details of horse harness have been
recorded among chance finds from East Kazakhstan (fig. 2.30). These
artefacts are likewise attributed to the archaic period in Saka art. Other

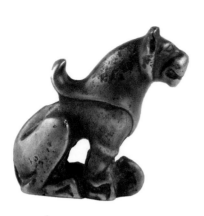

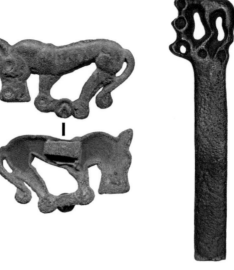

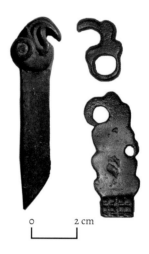

2.31a,b

Figures of beasts: (a) censer adornment in the form of a winged lion; (b) plaque from horse tack in the form of a horse or bear. Chance finds. BRONZE. East Kazakhstan

2.32

Fragment of a bronze knife topped with the figure of a predatory beast. Chance find. BRONZE. East Kazakhstan

2.33

A fragment of a bronze knife (left) and horse decorative equipment (right), decorated with bird of prey (or perhaps griffin?) heads. Chance find. BRONZE. East Kazakhstan

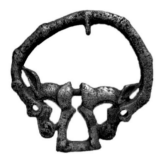

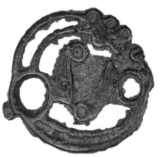

2.34

Bronze buckle formed from the protomes of mountain goats. Chance find. BRONZE. East Kazakhstan

2.35

Bronze horse tack decoration, formed from a feline predator curled into a ring. Chance find. BRONZE. East Kazakhstan

forms of decoration identified in chance finds include winged lions, bears and horses (figs. 2.31–32), protomes of birds of prey (fig. 2.33), ungulates (fig. 2.34) and feline predators curled into a ring (fig. 2.35).

Among the earliest weapons attributed to the Early Saka period is the bronze sword housed at Semey Regional History Museum in Kazakhstan. The sword in question has a broken blade, straight crossguard, mushroom-shaped pommel and relatively long hilt shaft.[33] The shape of this artefact can be considered a prototype and, therefore, serves as a reference for the subsequent development of various types of blade weapon (fig. 2.36).

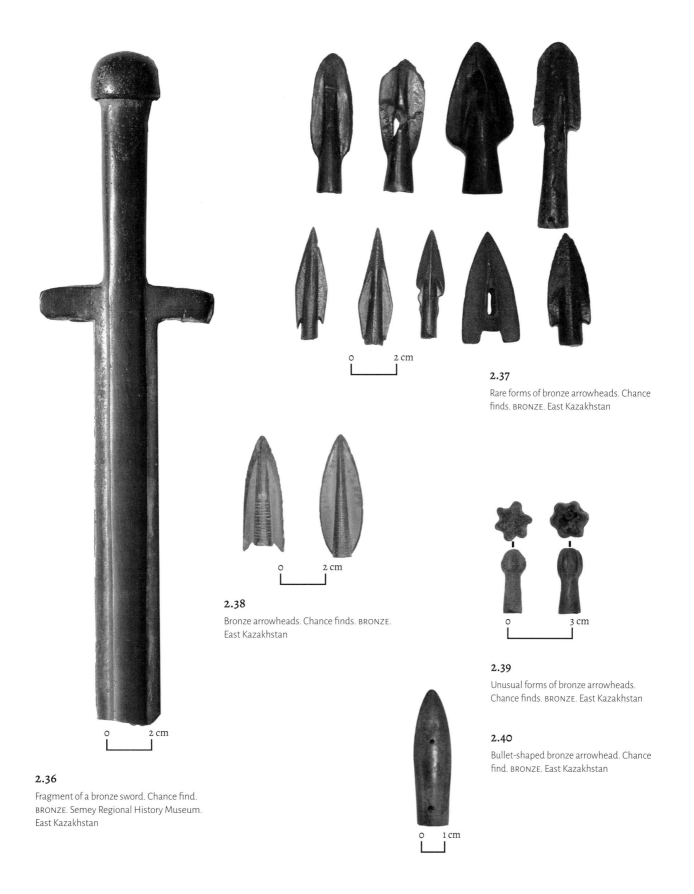

2.37
Rare forms of bronze arrowheads. Chance finds. BRONZE. East Kazakhstan

2.38
Bronze arrowheads. Chance finds. BRONZE. East Kazakhstan

2.39
Unusual forms of bronze arrowheads. Chance finds. BRONZE. East Kazakhstan

2.40
Bullet-shaped bronze arrowhead. Chance find. BRONZE. East Kazakhstan

2.36
Fragment of a bronze sword. Chance find. BRONZE. Semey Regional History Museum. East Kazakhstan

0 2 cm

2.41

Bronze awls. Chance finds. BRONZE.
East Kazakhstan

In East Kazakhstan, a huge number of bronze arrowheads have been recorded which are attributed to the Early Saka period and are cited in various publications on the weapons and military practices of the ancient peoples of Central Asia and adjacent territories. Here we draw attention to socketed arrowheads, in which the blades are fashioned in different ways, sometimes with angular notches; two arrowheads have small heads with stabilizing edges; others are bullet-shaped and occur with and without a hooked spike at the base (figs. 2.37–40).

Also impressive is the variety of horse trapping details found which date to the Early Saka period (see figs 5.6–7). Numerous parallels have been recorded among those discovered in the Altai region dating to the same period.[34] Lastly, various bronze tools have been recorded that appear to be awls used in the manufacture of leather clothing and horse trappings (fig. 2.41).

With a description of these remarkable chance finds, we conclude our characterization of the archaic stage in the development of the cultural complex of the Saka peoples who lived in the area covering modern-day East Kazakhstan. We suggest that it was here, in the Kazakh Altai, that the Early Saka culture was established due to ecological conditions, a wealth of mineral resources, and the continuity of late Bronze Age

2.42

Eleke Sazy, Group VI, Great Earthen Mound 'Patsha', showing repeated heavy damage by looters. c. 6th–5th century BC

2.43

Eleke Sazy, Group VI, Great Earthen Mound 'Patsha' during excavation to investigate its structure. c. 6th–5th century BC

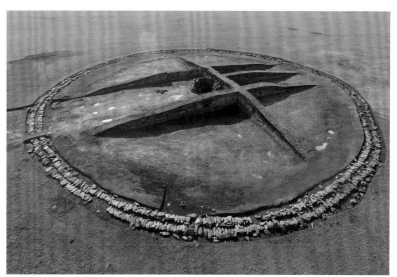

tradition, technique and technology. What appears to follow is an intense process of consolidation, which later shifts into a stage of transformation that marks the onset of the classical period of Saka culture. This transformation is tentatively dated to a period that spans the end of the 6th and the early 5th century and continues to the early 3rd century BC.

This transformation in the Early Saka cultural complex is reflected in materials found at the largest earthen kurgan at Eleke Sazy (group VI), as well as the structural features of the kurgan, which differ significantly from the other kurgans described above.

This Great Earthen Mound, the largest of the entire Eleke Sazy necropolis, was erected at a prevailing height overlooking the

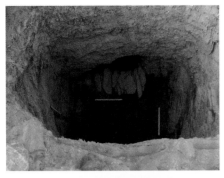

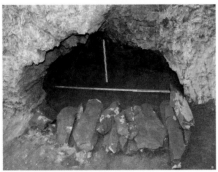

2.44
Grave shaft with lateral niche carved into the bedrock. Eleke Sazy, Group VI, Great Earthen Mound 'Patsha'. c. 6th–5th century BC

2.45
Lateral niche in the grave shaft at a depth of 5m from the ancient land surface. Eleke Sazy, Group VI, Great Earthen Mound 'Patsha'. c. 6th–5th century BC

2.46
Section drawing of the grave shaft with lateral niche. Eleke Sazy, Group VI, Great Earthen Mound 'Patsha'. c. 6th–5th century BC

surrounding landscape (fig. 2.42). Its height from ground level is 2.3 m, and the top of the mound is 1,442 m above sea level. The diameter of the mound itself measures 58 m, and the entire monument is 76 m in diameter when taking into account the impressive stone enclosure around the mound, which comprises two rows of thick, flat, horizontally arranged slabs (fig. 2.43). This kurgan remains in a preserved state despite significant signs of plundering in antiquity and later periods. Upon further analysis, researchers will be able to obtain a clearer picture of the consecutive stages in which the multi-layered ground structure was created, and the composition of materials used, as well as technical processes and other aspects of Saka ritual and memorial custom practised here.

The burial pit, measuring 4.5 m deep, 5.2 m long and 5 m wide, includes a lateral niche cut into the bedrock of the northern wall (height 1.2 m, width 1.9 m, length 3.1 m; figs. 2.44–46). This burial was entirely looted. During the process of removing the stones from the dome structure above the grave pit, in the space between large boulders, a lump of heavily compacted, mainly gold artefacts was found (figs. 2.47–48). The item was initially presumed to be a felt bag containing male and female clothing adornments hidden by looters in the ancient past.

During the cleaning procedure, the clump of metal was revealed to consist of a large quantity of clothing plaques in the form of zoomorphic protomes, a pendant in the shape of a deer figure on a chain, an iron bracelet, a fragment of a gilded torc, right- and left-facing figures of argali 'on clouds', feline predators, beads made of coloured stones, tiny gold beads and other prestigious items, that clearly indicate the high status of the personages buried in the Great Earthen Mound (figs. 2.49–56).

Our argument for dating the 'Great Earthen' kurgan after the Early Saka period, i.e. post-7th century BC, is as follows. Firstly, most of the Early Saka mounds and particularly the elite Saka mounds studied to date have the following features in common: they were erected at the level of the ancient land surface; the burial chambers were made from logs, poles and stone; they have distinct trapezoidal outlines. In contrast, in the 'Great Earthen' kurgan, the deceased is buried in a very large, deep hole beneath a multi-layered mound. This marks a significant cultural-chronological shift. The 'Great Earthen' kurgan also displays differences of a topographic nature. Secondly, some of the finds originating from the 'Great Earthen' kurgan are three-dimensional. These include figurines of argali 'on clouds', where the figure of an animal soldered from two (hollow) halves is placed vertically on a light horizontal platform, fashioned in the form of seven or eight petals with two claw-shaped (or beak-shaped) cutouts. This technique is not characteristic of the initial stages of the Saka culture. In addition, this same kurgan yielded a bracelet and an iron torc decorated with gold overlay. Numerous artefacts of this type recorded at Arzhan-2 in Tuva are dated mid to late 7th

2.47

Hoard of clumped gold items hidden by
ancient looters in the grave niche. GOLD AND
IRON. Eleke Sazy, Group VI, Great Earthen
Mound 'Patsha'. c. 6th–5th century BC

2.48

Gold artefacts from the hoard prior to
cleaning. GOLD. Eleke Sazy, Group VI,
Great Earthen Mound 'Patsha'. c. 6th–5th
century BC

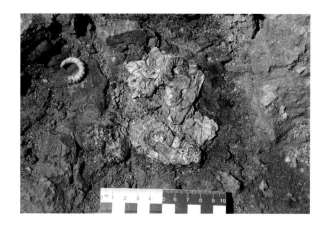

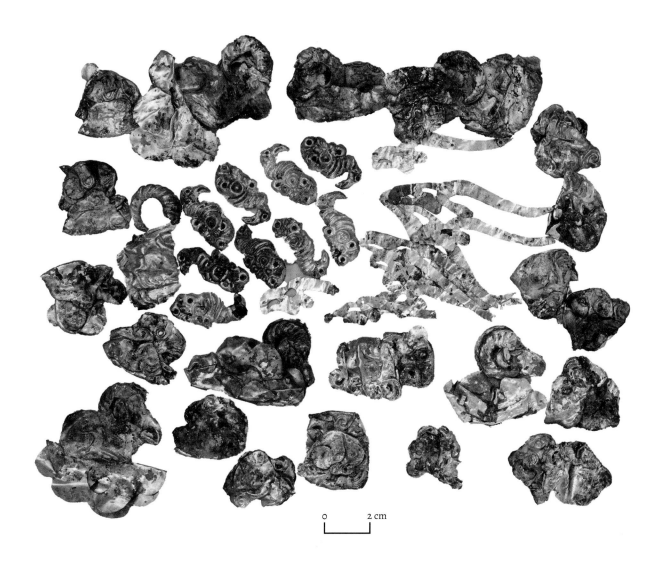

0 2 cm

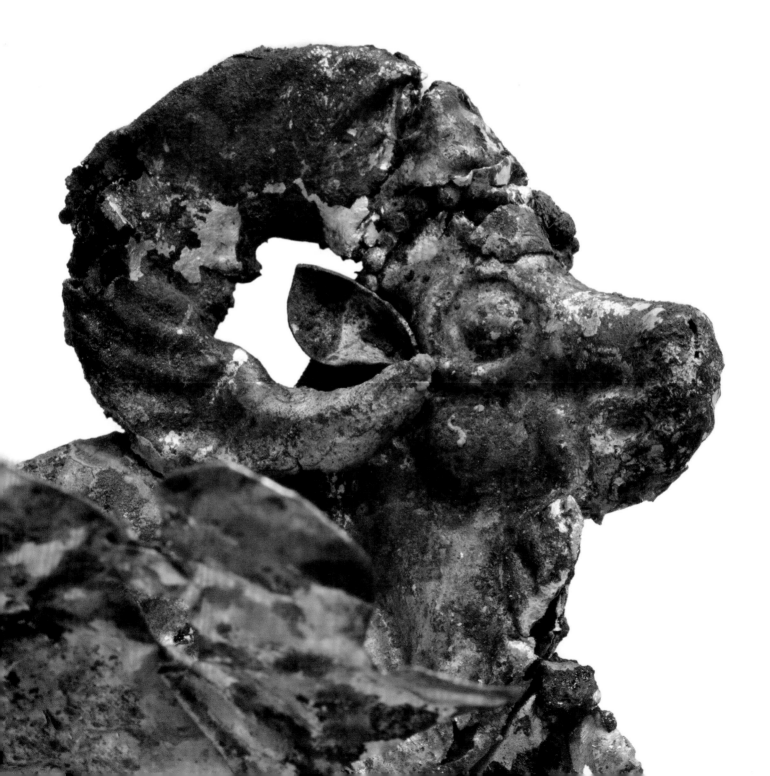

2.49a

Close-up of argali (wild mountain sheep) figure prior to restoration. Discolouration due to proximity to corroded iron and bronze. GOLD. Eleke Sazy, Group VI, Great Earthen Mound 'Patsha'. КПО94–38866.
c. 6th–5th century BC

2.49b–f

Figures of argali on petal/cloud stands. Details of construction, including base showing sewing loops, and stand with centre slot. Varying states of preservation. Eight examples found. GOLD. Eleke Sazy, Group VI, Great Earthen Mound 'Patsha'. КПО93–38859, КПО93–38862 to 38865. c. 6th–5th century BC

Shown at actual size (approx.)

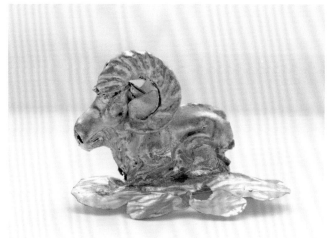

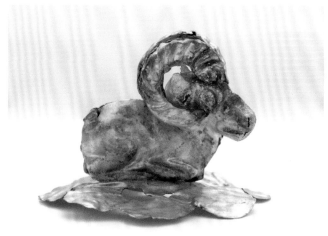

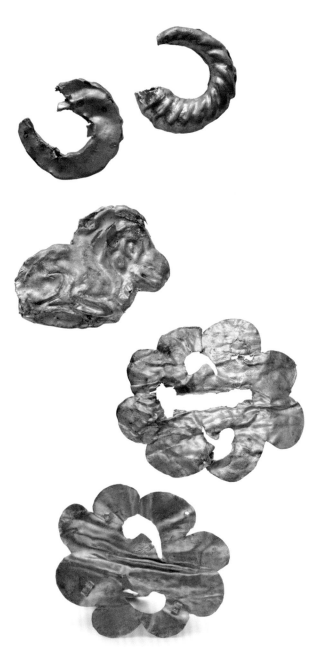

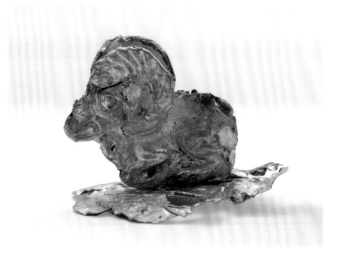

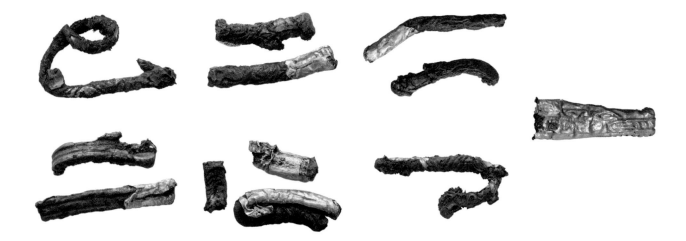

2.50

Fragments of a torc or bracelet made of
iron with gold overlay, with the image of a
wolf's head (right). IRON, GOLD. Eleke Sazy,
Group VI, Great Earthen Mound 'Patsha'.
КПО94–38966/1–7, КПО94–38967/1–12,
КПО94–38969/1–5. c. 6th–5th century BC

2.51

Fragments of worked gold sheet depicting
various parts of animals. GOLD. Eleke Sazy,
Group VI, Great Earthen Mound 'Patsha'.
КПО94–38970/1–2. c. 6th–5th century BC

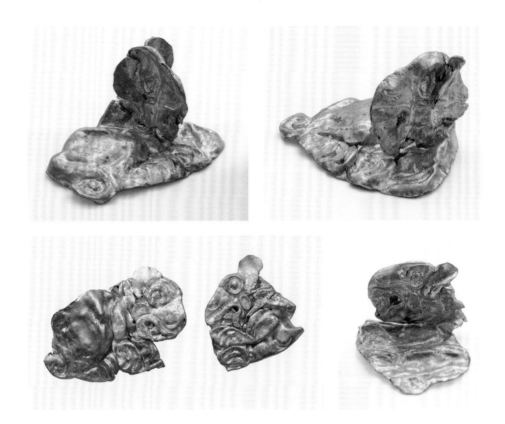

2.52

Reclined cat predator figures with bared
teeth, claws and curled tail. GOLD. Eleke Sazy,
Group VI, Great Earthen Mound 'Patsha'.
КПО94–38867 to КПО94–38887.
c. 6th–5th century BC

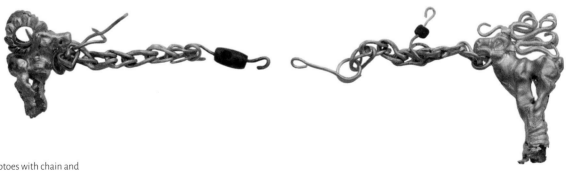

2.53

Left: argali on tiptoes with chain and
fastening hook. Right: stag on tiptoes with
chain and fastening loop. GOLD, PRECIOUS
STONES. Eleke Sazy, Group VI, Great Earthen
Mound 'Patsha'. КПО94–38888; КПО94–
38889. c. 6th–5th century BC

2.54a–c

(a) Plaques depicting polymorphic creatures facing right and left with the beak of a bird of prey, eyes, ears, stripes. Twenty-five examples found (*shown at actual size, approx.*); (b–c) details of front and reverse with sewing loops. GOLD. L: 2.8 cm W: 1.4 cm. Eleke Sazy, Group VI, Great Earthen Mound 'Patsha'. КПО94–38834 to КПО94–38858. c. 6th–5th century BC

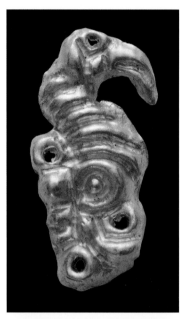

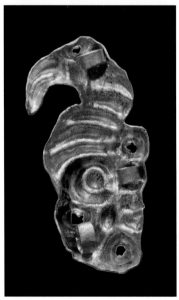

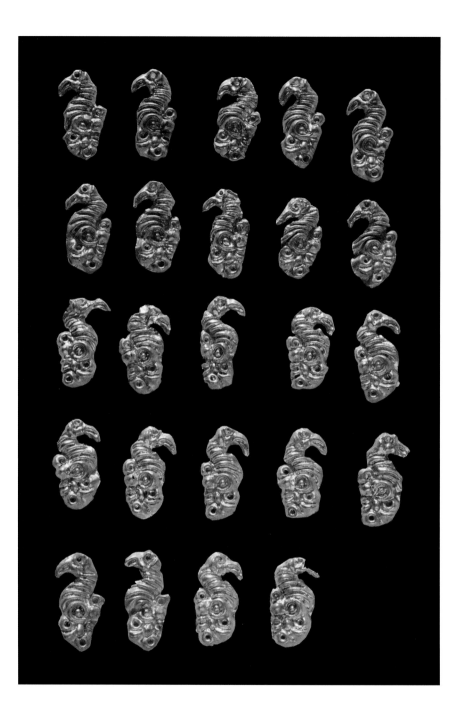

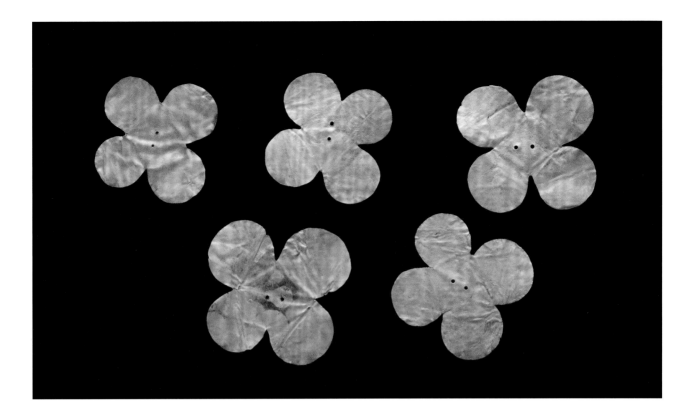

2.55

Gold clothing patches in the form of a four-leaf clover with two central sewing holes. Twelve examples found. GOLD. Eleke Sazy, Group VI, Great Earthen Mound 'Patsha'. КПО94–38891 to КПО94–38902. c. 6th–5th century BC

Shown at actual size (approx.)

century BC.[35] It is quite possible that the technique of applying decorative gold plates to an iron surface was not widespread, if used at all, until the mid to late 7th century BC.

The most probable date for the construction of the 'Great Earthen' kurgan at Eleke Sazy is somewhat later than those artefacts recorded there and described above. At this stage, the 'Great Earthen' kurgan can be dated to the 6th–5th century BC, and, accordingly, attributed to the beginning of the classical Saka period.

The culture of the classical period (5th–3rd century BC) in the history of the Saka peoples of the Kazakh steppes is illustrated by the Berel kurgan assemblages, which are already very well documented in the archaeological literature.[36] At Berel (see fig. 1.1), the frozen tomb burials stand out as a special cultural phenomenon with their accompanying mass horse burials and striking examples of craftsmanship exemplified in examples of horse harness and trappings (see figs. 5.6–19.

Monuments attributed to the Kulazhurga culture situated in East Kazakhstan date to this same period, as do a large number of monuments studied over many different field seasons by excavators S. Chernikov, F. Arslanova, G. Omarova, A. Toleubayev and others, which include a number of early Iron Age kurgans that have yielded numerous and fascinating artefacts (figs. 2.57a–c).

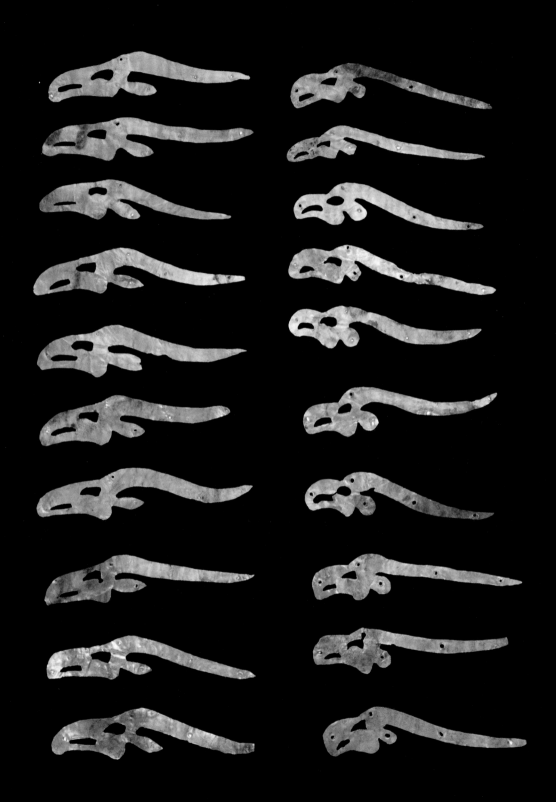

2.56

Gold clothing patches in the form of horned ungulate heads, two distinct types: elongated snout, long tear drop ear and tapering horn (resembling goitered gazelle); curved short snout, round ear and straight horn (resembling Saiga antelope). 53 examples found. GOLD. Eleke Sazy, Group VI, Great Earthen Mound 'Patsha'. КПО94–38907 to КПО94–38960/1–10.
c. 6th–5th century BC

Shown at actual size (approx.)

2.57a–c

Ceramic vessels of unusual form. Left to right: (a) ceramic vessel decorated with short processes, Berel, Kurgan 10, 4th–3rd century BC; (b) ceramic vessel decorated with seams to imitate those of a leather vessel, Katon-Karagay region, East Kazakhstan, 3rd century BC (according to S.S. Chernikov); (c) ceramic vessel with engobe decoration, Zhetysu (Almaty region), 3rd century BC (according to S.S. Chernikov), Museum of Archaeology, Almaty

A further three kurgans along with their assemblages were excavated at Eleke Sazy in 2019 (Group VII, 1–3), which can be attributed to the late stage of the classical Saka period (figs. 2.58–59). These kurgans were constructed from several layers of loam interspersed with gravel, clay and individual flat slabs. The ground structures consisted of a 'protective shell,' a crepidoma-like structure of large stones at the base, and a double ring enclosure with gaps presumably left as 'entrance passageways'. Despite being significantly disturbed by looting in antiquity, the remains of female clothing adornments were found in shallow grave pits aligned east–west (figs. 2.60–65).

Particularly curious are the remains of a conical-shaped headdress, which at this stage may be attributed to the Sarmatian-Kangju period (figs. 2.66–68). The headdress is adorned with rows of framed, narrow, openwork clothing plaques. Each plaque depicts an anthropomorphic figure shown in full height wearing a trapezoid-shaped headdress similar to a tiara with flat-top, frontal projection and short extensions to the sides (fig. 2.67). This same type of headwear can be seen depicted in a number of Bactrian statuettes. The figure is also shown wearing a long gown divided at the front by a vertical strip or sash and with horizontal folds in the lower part. The character depicted here, possibly a fertility goddess, is shown holding onto the trunk of a vine on both sides with arms raised and bent sharply at the elbows (fig. 2.67). This character, widely known in Bactrian art and mythology, is represented in the *Oxus Treasure* (figs. 2.69–71),[37] which some researchers date, at least in part, to as early as the mid to late 3rd century BC.

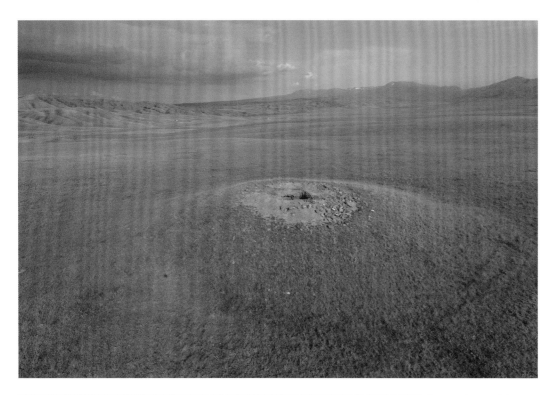

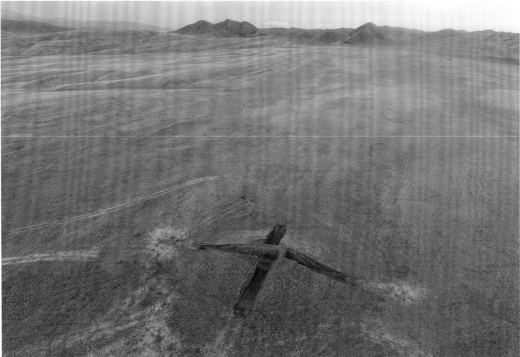

2.58
Eleke Sazy, Group VII, Kurgan 1 showing evidence of recent looting

2.59
Eleke Sazy, Group VII, Kurgan 1 after excavation to reveal its construction of loam interspersed with large flat stones.

2.60

Remains of a female burial with posed pointed feet and skull missing. Eleke Sazy, Group VII, Kurgan 1. c. 4th–3rd century BC

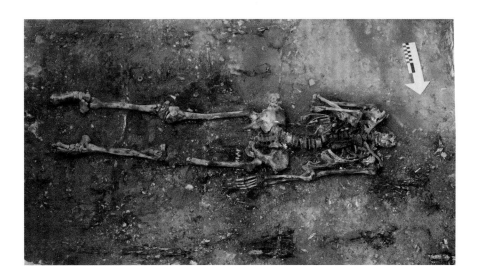

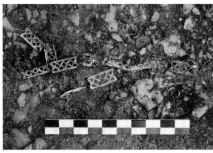

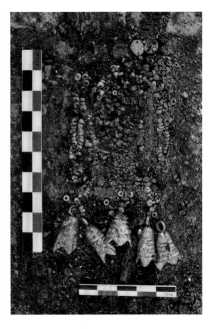

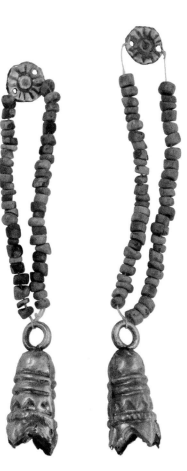

2.61

Triangle Plaque during excavation. Eleke Sazy, Group VII, Kurgan 1. c. 4th–3rd century BC

2.62

Lattice plaques during excavation. Eleke Sazy. Group VII, Kurgan 1. c. 4th–3rd century BC

2.63

Woman's hair braid decorations with coloured beads, gold bell shaped pendant and gold floral bead fixing. During excavation (left), and restrung (right). GOLD, STONE/PASTE(?). Eleke Sazy, Group VII, Kurgan 1. КПО94–39002/1–52, КПО94–39003/1–52, КПО94–39004/1–54, КПО94–39005/1–51 & КПО94–39006/1–37

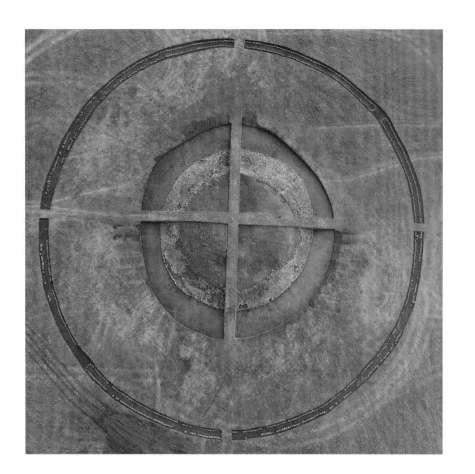

2.64a

Aerial view during excavation. Eleke Sazy. Group VII, Kurgan 2. c. 4th–3rd century BC

2.64b

Female remains found in a tunnel created by looters. The articulation of the bones and position of the body shows that she was pulled from the burial pit while ligaments were still attached, indicating the looting occurred in antiquity, not long after burial. Eleke Sazy. Group VII, Kurgan 2. c. 4th–3rd century BC

2.64c

Bone plate with carved ornamentation. BONE. Eleke Sazy. Group VII, Kurgan 2. c. 4th–3rd century BC

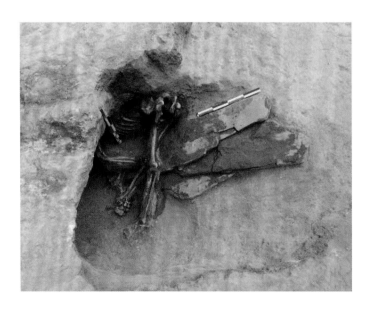

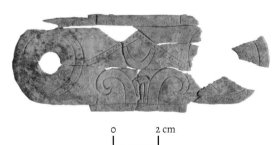

0 2 cm

2.65a

Bronze mirror with handle during excavation. Eleke Sazy. Group VII, Kurgan 3. c. 4th–3rd century BC

2.65b

Grave pit with the remains of ornamentation for a woman's costume, a bronze mirror and a stone pigment grinder. Eleke Sazy. Group VII, Kurgan 3. c. 4th–3rd century BC

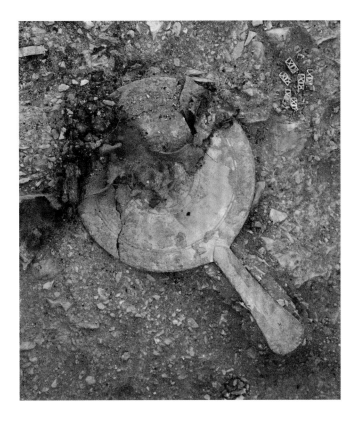

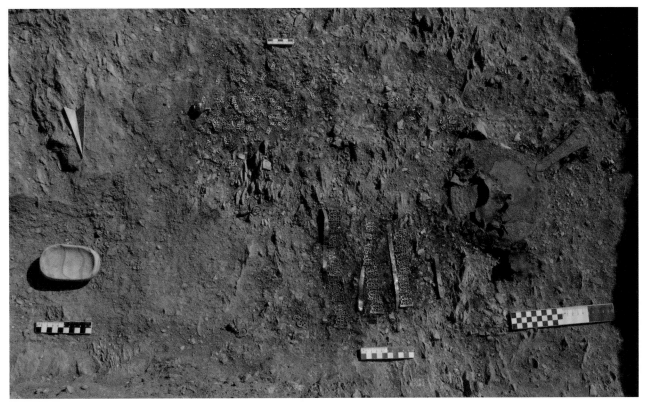

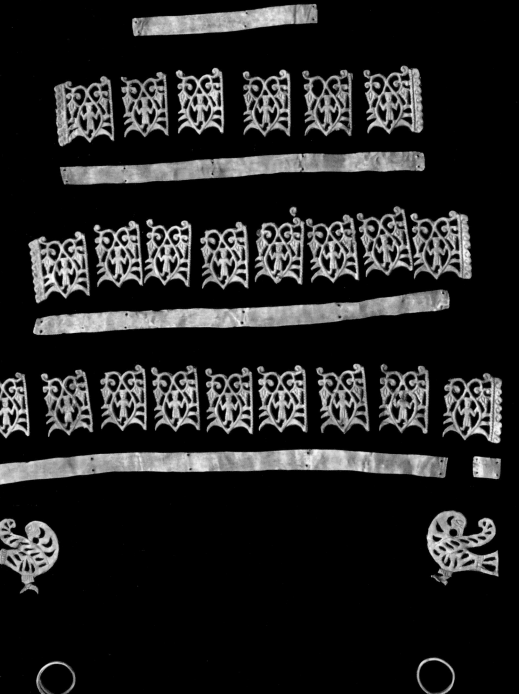

2.66

Gold parts of a headdress, plaques and earrings in the arrangement in which they were found; gold strips, plaques in the form of a figure holding vines, dove plaques, and bell shaped earings with granulated decoration. GOLD. Eleke Sazy. Group VII, Kurgan 3. КПО94–39006/1–17, КПО94–39007/1–3 & КПО94–39008/1–3, КПО94–39009, КПО94–39010, КПО94–39012/1–2, КПО94–39013, КПО94–39014 & КПО94–39015. c. 4th–3rd century BC

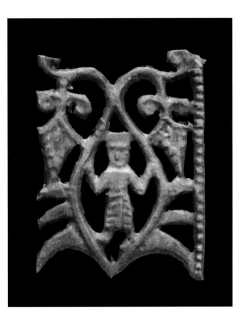

2.67

Plaque from headdress detail. Human figure with vines. GOLD. Eleke Sazy, Group VII, Kurgan 3. КПО94–39006/1–17, КПО94–39007/1–3 & КПО94–39008/1–3. c. 4th–3rd century BC

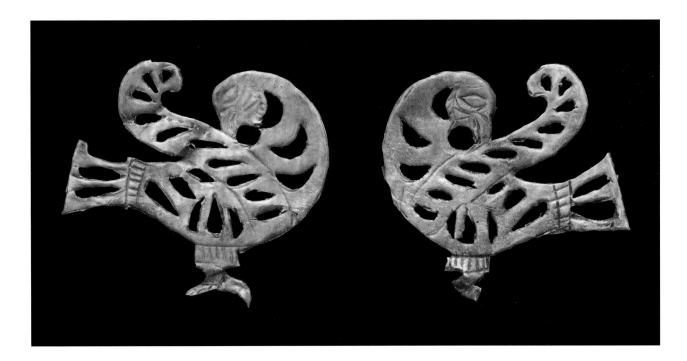

2.68

Plaques in the form of birds with heads twisted round and unfurled wings. GOLD. Eleke Sazy. Group VII, Kurgan 3. КПО94–39009 & КПО94–39010. c. 4th–3rd century BC

2.69

Rectangular gold sheet cut-out plaque: shows a figure walking to the left, wearing a crenellated crown or dentate tiara, a long garment with long sleeves decorated with a row of circles, and shoes or boots. Takht-i Kuwad, Tajikistan. British Museum, BM 123939

2.70

Cast and chased silver statuette; a bearded man in Persian costume standing with his right arm hanging by his side and holding in his left hand a bundle of rods (barsom) in front of his chest. Takht-i Kuwad, Tajikistan. British Museum, BM 123901

2.71

Gold plaque with serrated top showing a palmette in the centre, flanked by two pairs of confronted birds with averted heads which are separated by a vertical line of punched dots. Takht-i Kuwad, Tajikistan. British Museum, BM 123948

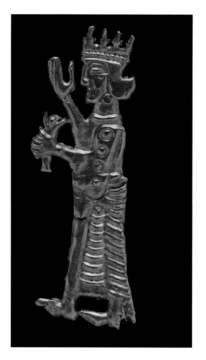
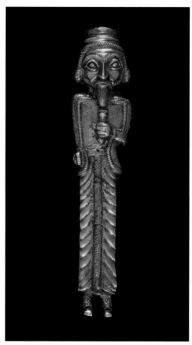

Other noteworthy artefacts from the same grave pits include gold earrings with bells decorated in triangles of 'false' granulation (fig. 2.72), pendants in the form of serrated edged bells (fig. 2.63), a headdress pin in the form of a ribbed poppy seed head with stem inlaid with cloisonne enamel (fig. 2.73), bird figures (possibly doves) with back-turned heads and stylized wings (fig. 2.68), a bone plate with engraved patterns (fig. 2.64), a stone pigment grinder (fig. 2.74) and many round, rhomboid-shaped, and rectangular openwork clothing plaques with cross and step-shaped elements (figs. 2.75a–c).

In terms of chronological attribution, a large bronze mirror is a significant find. This artefact has a flat, lateral handle that widens

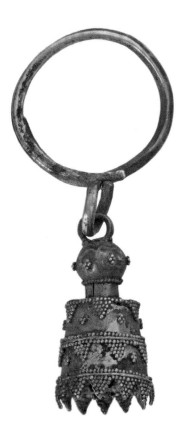
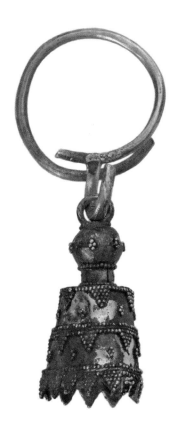

2.72a,b

(a) Golden bell shaped earrings with granulated decoration; (b) magnified detail of granulation. GOLD. Eleke Sazy, Group VII, Kurgan 3. КПО94–39012/1–2. c. 4th–3rd century BC

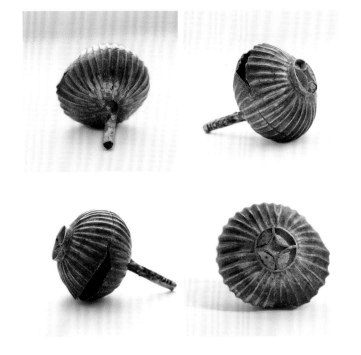

2.73a,b

(a) Poppy head, hair/headdress ornament – four views showing top, bottom and sides; (b) magnified detail of organic matter contained inside. GOLD, ORGANIC MATTER, Diameter: 2.5 cm. Eleke Sazy, Group VII, Kurgan 3. КПО94–39011. c. 4th–3rd century BC

2.74

Sandstone pigment grinder, traces of
pigment visible, three views. SANDSTONE
WITH PIGMENT. Eleke Sazy. Group VII, Kurgan
3. КПО94–39019. c. 4th–3rd century BC

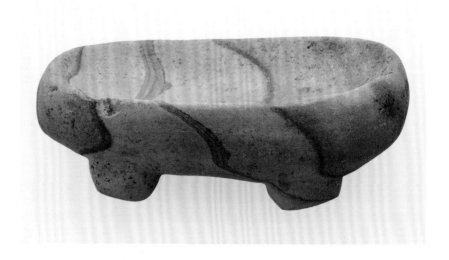

2.75a–c

(a) Plaques with geometic 'X' design, 163
examples found. (b) Plaques with geometric
mirrored design, 16 examples found. (c)
Plaques with lozenge shape, 16 examples
found. GOLD. Eleke Sazy, Group VII, Kurgan 3.
КПО94–39000/1–163, КПО94–38995/1–16,
КПО94–38997/1–16. c. 4th–3rd century BC

towards the bottom. The reverse side of the mirror disk is decorated with three pairs of concentric circles that divide the surface into several different segments (2.65a).

Archaeologists currently believe that the final transformation of the once vibrant Saka culture of the Kazakh steppe begins at the end of the 3rd century BC. From this time and by the 2nd century BC, the blossoming culture of the ancient Berelians (Pazyryk culture) and the Yuezhi State diminishes under the attack of the Huns from the east.

In the Kazakh Altai, the short-lasting dominion of the Huns (Xiongnu) is replaced by their Xianbei conquerors, who likewise left behind them material traces of their presence in this area.[38] Xianbei stone concentrations and enclosures are located around Pazyryk-era mounds at Berel (figs. 2.76–77), sometimes in compact groups and often containing solitary human or accompanying horse burials (figs. 2.78–80; see also Chapter 5). The assemblage of grave goods is represented mainly by objects of weaponry,[39] as well as various types of adornment (figs 2.81).

Conclusions

The end of the 3rd century BC marks the advent of a new era in the Eurasian steppe belt that evolves at different rates across both Hun-Xianbei and Hun-Sarmatian territories. Funerary rites and material culture undergo significant change at this time, although elements of pan-Scythian culture continue to be present in various archaeological monuments of the period. This is evidenced by the Hunnic Kegen IV burial ground in Zhetysu, where one particular earthen mound revealed a pentagonal 'klet', a structure made of three layers of logs, a characteristic that indicates the presence of a Saka component among the Hunnic tribes who erected the monument. In addition, the burial of a teenager was found in the same burial complex, dated approximately eighty to a hundred years later, in which the skull showed signs of artificial cranial deformation, which likewise points to the appearance in this region of a population with pronounced Hunnic anthropological features.

In the 5th century AD, and possibly even earlier, we see the advent of the period of the Great Turks, a striking and distinctive culture characterized by numerous monument types – kurgans, memorial enclosures, image stones, rock art in so-called 'graffiti' style, as well as a huge number of artefacts of decorative and applied art, etc.

However, all this was preceded, as we have tried to show, by periods in the formation and flourishing of the culture of the archaic Saka, which was closely connected with the traditions, particularly the technological traditions, of the tribes of the period of the final Bronze Age. As early as the 8th–7th century BC, the Saka peoples had created optimal versions of horse harness, tools, highly sophisticated works of craftsmanship and an economic and cultural type ideally adapted to the natural and ecological niche of the steppe landscape, which for the purposes of academic classification is often associated with the concept of the 'steppe civilization'.

Nomadic art blossoms with the emergence of new ideas that accompany military democracy, and we see a process in which warriors and the figure of the hero-*bogatyr* come very much to the forefront of society. According to M. Gryaznov, it is this period in which the epic tales of the Turkic-Mongolian peoples of Central Asia were first created, tales

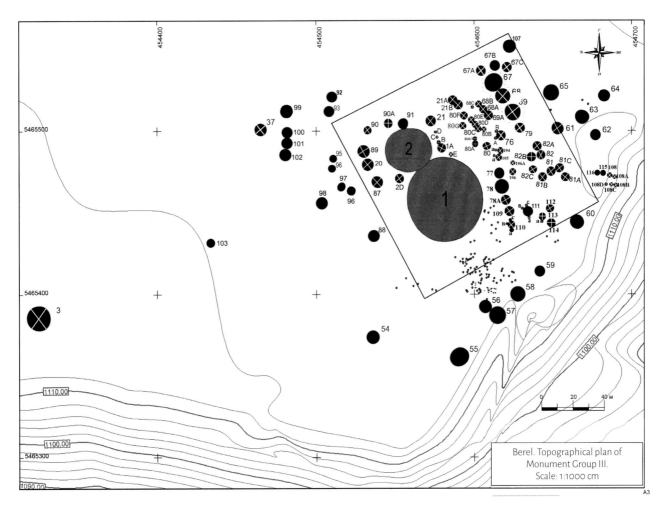

2.76

Plan showing the location of Hun-Xianbei burials (in black) in relation to Pazyryk culture burials (in red). Berel

2.77

Aerial photograph showing Hun-Xianbei burials of people and horses. Berel

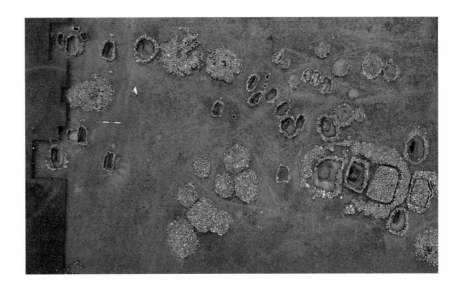

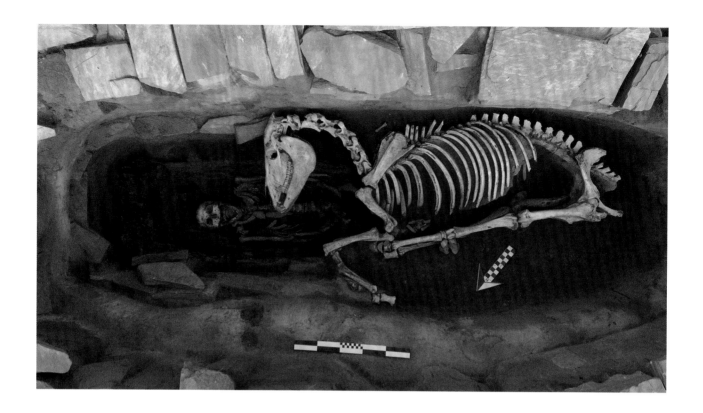

2.78

Hun-Xianbei burial of a man accompanied by a horse. Berel

2.79

Hun-Xianbei burial of a man in a stone cist, accompanied by a horse. Berel

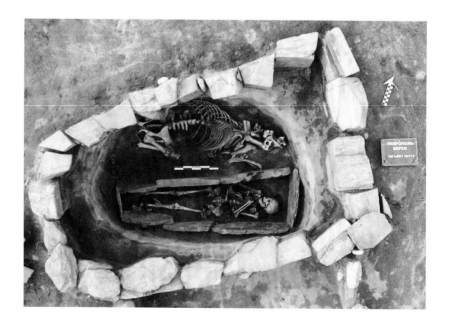

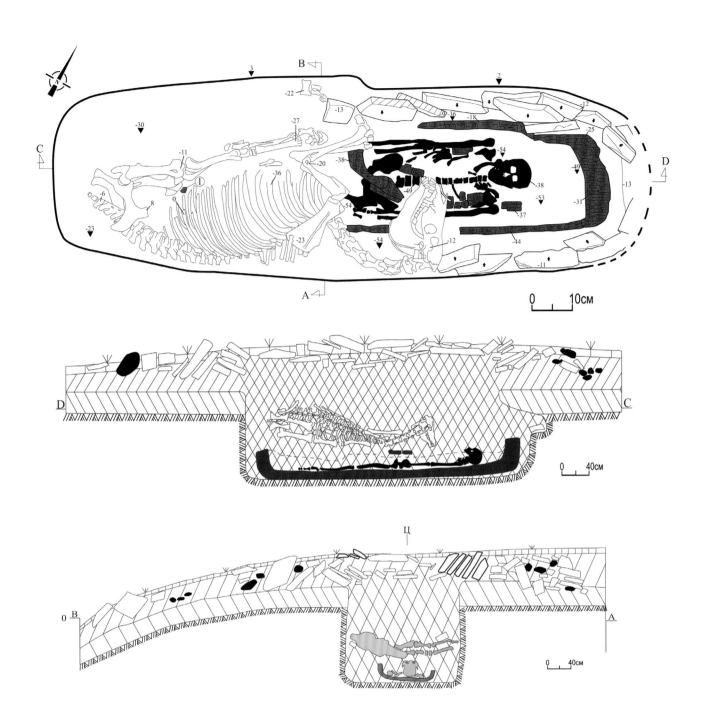

2.80

Hun-Xianbei burial of a man accompanied
by a horse. Berel

2.81

Items of jewellery, clothing, and grooming from Hun-Xianbei period burials at Berel. Worked bone items include combs and pierced hollow tubes. Items of jewellery include pendants, earrings, and bracelets made of metals and semi-precious stones

that celebrate the values of honour and valour, the feats of the hero in battle, mythical monsters, hunting, and the principles of fraternity and mutual support among friends.[40]

An abundance of archaeological material enables us to identify various religious ideas expressed both in the funeral rite and in the rich body of pan-Scythian art. The small, plastic arts of the Pazyryk and other cultures are steeped in the ideas of struggles and cycles, as well as elements of shamanism.

Ritual horse harness and trappings and horned masks from the Pazyryk culture kurgans at Berel are made in accordance with an established mythology (expressed in the precise spatial organisation of animal representations, and the use of decorative motifs and colour) in which the key principle is the division of all motifs into three worlds.

Numerous examples of decorative art have been preserved that are highly original both in content and execution. Scythian craftsmen ingeniously conveyed the dynamic movement of many types of animal, drawing both on the characteristics of the species as well as preferred artistic devices and techniques. The complex worldview of the nomads at this time has yet to be comprehensively researched, but what we can see from the current archaeological picture is that it was undoubtedly a worldview harmoniously linked with nature, one that included a set of iconic symbols, which to a greater or lesser degree reflected the social and historical events that characterize this period in history.

It would appear that the religious beliefs of the Central Asian nomads in the Scythian period represent a synthesis of shamanism (which was by this time fairly established), a northern version of Buddhism and an eastern version of Zoroastrianism, and can tentatively be referred to as the 'Sayan-Altai' belief system.

Various types of archaeological material indicate that in the Eurasian steppe belt of the first millennium BC, there existed a distinctive 'civilization' of nomadic peoples with very similar cultures, developed social stratification, and an economy based on animal husbandry, and that these tribes were consolidated into powerful polities capable of carrying out distant military campaigns.

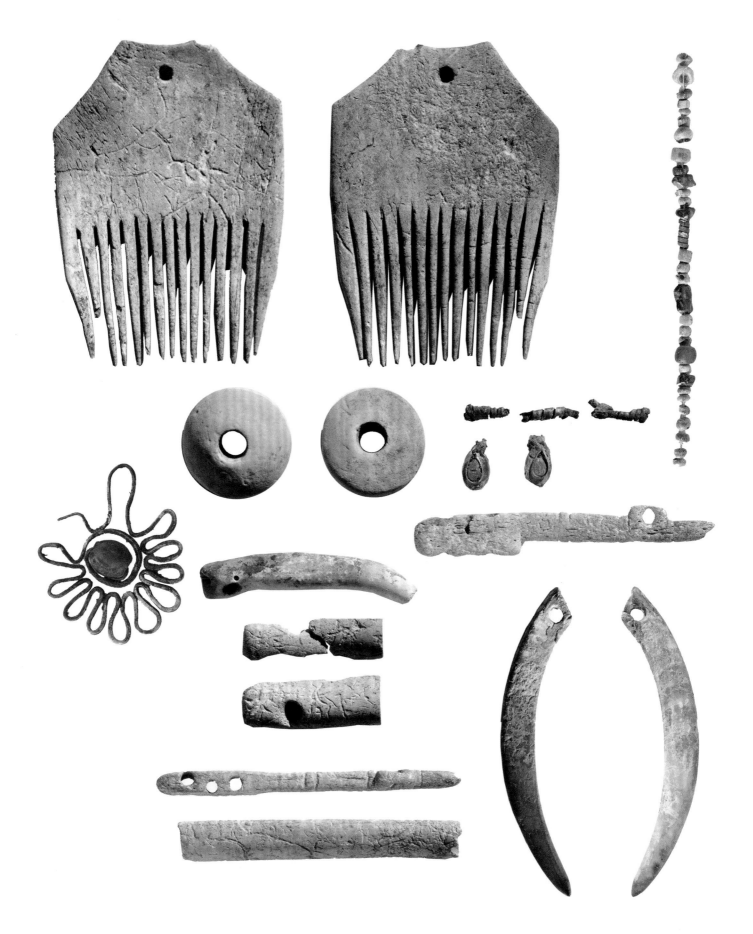

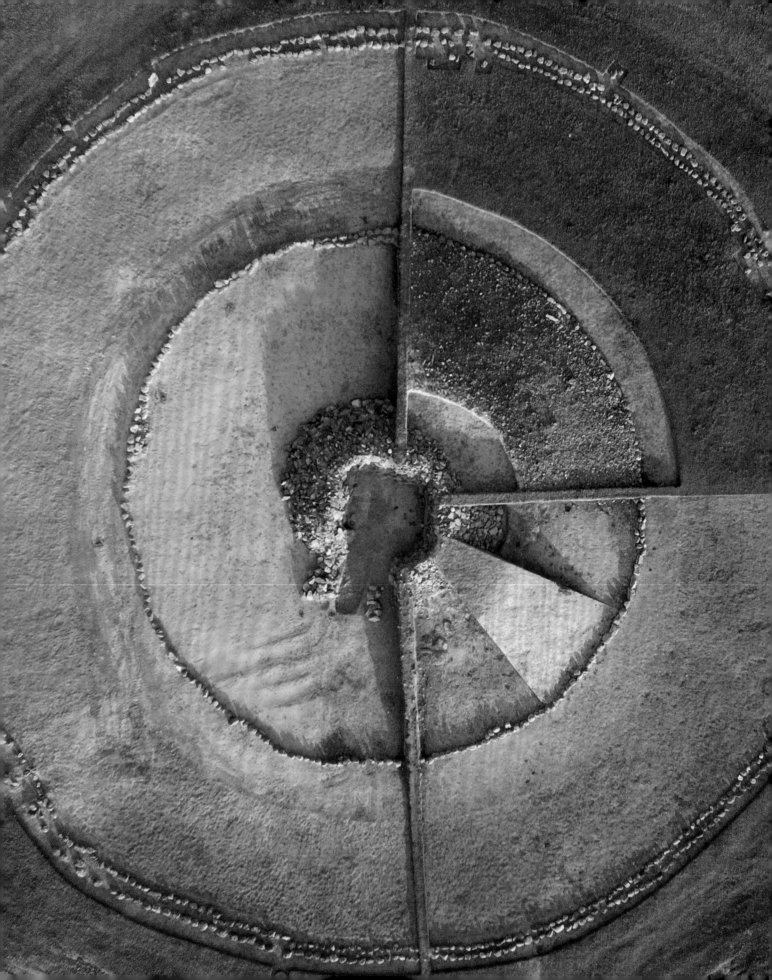

3. ELEKE SAZY, KURGAN 4

ZAINOLLA SAMASHEV

TRANSLATED BY
JOANNA DOBSON

Eleke Sazy is a vast, uneven basin in the northern foothills of the Tarbagatay Range. The northward sloping, cup-shaped valley is surrounded by low mountains, and is a mosaic landscape cut by tributaries of the Kargyba River consisting of swampy areas and flat elevations upon which over 300 kurgans are arranged in independent groups and chains following the meridional direction of the valley (fig. 3.2).

Eleke Sazy Kurgan 4 was excavated in 2018.[1] Kurgan 4 is situated further towards the northern periphery of the second group of monuments at Eleke Sazy and represents the type of medium-sized burial structure most common at this burial ground. The mound turned out to be extremely interesting, both in terms of its architectural and structural features. Most importantly, a rich burial was recorded here. Originally a double burial, one skeleton was heavily disturbed by looting. With remarkable fortune, the second individual was found completely intact, possibly on account of having been obscured from the looters' view by a pile of collapsed stones inside the chamber.

Construction

The kurgan consists of a hemispherical structure surrounded by a ditch and double ring of stones (fig. 3.3). Including the areas of collapsed stone, the main structure measures 33.25 m in diameter and 1.6 m in height. A ditch surrounds the perimeter of the kurgan (diameter 49.8–50 m, width 0.6–1.25 m). The area between the ditch and the outer edge of the mound crepidoma is flat and free of stones (figs. 3.4–5).

3.1

Eleke Sazy, Group II, Kurgan 4. Final stage of excavation. The kurgan has been excavated in such a way as to allow its presentation to the public

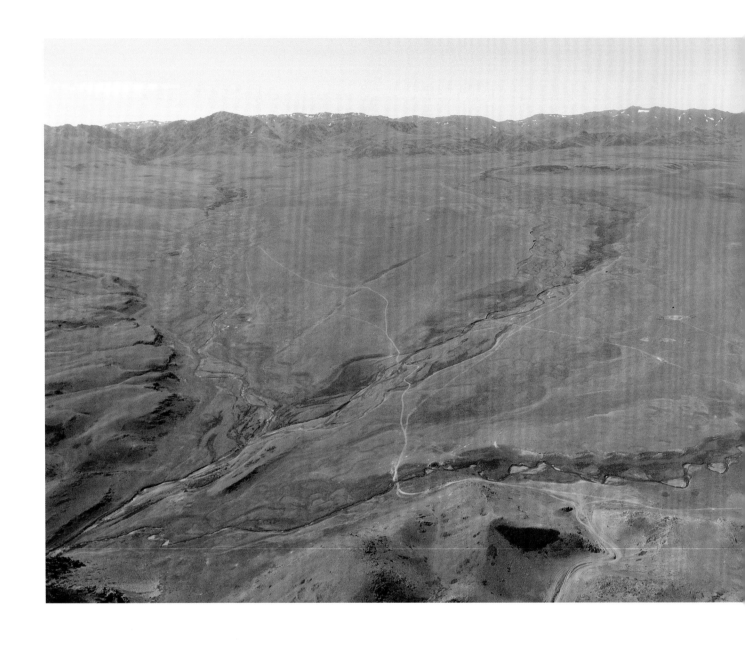

3.2

Panorama of the central section of the Eleke Sazy necropolis, view from the north. In the foreground are kurgan groups I and II

The burial chamber, the key structural component of the entire memorial complex, was built according to ritual practice on the ancient land surface. Its main structure was erected using large- and medium-sized stones. Externally, it is trapezoidal in shape (and in plan view is slightly oval and elongated) with a dromos on the eastern side. The internal space of the burial chamber is rectangular in plan, measuring 3.5 m east-west and 3.6 m north-south.

Post-holes were recorded in the burial chamber floor (fig. 3.6) and traces of severely rotten timber were found along the walls, suggesting that originally the beams of a timber frame were positioned horizontally

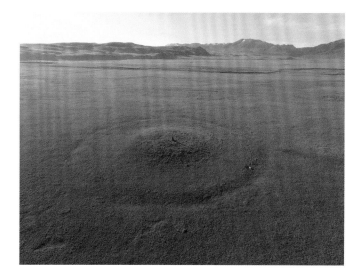

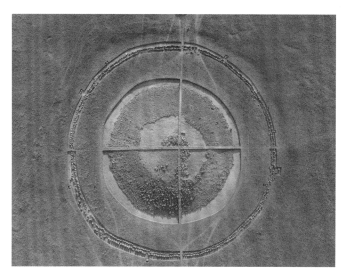

3.3
Eleke Sazy, Group II, Kurgan 4.
Prior to excavation

3.4
Eleke Sazy, Group II, Kurgan 4.
Outer enclosure ditch with river stones
chosen for colour and size

3.5
Eleke Sazy, Group II, Kurgan 4.
Initial stages of excavation

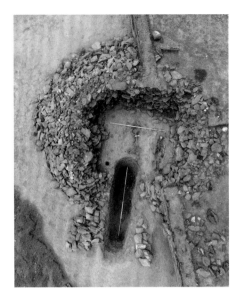

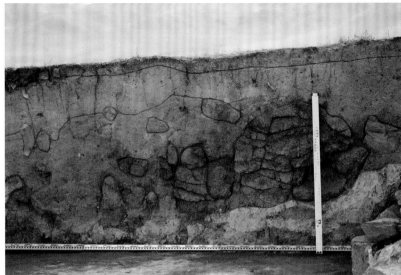

3.6

Aerial view of the central burial chamber, an oval-trapezoidal central structure with a rectangular chamber and a dromos (badly damaged) adjoining from the east, showing surviving burial and post-holes from central wooden chamber

3.7

Detail of section of Kurgan 4, showing layers of cut sod slabs, loam, and other earthen fill. Eleke Sazy, Group II

and vertically inside the stone structure. In effect, the stone oval-trapezoidal structure at the centre of the mound represents an outer encasement of the timber frame. Similar wooden chambers, albeit constructed using different technical methods, have been recorded in a number of the region's monuments of the same chronological period (Baigetobe, Shilikti, etc.). It was inside this timber structure that archaeologists discovered the remains of those interred, placed in special wooden sarcophagi.

This stage of construction was finished by overlaying the log chamber and dromos to the eastern side with large stones. Overall the dromos measures 5.3 m in length and is 1.3–1.56 m wide. At floor level it measures 4.15 m in length and is 0.85–1.15 m wide. The original height of the dromos from the ancient land surface remains unknown, due to significant damage caused by looters, but its current height measures 1.68 m.

Earthworks formed the next stage of construction. The western side of the burial chamber, which, according to Saka symbolic practice and mythological notions, would have been the most vulnerable portion of the ritual space, was strengthened from the outside by a half-arc of rammed clay fill.

Next, the entire ground structure was systematically built up with a layer of cut sod slabs (sometimes marsh tussocks), disc- and clod-shaped mud bricks, loam layers and other earthen building materials until the fill reached the very top of the mound (figs. 3.7, 3.8). At this final stage, the mound was covered with a 'protective shell' of crushed pebbles and river stones. Not fully covering the whole mound, this protective shell may have been dismantled by looters, or the ancient builders of the mound

3.8

Section of Kurgan 4, showing central
chamber and layered construction of
mound. Eleke Sazy, Group II

may have left a part uncovered intentionally in accordance with the
prescriptions of ritual (fig. 3.5).

The entire structure of the multilayer earthen mound was supported
by a circular *crepidoma* at the base (28 metres in diameter) comprised of
large rounded stones (fig. 3.1). The crepidoma likely served a religious
and magical protective purpose as well as a technical one.

The entire construction is ringed by a perimeter ditch, which is
comparatively wide (4.6–5.9 m) and shallow (no deeper than 0.35 m). It
is lined with a concentric double ring of variously coloured river stones
(fig. 3.4). The outer stone ring alignment touches the external edge of
the ditch. It is probable that the laying of this component of the ground
structure formed the final stage of the funerary rite associated with the
construction of the mound.

Hoard

During excavation of the 'protective shell' in the north-eastern sector
of the kurgan, adornments of male and female clothing as well as
household items were found tucked under some of the stones that make
up the crepidoma (figs. 3.9a,b). It is possible that the objects found here
were intended as an offering made by participants in a funeral rite, or

OVERLEAF

Eleke Sazy, Kurgan 4 fully excavated

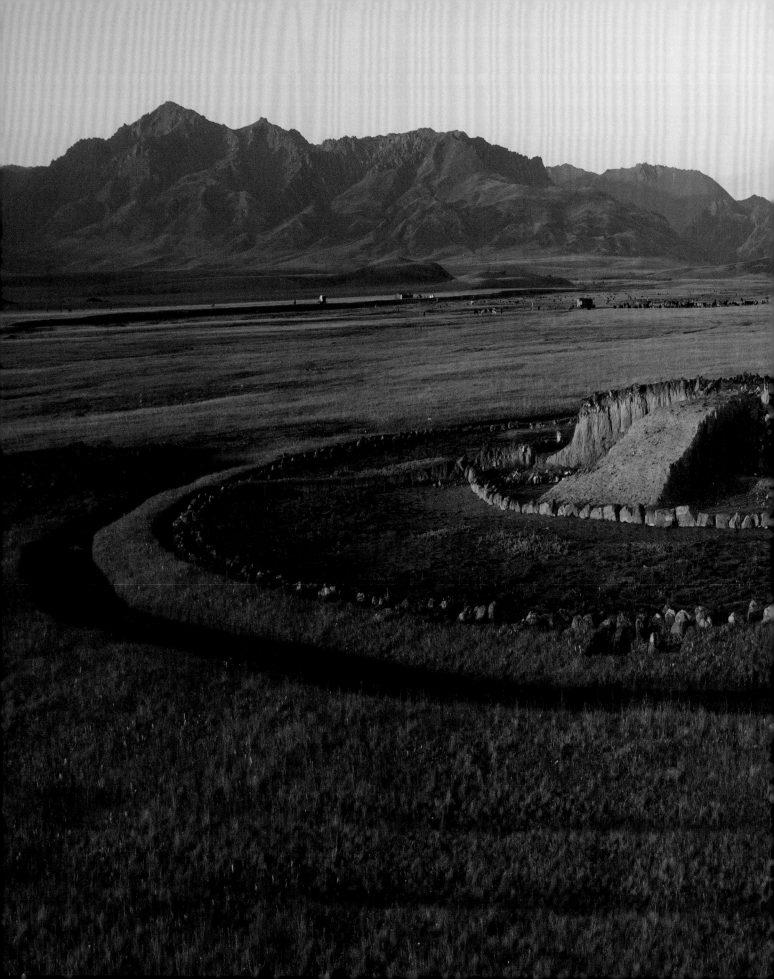

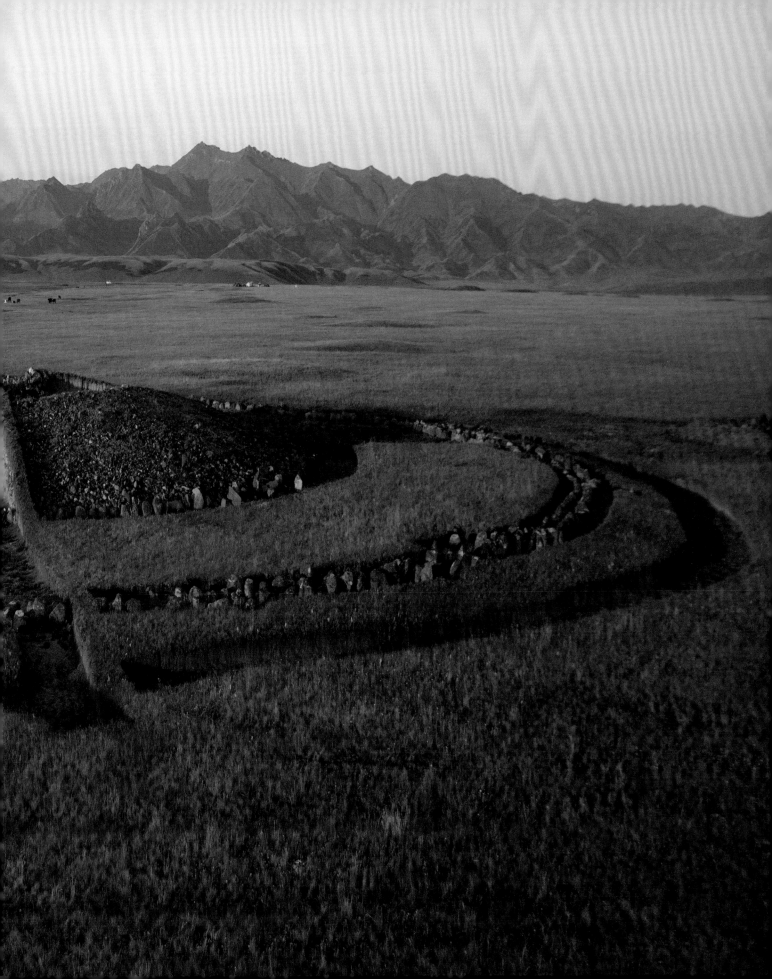

3.9a

Location of hoard under stones of crepidoma. Eleke Sazy, Group II, Kurgan 4

that the items were hidden under the stones much later during a post-funerary cyclical ritual. Nor can it be ruled out that these adornments were deliberately removed from the burial vestments of the interred and hidden beneath the stones after the completion of a ritual, which had meaning in a religious and philosophical context currently unknown to us. As a characteristic parallel, however, one may point to the Kazakh custom of Kazakh customs of '*təburik*' and '*zhyrtys*', which are expressed in the distribution of the deceased's clothing and other items of value to his or her own people, so that the positive qualities (or spirit) of the individual in question passes through these gifts or fragments and helps to preserve a positive memory of that person's life.

Roundels made from gold foil (fig. 3.10)

The roundels measure 8 mm in diameter and two or four flat loops soldered onto the reverse side. The gold loops measure: width -2 mm, circumference -4 mm, distance between loops -2 mm. The roundels appear to have formed the main decorative element of a male funerary caftan.

Zoomorphic plaque (fig. 3.9b)

This small, elongated-oval-shaped gold plaque bearing an embossed predator figure has been crushed, but the head, croup (rump) and front and hind legs, which both show claws, are still visible. In the head, one can make out the muzzle and ears, and the nostrils and eyes are indicated by triangular indentations. Several plaques of this type were recovered but only fragments of the remaining examples are preserved. Close analogues to these plaques are recorded at Tasmol burial ground, Kurgan 5, Saryarka,[2] as well as in the western regions of Kazakhstan, the Urals and the Volga region.

Bird head plaques (fig. 3.9b)

The plaques are fashioned at opposite ends in the form of a bird head with tightly curved beak and tuft above the head. The two bird heads make the single S-shaped form of the plaque. Each artefact is cut from thick gold sheet. The reverse side is fitted with two loops of standard size.

Narrow S-shape plaque (fig. 3.9b)

The plaque itself measures 2 cm in length and 0.5 cm at its widest part and has two slots in the middle. The shape of the slots repeats the same smooth curves of the plaque, resembling a teardrop or beak. The pointed terminals narrow slightly and turn in opposite directions.

Biconical hanging adornment (fig. 3.9b)

This piece is made up of two halves and has a loop at the top and three 'spikelets' at the opposite end. The pendant is 15 mm in length and 6 mm

3.9b

Items of the hoard found under stones of crepidoma. GOLD, BONE/HORN, SEMI-PRECIOUS STONES. КПО93- 38577/1-103, КПО93- 38578/1-7, КПО93-38579/1-11. Eleke Sazy, Group II, Kurgan 4

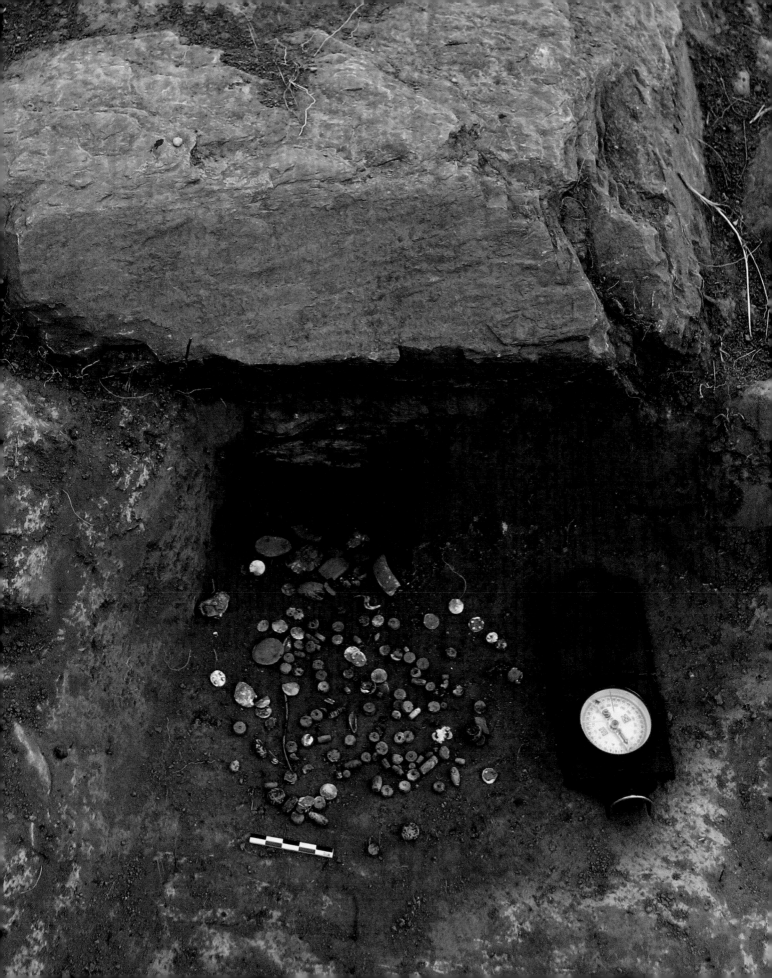

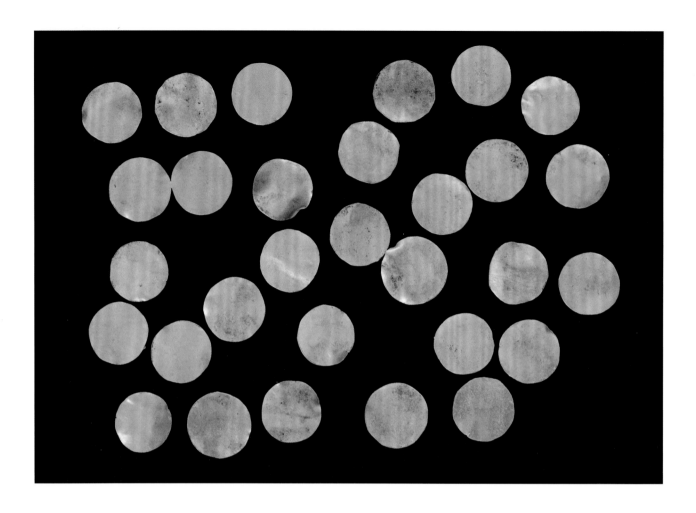

3.10a,b

(a) Examples of gold roundels; (b) reverse of gold roundels, showing four sewing loops.
GOLD. Diameter: 1 cm. КПО93- 38577/1-103.
Eleke Sazy, Group II, Kurgan 4, hoard

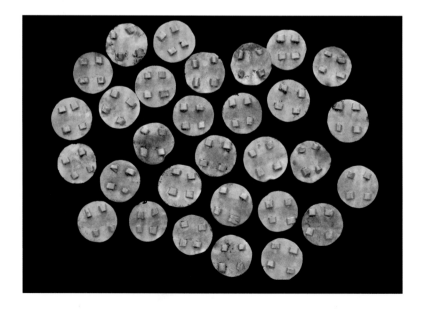

3.11

Necklace made of gold beads. Barrel-shaped ribbed beads, between them beads formed of two hemispheres. Three gold pendants: one consists of an eyelet and a three-leaf pendant, and two of eyelets and four-leaf pendants. GOLD. КПО93- 38580/1-128. Eleke Sazy, Group II, Kurgan 4, hoard

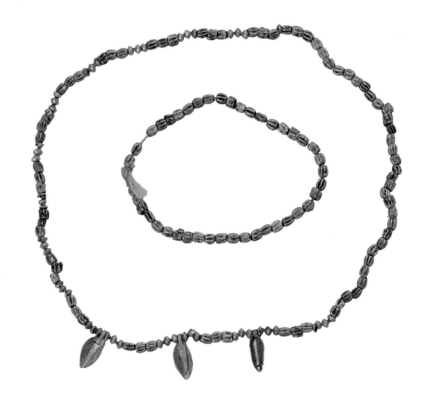

wide at its widest part, where the two cone-shaped pieces join. Similar clothing adornments have been recorded among the grave goods of the Baigetobe kurgan, Zhalauly treasure and Arzhan-2.

Tubular shaped-beads (see figs. 6.15a,b)
More than 10,000 beads were recorded, each no more than 1 mm in diameter. The beads were probably used to decorate the cloth in a pair of trousers. The technology used in the production of these beads is of particular interest.[3]

Fragments of spiral gold wire ornament (fig. 3.9b)
Spiral ornaments such as these are often found among the grave goods of Early Saka kurgans.

Gold barrel-shaped beads (fig. 3.11)
Some of these beads have raised vertical ribs and grooves. Others are oval-shaped, made of two hemispherical pieces joined at the centre.

Gold pendant (fig. 3.11)
The pendant is formed of three leaf-shaped lobes, which taper towards the bottom. There is a soldered loop at the top and a hole has been drilled through the lower tip of the pendant.

3.12a

Restrung beads. SEMI-PRECIOUS STONES, TURQUOISE, JASPER, CARNELIAN, CHALCEDONY, PYRITE, JET, COQUINA. KП093- 38597/1-371. Eleke Sazy, Group II, Kurgan 4, hoard

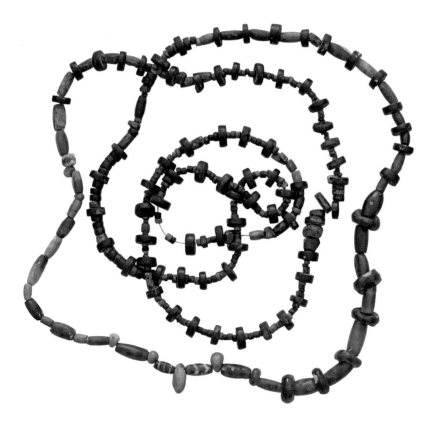

3.12b

Worked bone/horn pendants. BONE/HORN. KП093- 38608/1-3. Eleke Sazy, Group II, Kurgan 4, hoard

Bronze needle (fig. 3.9b)
The needle – an elongated shaft, circular in cross-section – narrows towards the tip and widens slightly in the central part. The specific function of this artefact is not known but it may have served as a hairpin.

Beads and pendants (figs. 3.12a,b)
The numerous beads and pendants are made of multi-coloured semi-precious stones, including turquoise, jasper, carnelian, chalcedony, pyrite, jet and coquina.

Bronze mirror (figs. 3.13a,b)
The mirror has a slightly raised lip and measures 16.5 cm in diameter. Traces of a loop are visible on the reverse side.

Burial

According to preliminary anthropological studies, the human remains found lying to the right of the double burial belonged to a female, approximately fifteen years of age. Judging by the location and remains of some bones found closer to the right-hand wall, these skeletal remains were originally placed on the chamber floor and were later disturbed by ancient looters, who appear to have accessed the burial via the dromos.

3.13a,b

(a) Bronze mirror; (b) bronze mirror reverse side. BRONZE. Diameter: 16.5 cm. КП093-38576. Eleke Sazy, Group II, Kurgan 4, hoard

Only a fragment of the cranium was preserved. Fragments of other bones were recorded, including the humerus, femur and left tibia, which showed evidence of drilling probably made during a medical procedure or the embalming process (fig. 3.15).[4]

Elements of clothing adornments in the shape of long, exaggerated antlers were found cut from sheet gold. Other finds include a square, horn artefact, which may have served as part of a device for working woollen threads (fig. 3.14).

The skeleton of the second personage interred in this burial was found to the left of the female skeleton, closer to the northern wall. The remains belong to a seventeen- to eighteen-year-old youth of noble status. The deceased was placed on his back, head to the west-facing slightly to the north (fig. 3.16a). The bones of the right hand rested on top of a dagger held in a scabbard. The left hand was placed across a *gorytos* (a combination bow and quiver case). The legs were extended with the soles of the feet turning outwards to the side. The long bones of the arms and legs show signs of drilling, perhaps for the purpose of introducing preservative substances during the embalming process, and carried out as part of a lengthy ritual linked with the journey of the interred into the other world. Anthropologists suggest that the purpose of embalming may be explained by the need of a tribal association to participate in the funerary rites of a high-ranking individual. Nomadic lifestyle meant that these were not always possible to arrange quickly, however.[5]

The remains of wooden planks were found in places lying on top of the skeleton suggesting that the interred was originally placed in a wooden sarcophagus.

3.14
Worked bone square plate with nine drilled holes. Possibly for tablet weaving.
BONE. КПО93-38606. Eleke Sazy, Group II, Kurgan 4. 8th–6th century BC

3.15
Partial remains of a 13–15 year old female, including partial cranium and partial long bone with clear drill marks. Remains were scattered and disturbed by looters. Eleke Sazy, Group II, Kurgan 4. 8th–6th century BC

As the bones were reasonably well preserved, an anthropological reconstruction was carried out under the supervision of E.V. Veselovskaya at the Institute of Ethnology and Anthropology, Russian Academy of Sciences, and a series of analytical studies – including ancient genetic analysis of paternal and maternal lines – were undertaken at the Institute of General Genetics and Cytology Ministry of Education and Science Republic of Kazakhstan, headed by L.B. Dzhansugurova. Geneticists arrived at the interesting conclusion that the young male and young female recorded at Eleke Sazy Kurgan 4 have "the same J1b1a1e mtDNA haplotype, which indicates that these two individuals shared a common ancestor on the matriline".[6] Analysis of the SNP Y chromosome showed that the patriline of the young male belongs to haplogroup R1a1a1-M417.

Closer to the north-western corner of the burial chamber, a significant distance above the skull of the interred male, traces of an artefact were recorded which consisted of a circular formation of short (max. 1 cm) bronze rivets (fig. 3.17a). The purpose of the original artefact remains unknown, however it may represent the decorative element of a headdress.

Items of gold jewellery were discovered to the left of the cranium, probably the details of a headdress – a deer head cut out of sheet gold and figures of maral deer in twisted position, without antlers, also cut from sheet gold (fig. 3.17b). The ancient craftsman fashioned the contours of the animal's head, ear, eyes and nostrils with laconic style and precision. Of greatest interest are the antlers, which are depicted in a single extended line. The forehead tines are executed in traditional S-shape but are not preserved in all examples of this artefact type.

Fragments of two more deer heads cut from gold foil were discovered in the space between the left shoulder and cranium, as well as above the left shoulder blade and collarbone.

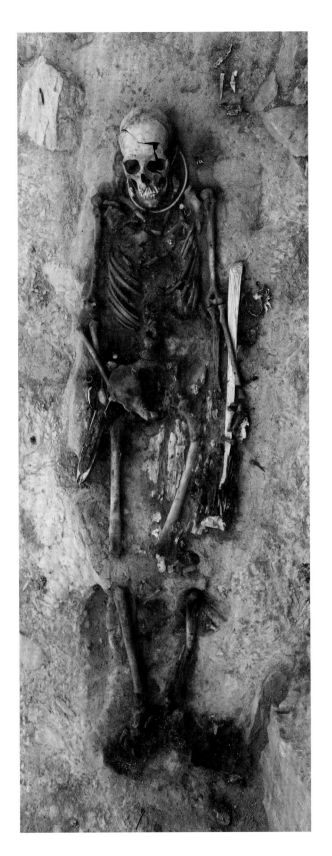

3.16a
Undisturbed burial of 17- to 18-year-old male. Eleke Sazy, Group II, Kurgan 4. 8th–6th century BC

3.16b
Drawing of undisturbed grave, showing locations of aretefacts. Eleke Sazy, Group II, Kurgan 4. 8th–6th century BC

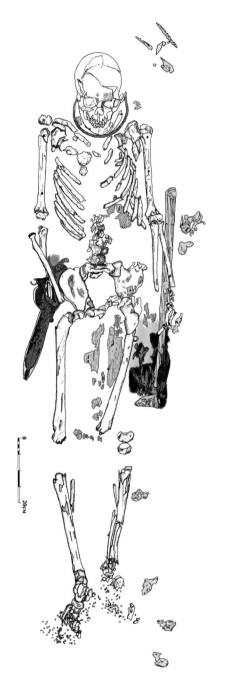

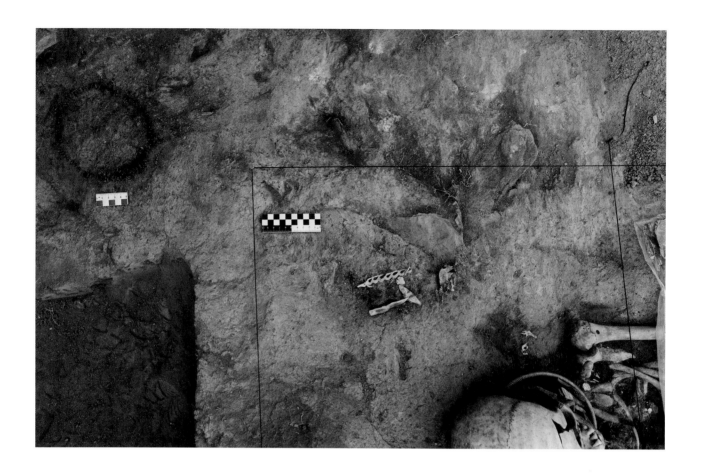

3.17a

Excavation photograph showing likely remains of a headdress. At top left is a circular formation of bronze rivets.

3.17b

Gold plaques in the form of deer with long antlers, likely a headdress ornamentation. Eleke Sazy, Group II, Kurgan 4. 8th–6th century BC

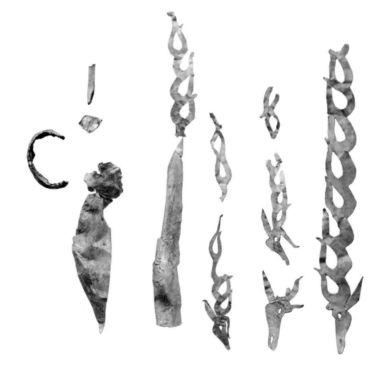

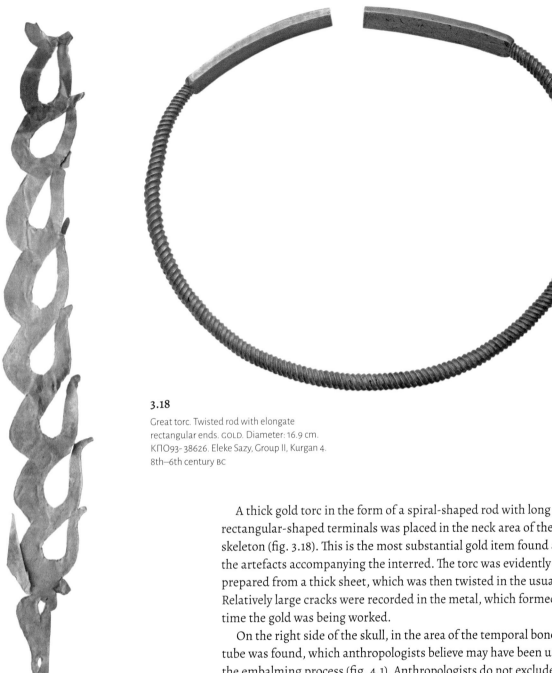

3.18

Great torc. Twisted rod with elongate rectangular ends. GOLD. Diameter: 16.9 cm. КПО93- 38626. Eleke Sazy, Group II, Kurgan 4. 8th–6th century BC

3.17c

Gold plate-stripe in the form of a deer from a human headdress. Cut out eye holes, nostril and ear shown. GOLD. L: 11.4 cm, W: 1 cm. КПО93-38617. Eleke Sazy, Group II, Kurgan 4. 8th–6th century BC

A thick gold torc in the form of a spiral-shaped rod with long rectangular-shaped terminals was placed in the neck area of the male skeleton (fig. 3.18). This is the most substantial gold item found among the artefacts accompanying the interred. The torc was evidently first prepared from a thick sheet, which was then twisted in the usual manner. Relatively large cracks were recorded in the metal, which formed at the time the gold was being worked.

On the right side of the skull, in the area of the temporal bone, a gold tube was found, which anthropologists believe may have been used in the embalming process (fig. 4.1). Anthropologists do not exclude the possibility, however, that the artefact was used to decorate the end of a strap used in a piece of headgear.

A second tube was recorded in the vicinity of the cervical vertebrae, this time a little larger in diameter, but still short and fashioned from sheet gold and bearing a decorative relief in the form of a twisted spiral. One of its ends is rounded.

A small plaque in the form of a feline predator curled into a circle was discovered lying on the left collarbone. The plaque is executed in classic

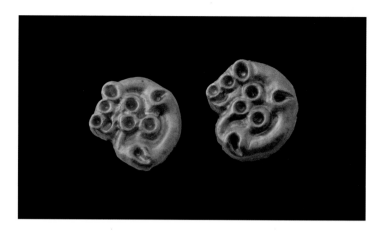

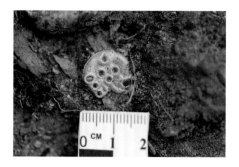

3.19a
Gold plaque in the shape of a feline predator curled in a ring. *In situ*, next to dagger hilt. КПО93-38616. Eleke Sazy, Group II, Kurgan 4. 8th–6th century BC

3.19b
Two small plaques in the form of feline predators curled in a ring. GOLD. КПО93-38616, КПО93-38616. Eleke Sazy, Group II, Kurgan 4. 8th–6th century BC

Early Saka style, in which the limbs, head, ears, shoulder blade and muzzle are all depicted by means of circular depressions (fig. 3.19a).

A second plaque of this kind was found on the right side of the skeleton above the pelvic bone. It appears to mark the position of the fittings of a waist belt or the straps of a sword-belt because, slightly lower down near the right thigh bone, a bronze dagger was discovered with a pommel fashioned in the shape of a pair of facing predator heads. The dagger was placed inside a luxuriously fabricated scabbard with gold overlay decorated with symbolic forms and figures of granulated deer and predators.

The finds mentioned above are described below in more detail:

Scabbard (figs. 3.20a,b)
The scabbard consists of three main components – a base of fine, wooden plates, an overlay comprised of four plates of sheet gold and a bronze, two-part, hinge-like attachment reminiscent of a bi-composite horse bit, by which the weapon was suspended from the sword-belt (fig. 3.23).

The gold overlay, which has a decorated front and hollow back, is comprised of four, variously sized gold plates, connected together to create one visual semantic field made up of three vertical zones. The entire scabbard surface is decorated with whole animal figures or their *protomes*, as well as symbolic shapes finely rendered in granulation (i.e. by micro-soldering gold 'granules' 1 mm in diameter onto the smooth surface of the gold sheet) and partially inlaid with coloured stones. In contrast to the upper and middle parts, the scabbard base consists of two equally proportioned elements that join together in a reinforcement rib that runs down the middle.

The upper part of the gold scabbard, which houses the dagger crossguard and a hole for fastening the rivet of the hinge-like attachment, is wider than the other two parts and has a somewhat complicated triune structure. The mouth of the scabbard is fashioned

in the form of slightly raised, semi-circular bars, which almost perfectly repeat the shape of the dagger crossguard. This type of scabbard, with relief accentuated bars, gold overlay and central reinforcement rib, is clearly depicted in the relief from the north stairs of the Apadana at Persepolis (fig. 2.4). The lower portion of the scabbard mouth repeats the shape of the downward-pointing ends of the dagger crossguard. This area is adjoined to the right by a hanging plate reminiscent in shape of a fang-like pendant. An oval hole measuring 1.16 cm by 0.98 cm is situated in the upper right corner. This hole was used to fasten the rivet at one end of the belt attachment. The rivet on the other end of the attachment was fastened to the sword- or weapons-belt. The third element of the upper section of the gold overlay represents an area equal in width to the blade and is located immediately below the 'butterfly-shaped' protrusion of the crossguard. E. Chernenko has pointed out the inadequacy of this entomological term to describe the shape of the crossguard in a blade weapon.[7]

The middle portion of the scabbard consists of a long ribbed sheet, which tapers slightly towards the point. This portion, which measures 11.29 cm long and 4.6–3.95 cm wide, slots into the upper portion.

The lower portion of the overlay consists of two identical elements. These wing-shaped, rounded lateral parts are joined together to form the chape (tip), the raised lip of which stands perpendicular to the scabbard's main surface.

The decoration covering the scabbard overlay, comprised of animal representations and other symbolic elements, is arranged harmoniously within each of the three portions described above. This arrangement likely reflects Early Saka beliefs concerning the structure of mythological space.

The upper portion of the overlay, the plate most densely saturated with decorative elements, depicts three hornless herbivores, possibly roe deer, as well as a single feline predator. The contours of all four images are rendered in granulation. The figures of the two ungulates, arranged in mirror symmetry with back-turned heads and depicted in recumbent position, are harmoniously arranged, one either side of the 'butterfly-shaped' area of the scabbard mouth.

Certain areas of the animals' anatomy are especially emphasized – the lean, curved body, powerfully arched neck and elongated muzzle tapering finely towards the tip. The long, pointed ears are equally striking and inlaid with coloured stones. The eyes, tails and hooves of the front and hind legs are similarly encrusted, while the shoulder joints and haunches are rendered using traditional spiral symbols.

A feline predator shown in contours adorns the narrow area just below the 'butterfly-shaped' protrusion. The torso points downwards toward the scabbard tip and the thick, short-muzzled, back-turned head faces upwards toward the scabbard mouth. The tail runs parallel to the animal's

3.20a

Scabbard *in situ*, showing a base of fine wooden plates with gold overlay. Eleke Sazy, Group II, Kurgan 4. 8th–6th century BC

3.20b

Four-part overlay of scabbard. GOLD, SEMI-PRECIOUS STONES. L: 26.5 cm, W: 3.8 cm. КП093-38628. Eleke Sazy, Group II, Kurgan 4. 8th–6th century BC

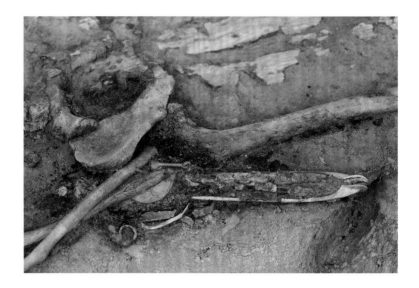

back, the tip curling into a spiral. The predator's legs are shown extended, as if the animal had come to a sudden stop, and are inlaid at the tip. The animal's mouth, nostrils, eyes and ears are likewise inlaid with coloured stones, somewhat larger in proportion than the inlays used to decorate the ungulates depicted above it. The predator's body is marked with volutes.

The fang-shaped hanging plate with hole for the riveted, hinge-like belt attachment is decorated with the representation of a herbivore, its head facing downwards. The pose and stylistic characteristics of this figure are analogous to the beasts described above, although larger in proportion. Various symbols surround the fastening hole, one of which is S-shaped with a curled extension.

The middle portion of the overlay is covered on either side of the reinforcement rib with a deer head facing downward with long, exaggerated antlers. The heads of both deer are raised so that the tip of the muzzle points into the outer corners of the lower sheet area. The ears are also long, and the eyes large with turquoise inlays. The S-shaped forehead tine in both animals is shown, in traditional manner, running forward above the head, while six more antlers extend out in rhythmic waves behind the head. Between the two deer heads in the lower portion of the sheet, there is a horizontally arranged S-shaped symbol, which marks the boundary of the middle zone of the scabbard surface. Here, the same granules that mark the contours of the decorative zoomorphic images are soldered along the reinforcement rib.

The lower, bi-composite zone is decorated with similar deer head images, only now arranged facing upwards so that the tips of the animals' muzzles are almost touching those of the animals depicted in the middle portion of the overlay. The two narrow, vertically arranged lateral wings,

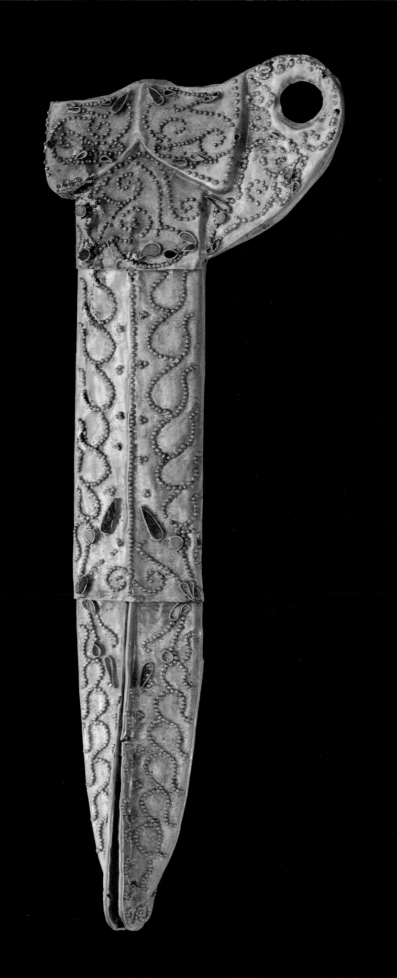

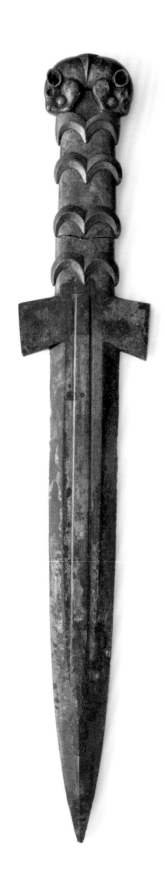

which widen towards the chape are decorated with S-shaped symbols and lines, four on one side and five on the other.

Three minerals are used for the scabbard inlays: blue-green turquoise, $CuAl_6(OH)_2[PO_4] \cdot 4H_2O$; lazurite, grey, $(Na, Ca)_8[(S,Cl,SO_4,OH)_2|(Al_6Si_6O_{24})]$; and azurite, blue, $CuAl_6(OH)_2[PO_4] \cdot 4H_2O$.

The decorated gold plates, from which the gold overlay is fabricated, cover the front surface of the scabbard only. The wood on the reverse side may have been covered with leather.

Dagger (figs. 3.21a,b)

The fashioned hilt of the cast bronze dagger, rectangular in cross-section with slightly rounded edges, is decorated on both sides with four stylized bars, possibly representing mouflon horns, stacked vertically, one above the other and slightly protruding beyond the width of the dagger handle. Each bar measures 2.7 cm wide and 1.3 cm high. The vertical distance between each element varies; the distance between the upper bar and the second, for example, measures 0.4 cm, the distance between the second and third, 0.8 cm, and between the third and fourth, 0.7 cm. These ribbed decorative elements are lighter in colour than the rest of the dagger and may have been made separately before being carefully welded on both sides to the main shaft of the hilt. The handle was broken in two, possibly intentionally, in antiquity. The break line runs at a point 6.9 cm from the upper edge.

The pommel is fashioned in the shape of the heads of a pair of feline predators shown in profile, muzzles facing in opposite directions. The figures are shown in high relief, the eyes as circular depressions, the ears as large, deep, oval depressions, suggesting that they may have served as cells for coloured mineral inlays. The cheeks of the predators are accentuated, conveying plumpness. The heads are rounded and in terms of morphological characteristics may be said to correspond most closely to that of a snow leopard.

The dagger crossguard is cast from the same piece of metal as the rest of the dagger but has the appearance of consisting of two irregular trapezoid-shaped plates positioned either side of the blade and lowered at a slight angle from the horizontal. The lower corners of each plate descend at an acute angle, while the straight, almost vertical outer edges resemble the shape of a sharp axe blade.

A similar type of crossguard belonging to the same type of blade weapon has been discovered further west ('Kelermes type', 'Kabardino-Pyatigorsk type', etc.), but, in general, these are somewhat later in date than the artefact in question,[8] which can most likely be attributed to the Karasuk culture typology in Central Asia and southern Siberia.

The closest analogy with similar interpretation of the crossguard and blade, but with rod-like pommel, is an artefact discovered among chance finds in eastern Kazakhstan (fig. 2.36). The handles of many eastern and

3.21a

Bronze dagger, broken in two. BRONZE.
L: 32 cm. КПО93- 38627. Eleke Sazy, Group II,
Kurgan 4. 8th–6th century BC

3.21b

Detail of bronze dagger pommel

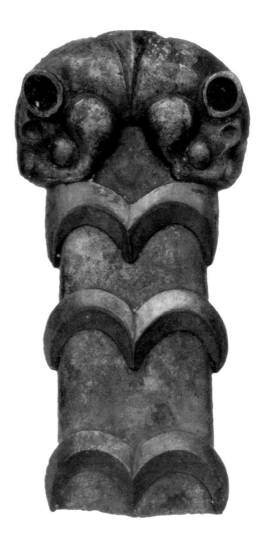

northern parallels to the Eleke Sazy dagger end in rod-like or mushroom-like pommels.[9] This may indicate that such similar structural elements point to a comparative typology of daggers.

The blade point is narrow and triangular in shape. A rectangular-shaped raised rib extends lengthways from the handle to three quarters of the way down the full length of the blade (length 15 cm, width 6 mm, height 1.5 mm). The rib is framed on both sides with a shallow groove. The width of the grooves gradually narrows from the handle to the top of the blade. The rectangular-shaped rib terminates smoothly, and the line continues from the top of the blade to the point in the form of a narrow rib sub-triangular in cross-section (length 5.4 cm, width 0.2 cm).

Dagger proportions: length 29.4 cm; length of handle to guard 9 cm; handle width 2.37 cm; length of blade 19.1 cm; width at widest part 2.7 cm; length of cross guard 5.08 cm, width 2.16 cm.

3.22
Bronze mirror, with corroded iron handle attached with rivets. BRONZE, IRON. КПО93-38612. Eleke Sazy, Group II, Kurgan 4. 8th–6th century BC

3.23
Bronze belt fitting with interlocking ring joint. BRONZE. L: 4.7 cm. КПо93-38644. Eleke Sazy, Group II, Kurgan 4. 8th–6th century BC

Bronze mirror (fig. 3.22)

A bronze mirror (diameter 6–7 cm) was found lying over the hole of the scabbard's gold overlay on top of a wooden board, with the narrow, iron handle pointing downward (fig.3.20a). The handle, which is poorly preserved, was attached to the reverse side of the mirror disk with three rivets. The mirror disc is slightly raised at the top on the side opposite the handle.

Bronze belt fitting with interlocking ring joint (fig. 3.23)

This belt fitting was used to suspend the dagger and gorytos from the sword-belt. Examples of this artefact were found lying to the right of the interred close to the bronze dagger and scabbard, as well as to the left of the skeleton, close to the base of the gorytos (fig. 3.16a). Both parts of the fitting consist of a single cast bar ending in a ring. The rings interlock in the middle, similar to an equestrian two-piece bit, creating an articulate joint, which served as a stabilizing system when in motion. The far end of both bars is shaped into a rivet, one of which would have been attached to an object or weapon, and the other to the weapons belt. The rivets take the form of a hitch clasp with a disk-shaped cap and flat base connected by a short, narrow rod (0.5 cm). The distance between the cap and base (approx. 0.5 cm) is sufficient to fasten firmly the rivet to the slot in the leather waist belt as well as to the oval opening in the hanging plate of the scabbard. Evidently, the leather casing of the gorytos was fitted with a special strap with a punctated hole or slot through which the rivet could be inserted, and indeed a fragment of the tip of a narrow strap with gold overlay was found in association with the gorytos.

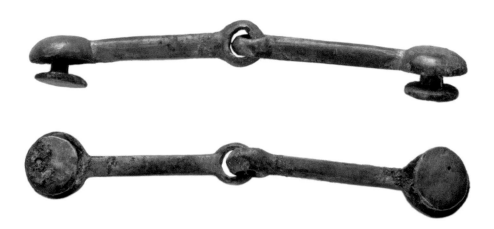

3.24a

Long side overlay of the gorytos. GOLD.
КПО93-38632. Eleke Sazy, Group II, Kurgan 4.
8th–6th century BC

3.24b

In situ remnants of the gorytos. Visible are:
arrows, bronze belt fitting with interlocking
ring joint, gold overlays of base and sides
of quiver. Eleke Sazy, Group II, Kurgan 4.
8th–6th century BC

Gorytos (figs. 3.24a–d, 3.26)

A quiver and a bow case, placed beneath the left arm of the deceased, may
represent the two parts of a gorytos, connected by short straps, similar
to that depicted on the Bayan Zurkh deer stone in Mongolia.[10] Significant
artefacts associated with the gorytos are two highly decorative gold
overlays and forty bronze arrowheads. These objects are detailed below.

Saka-Scythian *toreutics* are useful in the task of reconstructing the
gorytos. A long, narrow, gold overlay was discovered, which originally
lined the front surface of a wooden plate running along the top edge
of the quiver and acted as a reinforcement rib. This artefact was
displaced slightly under the weight of stones and soil. The wooden
base of the quiver was also lined with a gold overlay. This wonderful
item is decorated with the striking figures of a pair of deer, rendered in
granulation.

The overlay of the quiver base is rounded in the lower part (diameter
approx. 9 cm), and in its upper part is an elongated oval shape
reminiscent of the profile of a pear or the silhouette of a nomadic leather
drinking vessel (overall length, approximately 12.5 cm). The piece is
framed by a circular arc-shaped rim in high relief, which was fabricated
by stamping on the reverse side. The base rim of the leather case was
inserted into this shallow groove (3–4 mm), fragments of which are
preserved. The ends of the arc run adjacent to a straight (vertical) relief

93

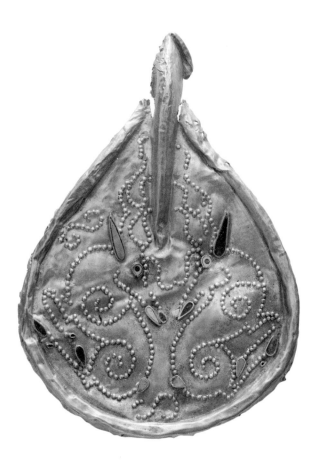

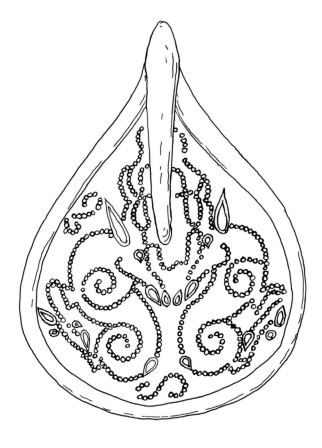

3.24c

Gold overlay of the wooden base of the
gorytos. Heraldic design of addorsed deer
rendered in granulation with inlays.
GOLD, SEMI-PRECIOUS STONES. H: 10.5 cm,
W: 7.2 cm. Diameter: 0.5 cm. КП093-38629.
Eleke Sazy, Group II, Kurgan 4. 8th–6th
century BC

3.24d

Drawing of gorytos base, detailing heraldic
design

strip, also created by stamping on the reverse side. The raised strip
tapers towards the lower part, which extends almost two-thirds of the
way towards the centre of the overlay. The bottom part of a thin wooden
wall was inserted into this groove, and would have extended outwards,
dividing the inner space of the quiver into two parts. This wooden section
would have protruded at the opening of the quiver, and served both as
a reinforcement rib and a surface to which a loop could be sewn for the
purpose of suspending the case from a sword-belt. We may assume that
the quiver would have been used to store two groups of multi-purpose
arrows equipped with different arrowheads. However, it should be noted
that all forty bronze arrowheads discovered at the bottom of the quiver
were solid tanged and bilobate.

The gold overlay on the base of the quiver is decorated with two
addorsed (back-to-back) deer figures, which confers upon the
composition a heraldic appearance (figs. 3.24c, d). Because of the way
the gorytos was worn, attached to the sword-belt, and the angle at which
it was suspended, anyone facing the wearer would have a clear view
both of the distinctive fashioning of the gold surface, and the images of
sacred animals that encoded the mobile lifeways of Early Saka society.

We assume that the viewer would have been able to 'read' this visual vocabulary of the Saka belief system.

The general design of the composition is as follows: the two animals, whose bodies are positioned back-to-back, are depicted with back-turned heads so that they appear to be facing one another. The antler racks of both deer extend vertically upwards. Both animals are arranged as if rotated at a roughly sixty-degree angle, so that the spines of both deer are almost parallel and the legs of both animals occupy the outer area of the composition on either side. A horizontally arranged S-shaped symbol is positioned below the animals' tails, roughly equidistant between the two. The same symbol can be seen above the arched neck of the deer to the left at the level of the ear. The composition made on the limited surface area of the gold sheet cannot but create in the mind of the viewer a dynamic impression of the binary structure of space.

The granulation technique used to create the deer figures strengthens the visual effect, as in certain conditions the play of light and shadow on the metal creates an additional sense of volume and movement. The colours of the inlays in turquoise, lapis lazuli, azurite, chalcedony, etc. placed in the ears, eyes, tips of the legs, tail and muzzle even more vividly contribute to the emotional and psychological power of the deified image of the young male interred in this burial.

In terms of spatial arrangement, the animal representations depicted on the gold overlay emulate certain aspects of heraldry, and yet the composition includes other decorative elements that do not conform to the principles of mirror symmetry. The two volutes at the level of animals' shoulder blades, which are usually interpreted as symbols of the wings of mythical creatures, are directed upwards in one case, and downwards in the other. The positioning of the volutes may be intended to communicate an example of binary opposition – right-left, top-bottom, male-female, etc. There are also differences in the execution of the arch of the neck and antler tines in each animal, and yet none of these features distract from the overall heraldic impression of the composition.

The deer antlers are depicted in traditional Early Saka style: three wave-like lines are directed vertically upwards from the height of the eye and both sets of antlers are positioned on either side of a vertical strip, which protrudes onto the surface and is introduced for the purpose of fastening additional components to the wooden base from the reverse side. This strip appears to represent the world tree, the mythological axis of the world, and, together with the deer figures, symbolizes the binary structure of space. By virtue of the fact that the heads of both animals are back-turned and therefore facing, the forehead and traditionally S-shaped tine of the antler racks, which make up the most important element of the composition, are almost touching.

Worthy of note is the fact that in some places a granule-ball is missing in the contour lines of the deer's torso and antlers; one may assume that

3.25a

Bronze solid tanged and barbed arrowheads.
BRONZE, BINDING (MATERIAL UNKNOWN).
L: 7.5 cm, W: 1.3 cm. КПО93-38646/1- 40.
Eleke Sazy, Group II, Kurgan 4. 8th–6th
century BC

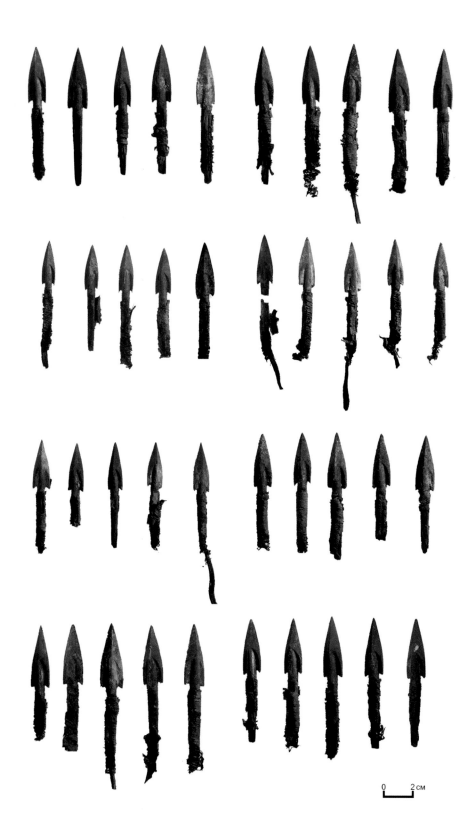

0 2 CM

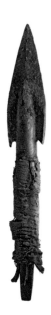

3.25b

Bronze solid tanged and barbed arrowhead
with binding still present. BRONZE, BINDING
(MATERIAL UNKNOWN). L: 7.5 cm, W: 1.3 cm.
КП093-38646/1-40. Eleke Sazy, Group II,
Kurgan 4. 8th–6th century BC

either these missing granules at some point came loose from the gold surface or that no granule was ever placed there. The absence of any trace of soldering in these areas would appear to support the second explanation.

The deers' ears are long, narrow, pointed and raised upwards. The ear cell of the deer to the right is inlaid with lapis lazuli, while that on the left is inlaid with turquoise, adding an appealing effect to the overall composition. The animals' heads are set on short necks, are disproportionately long and taper towards the muzzle tip. Due to the fact that the heads are back-turned and facing, the muzzle tips are almost touching.

The gracefully fashioned curve of the lower jaw adds a special expressiveness to the head of both animals. The curve is arranged such that it may also indicate the point where the inner curve of the neck meets the withers.

The nostril of the deer to the right of the composition is decorated with turquoise inlay while the nostril of the deer to the left is decorated with lapis lazuli. The inlays are exceptionally finely worked, which further imparts an elevated style to these animal representations. The inlay of the nostrils is leaf-shaped with the tip pointing upwards.

The lower lip, which may equally be interpreted as the opening of the mouth, is inlaid with lapis lazuli in the deer to the right and with turquoise in the deer to the left. In both cases, the colour inlays take the form of a narrow, willow leaf shape, similar to the ears but with the tip pointing downwards.

The deer's necks are short and tightly arched, which adds a particular expressiveness to the body. The eyes and pupils of both animals are decorated with circular turquoise inlay. The tails are inlaid with turquoise cut into the shape of a drop, tip pointing downwards. The legs of both deer are shown in a recumbent position. The pointed tip of the hooves and, curiously, the miniature sesamoid bones above them are also inlaid with coloured stones.

One of the most expressive elements of the deer representation is the volute sign in the area of the hind quarters, which spirals in the direction of the tail. Together with the similar decorative element at the shoulder joint, these volutes attribute to this deer image a certain cultural and chronological association, which may have represented a component of a semantic code widely employed throughout Early Saka society.

Bronze arrowheads (figs. 3.25a,b)
At the bottom of the leather case forty bronze arrowheads of the tanged bilobate type were recorded. The arrowhead top is sharp, rhombic in cross-section, and forms two blades with depressions around a curved rod. The ends of the blades descend downwards and are pointed. The tang is rounded, becoming flatter and gradually decreasing in thickness.

3.26

Remnants of leather quiver part of gorytos, which has moulded around the arrows. LEATHER. Eleke Sazy, Group II, Kurgan 4. 8th–6th century BC

3.27a

Recumbent stag plaque. Gold with inlays of turquoise and lapis lazuli. GOLD, TURQUOISE, LAPIS LAZULI. L: 8.5 cm, W: 6 cm. КПО93-38625. Eleke Sazy, Group II, Kurgan 4. 8th–6th century BC

The size of the heads varies since some of the tangs have been broken off in antiquity. Total length 8.1–7.2 cm, blade length 3.1–3.2 cm, width 0.54–0.9 cm.

The wooden arrow shaft was split so that the arrowhead could be inserted and then tightly bound with horsehair. Traces of binding are clearly visible on several arrowheads.

In another kurgan, located just a few steps away from Kurgan 4, bronze bilobate socketed arrowheads were found along with figures of hornless deer identical to those recorded in Kurgan 4. This indicates that no chronological gap existed between the production of these two arrow types.

Deer-shaped plaques (figs. 3.27a,b and 6.17–19)

Eight gold deer-shaped plaques, seven without antlers and one of larger proportions with antlers, were discovered in several places in the male burial of Kurgan 4, in the vicinity of the remains of the gorytos containing bronze arrowheads and alongside the left arm and left leg of the interred. The plaques lay scattered in a line from the left shoulder of the interred to the sole of the left foot. The plaques may have been disturbed from their original position by rodents but, nonetheless, are thought to be decorative elements of the gorytos.

The single deer plaque with antlers is depicted in a recumbent position (or flying pose), legs bent at the joints and tucked beneath the stomach, hind legs positioned lower than the front legs, the hooves pointed and inlaid with coloured stones. The deer head rests on a thick, sharply raised neck with muscles emphasized by a groove in the metal surface. The S-shaped antler tines extend back behind the head while the traditional front tine extends forward. The ear is elongated and leaf-shaped. The withers and tail are also marked by a triangle. Of great interest is the triangular inlay on the rump which is set inside a claw-shaped cell, composed of pieces of turquoise and a circle with a dot at the centre. This composite, triangular feature is, in turn, furnished with lapis lazuli inserts. A similar insert was likely worked in the area of the shoulder joint, of which only the claw-shaped (or tear-shaped) cell has been preserved. The deer joints, torso muscles, neck and cheekbone are especially accentuated, creating a heightened sense of dynamic tension.

The other seven deer plaques without antlers, which appear to represent the maral deer family, were used to decorate the gorytos surface. All these figures are executed in a similar figurative manner – legs bent tightly beneath the body, neck sharply raised. Nevertheless, there are slight differences in how the body of each deer is portrayed. The eyes, ears and all limbs of the deer were inlaid with coloured stones, although not all are preserved. It is possible that in creating the decorated weaponry intended to accompany this young royal male into the other world, the ancient master chose a symbolic number of deer plaques based on the principle

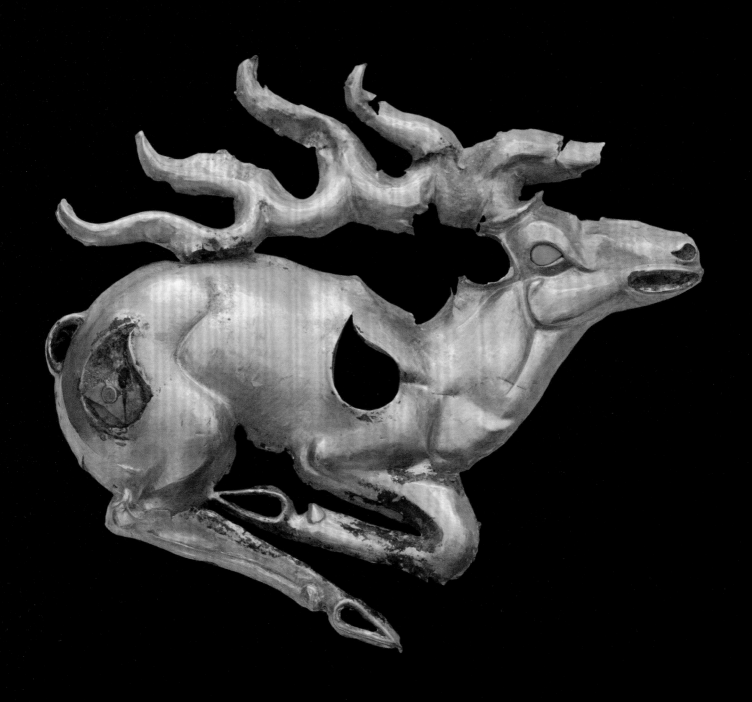

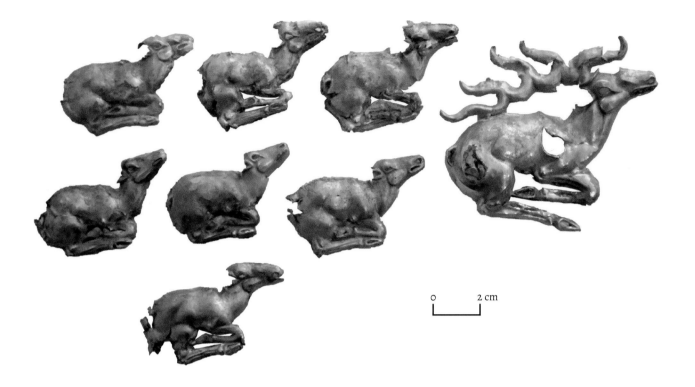

0 2 cm

3.27b

Deer plaques: stag and female deer. GOLD, TURQUOISE, LAPIS LAZULI. КПО93-38618 to 38625. Eleke Sazy, Group II, Kurgan 4. 8th–6th century BC

of one male and seven females, a choice motivated not only by numerical symbolism but informed by other beliefs, a fertility cult perhaps. The fact that the deer plaques are arranged on the surfaces of sacred objects, points beyond any doubt to the existence of an established deer cult in the society of the ancient nomads. The deer plaques are poorly preserved due to their degradation by the soil matrix.

As mentioned above, analogous examples of deer figures without antlers are documented together with bronze socketed arrowheads in another kurgan situated just a short distance from Kurgan 4.[11] Close parallels to the deer plaque with antlers and encrustation are recorded among Shilikti finds.[12] These figures are similar in the use of encrustation technique and overall portrayal of the image, i.e. in flying (or recumbent) pose, and are identical in the shape of the antlers.

Gold beads
A large number of tubular, gold beads were found just above the phalanges of both feet of the interred, and are very similar to beads found at Arzhan-2 in Tuva (see figs. 6.14a,b).

Comparative analyses of the architectural elements and grave goods at Eleke Sazy necropolis will be required in order to determine chronological attribution and to place this monument in chronological sequence with others in neighbouring regions.

Reconstruction

On the basis of materials recorded at Kurgan 4, a reconstruction was created of the burial costume and accompanying armaments of the young, elite male, who died approximately 2,800 years ago (fig. 3.28). The reconstruction shows a man standing at full height, dressed in a long suede caftan like the one depicted in the Persepolis relief. Long trousers hang outside the boots and the figure is wearing a pointed, white felt headdress decorated with gold appliqué.

A sumptuous dagger held in a sheath with a gold overlay decorated with animals and inlays of coloured stones is suspended from the right side of the sword-belt by a riveted fitting with interlocking ring joint. From the left side of the sword-belt hangs a gorytos with a quiver containing forty arrows and a case holding a combat bow.

In addition to providing a visual representation of the appearance of our ancestors, who inhabited this area in the 8th century BC, this reconstruction is considered a standard for further academic studies of the culture, lifeways, military affairs and religious beliefs of the Saka peoples.

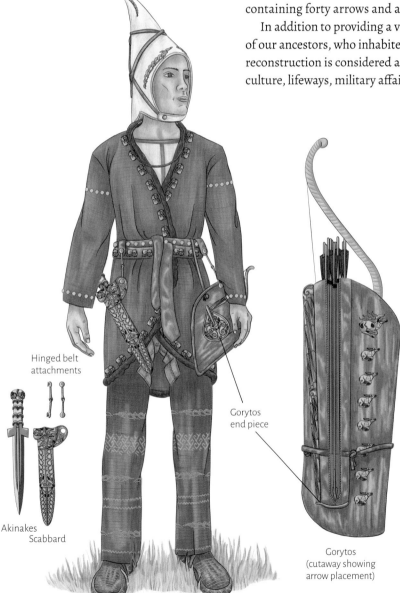

Hinged belt attachments

Akinakes
Scabbard

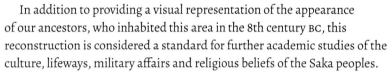

Gorytos end piece

Gorytos (cutaway showing arrow placement)

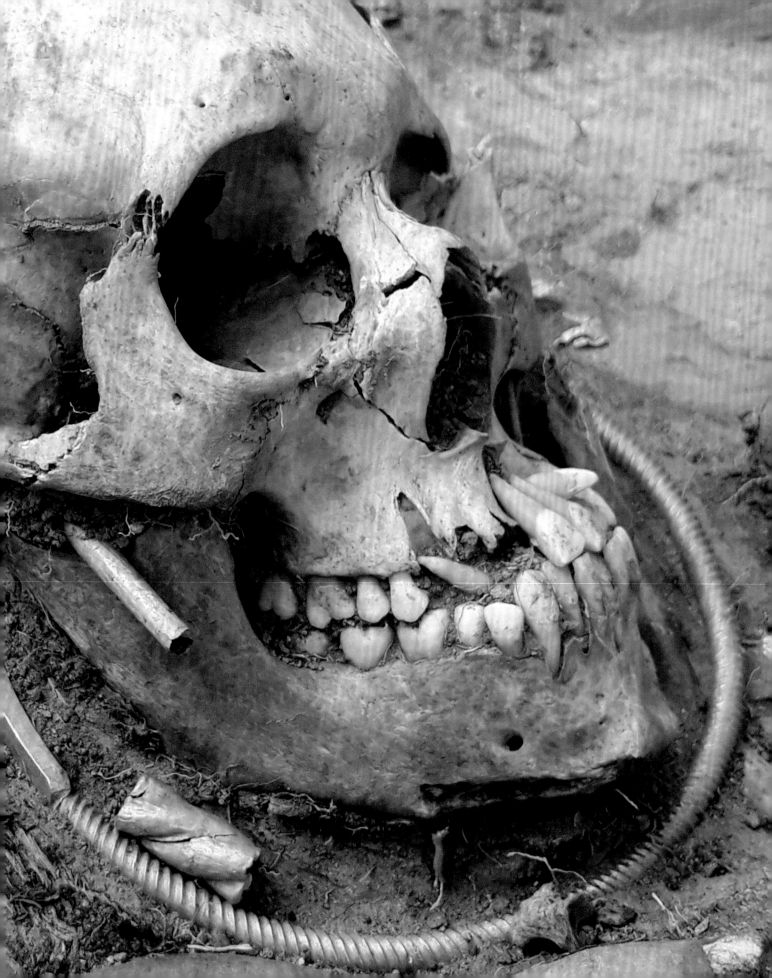

4. PARALLELS IN KAZAKH AND SAKA-SCYTHIAN FUNERARY RITES AND MEMORIAL CUSTOMS

ABDESH TOLEUBAYEV

TRANSLATED BY
JOANNA DOBSON

4.1

Eleke Sazy, Group II, Kurgan 4. Male inhumation. 8th–6th century BC

According to recent studies, Saka-Scythian cultures are believed to have existed from the 9th to the 3rd century BC, which places them at a temporal distance of 2,500–3,000 years from the Kazakh culture of the ethnographic period (18th–20th century). Some archaeologists, those who followed the scientific methods and principles characteristic of the Soviet period, and indeed others working in the post-Soviet space, claim that studies based on comparisons between the cultural phenomena of antiquity and the modern ethnographic period are academically unfounded and can lead only to erroneous conclusions. Such a rigid approach, however, greatly limits the potential of studies in cultural evolutionary development. Why should we not compare the ancient archaeological record with later ethnographic materials, practices and artefacts, especially when there exists an evident connection between them, both in form, but most importantly, in content and symbolic meaning?

This chapter shares the results of research aimed at seeking out forgotten cultural threads, a golden tendon connecting the traditions of the Kazakhs of the Middle Ages and the more recent ethnographic period to the bearers of early and late Saka-Scythian cultures, who occupied the territory of modern-day Kazakhstan and its adjacent regions. The approach taken was suitably thorough, while appropriate caution was exercised in the drawing of hypotheses. It goes without saying that the cultural connection between the Saka and the Kazakhs exists due to the indirect transmission of practices via the ancient Turkic and early Turkic tribes and peoples, the Huns, Yuezhi and Wusun. Naturally, over the course of millennia, many traditions have been lost or transformed beyond

recognition and new cultural values introduced. For this reason, any study in cultural evolutionary development is an inevitably complex task.

Nonetheless, as a researcher studying the ethnographic traditions of the medieval and later ethnic groups occupying the steppe, valley, and montane cultural landscapes of Eurasia, I am increasingly of the opinion that, throughout all these periods, or at least since the advent of the Bronze Age, this complex historical space was characterized by advantageous cultural interaction, resulting in processes of economic, cultural and linguistic syncretism.

These conditions are believed to have resulted from thousands of years of economic, ethno-cultural and linguistic interaction between speakers of the ancient Altai, Indo-European, and Uralic family of languages. Until recently, concepts which emphasize Indo-Iranian, Slavic, and Indo-European origins have largely dominated academic discussion on issues surrounding the cultural, historical and linguistic affiliation that exists between Siberian-Scythian and Saka cultures. This tendency reflects an undeservedly biased approach to studies in the cultural evolutionary development of the peoples of ancient and medieval Eurasia, in which the role of the proto-Turkic (Altai), and Turkic tribes is largely downplayed.

Consequently, this chapter documents the diachronic change of such cultural practices. Funerary rites and memorial customs serve as the most stable components of any culture. The extent to which this is true can be seen in the fairly comprehensive set of surviving parallels in funerary rites and memorial customs that can be traced between cultures separated by centuries or even millenia.

According to the testimony of Herodotus, Aristeas – a hero of Greek legend said to have lived in the 7th–6th century BC – journeyed north and, upon reaching the lands of the Issedones, wrote about them in a poem, his *Arimaspian Epic* (fig. 4.2). Ancient written sources contain many legendary tales about Aristeas himself. One tale recounts how his soul left his body and flew like a bird "observing everything below – the land, the sea, rivers, cities, peoples … then, on returning, the soul revived his body, and told him about all the things it had seen and heard in different places".[1] This story is entirely consonant with Kazakh legend and belief.

According to field material I gathered in the mid 1970s,[2] the oldest generation of Kazakhs imagine the human soul to have three forms – *Shybyn zhan* ('fly' soul), *et zhan* (bodily soul) and *rukhi zhan* (spirit). Shybyn zhan, the soul in the form of a small fly, is said to leave a sleeping person's body and wander about. The person sees in a dream whatever shybyn zhan sees on its wanderings: if shybyn zhan rests on a drop of water, then the dreamer sees water, rivers and seas; if shybyn zhan rests on a small hill, the person sees mountains in a dream. In the morning, the 'fly' soul re-enters the person's body before they wake. It is thought dangerous to disturb a person who is sleeping as the soul needs time to re-enter the body.[3]

4.2

Arimaspian fighting griffin, The Jena Painter.
Drinking cup (kylix) Greek, Attica, c. 4th century BC.
Fed-figure Athens ceramic, diameter 11.4 cm.
Museum of Fine Arts, Boston Henry Lillie Pierce
Fund 01.8092 (Photograph © 2021 Museum of Fine
Arts, Boston)

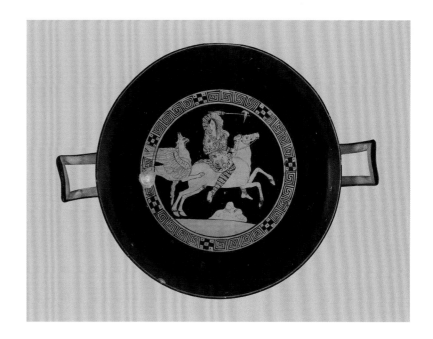

The ancient folk of the Pazyryk culture often buried members of their
kin in winter pastures. "It was as though the Pazyryk secured the lands
from which they would depart for the summer,"[4] wrote ethnographer and
archaeologist S. Rudenko, and this custom continued for centuries. "Until
fairly recently, the Kazakh and the Kyrgyz buried their dead in winter
pasturelands only."[5] Indeed, Kazakh clan cemeteries were usually located
in the vicinity of *kystau* (winter pasturelands).

Burial mounds served as a marker which secured the land rights of
individual families and clans.[6] This custom continued to be practised
up until the period of the late Kazakh nomads, for whom the graves of
notable clan members and tribal ancestors marked the boundaries of
land ownership.

Pazyryk winter dwellings may well have been similar to those
witnessed by V. Radlov during his travels of 1860–70 in the Altai –
octagonal log structures with roof tapering into a smoke vent and
covered with layers of birch bark.[7] S. Sapozhnikov described similar,
hexagonal log constructions on Altai winter roads.[8] Until recently, a
related type of log construction was used by the Altai Kazakhs as a *toshal*,
a cool utility room for storing meat and other foods.

Log-cabin-like burial chambers are common in royal burials of the
Scythian-Hun culture and are documented at Shilikti, Pazyryk, Bashadar,
Tuekta and Berel kurgans in the Altai (figs. 4.3, 4.4). In these kurgans, log
tomb chambers are sometimes erected at ground surface level. In other
cases they are lowered into large square, subterranean burial pits. The
Hun burials (Noin-Ula kurgans of Northern Mongolia) repeat the form
and construction principles of those in the Russian Altai.[9]

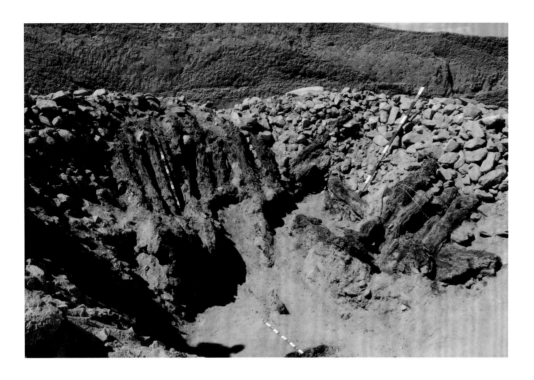

4.3

Shilikti II, Kurgan 16. Remains of log-cabin-like burial chamber

The wooden tomb at Shilikti is built of a double-row of thick larch logs stacked end to end according to the principle of log cribbing. On the vertical axis the tomb structure consists of seven rows of logs, stacked one on top of the other without fastenings or notch joints. The open spaces between the logs are filled with crushed stone. Viewed from the east, the wooden tomb resembles a pyramidal-shaped stepped structure, which tapers towards the top.[10] Historically speaking, the design of this type of funerary monument is a most stable feature, remaining almost entirely unchanged until as late as the mid-20th century. Among Kazakhs of the Chinese Altai, the same wooden burial structures were noted, albeit in somewhat simplified form.

The larch wood used in the construction of the Shilikti tomb originated in the Karasai area located at the northern end of the valley, at a distance of about 25 km from the burial. Transport was carried out with the help of draft-animals, mainly horse and camel. Long logs measuring 40–60 cm in diameter and up to 12 m in length show signs of oblique chafing at the narrow end as a result of traction, and a slot at the thicker end. An elderly resident of Zhalsha Village, who observed the burial chamber logs post-excavation, recalled that the Kazakhs of Shilikti Valley used this same method to transport logs as late as the 1930s–40s.[11]

The use of turf at burial mounds is widespread among Saka-Scythian cultures. At the kurgans at Shilikti, Baigara, Salbyk, for example, turf was mainly used as a reinforcing, fill material. In the Tarbagatay foothills

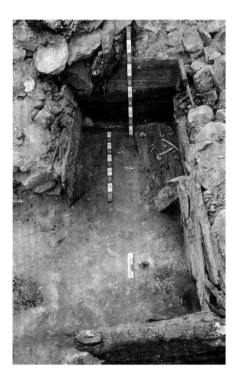

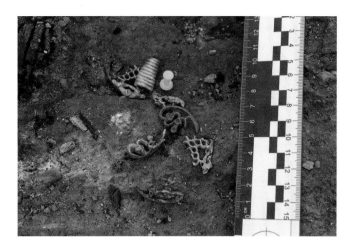

4.4a,b

(a) Shilikti II, Kurgan 16. Wooden sarcophagus; (b) *in situ* artefacts

and the Shilikti Valley, the local population uses turf rolls as a building material to this day.

Shale rock 'pillows' were discovered in the Baigetobe burial chamber and the Saka Bazar kurgan. In monuments of the Pazyryk culture, there was a custom in which an oblong-shaped boulder or slate slab was placed beneath the head of the deceased; sometimes wood was used (Ulandryk, Yustyd).[12] Oval wooden and felt pillows have been discovered at large Pazyryk mounds and other mounds in the Altai.[13] A very similar custom still exists among some Kazakh groups today: a small piece of turfed soil, *bas zhastyk* (head pillow), is placed to one side when a grave is first being dug and is later placed beneath the head of the deceased as they are lowered into the grave pit. This Kazakh tradition is a striking example of a custom which has its origins in the Saka period.

Until recently the Altai people, who generally share a close cultural and linguistic affinity with the Kazakhs, buried their shamans according to Scythian tradition, in a foetal position with a stone pillow placed beneath the head.[14]

In the permafrost burials at Ulandryk, archaeologist V. Kubarev documents the custom of placing the male in the southern half of the log chamber and the female in the northern half. The Altai Saka always buried the male on the right side of the chamber, sometimes right up against the southern wall, and the woman in the northern or central part of the chamber, closer to the 'utility area'. This spatial arrangement is repeated in dozens of monuments attributed to the Pazyryk culture.[15] Among the Huns, the right side of the yurt from the entrance served as the domestic half of the yurt, while the left side was considered the male half.[16] According to Kubarev, the division of the inside space of the log chamber into male and female areas corresponds to the tradition observed among the peoples of present-day Mongolia and the Altai, in which the household space to the right side of the entrance is considered

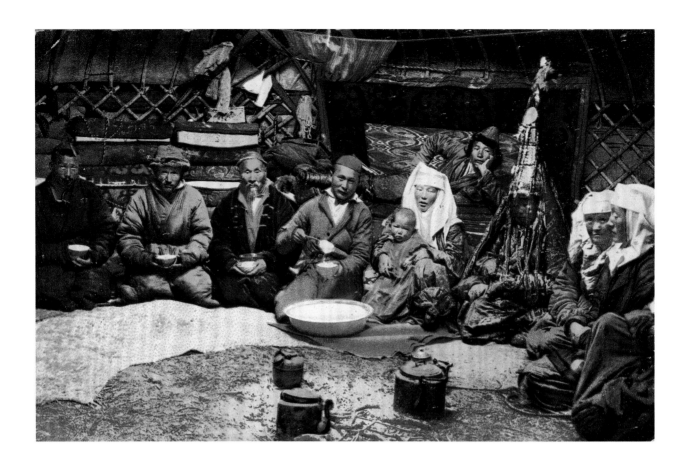

4.5

Kazakhs sitting in yurt occupying traditional male–female sides (including bride in wedding clothes and headdress), Altai mountains, 1911. Library of Congress, 2018683809

the female half and the space to the left side of the entrance, the male half.[17] In this light, it seems reasonable to infer that the positioning of the personages interred in the burial chamber corresponded strictly to the organization of the dwelling space of the same individuals in life. A similar tradition in the organization of the interior space of the yurt existed among the Kazakhs (fig.4.5). The right side of the yurt was the male side, and the left side the female (in this case, we see the viewpoint of a person facing the door while sitting in the *tor*, the most revered spot inside the yurt).[18]

Baigetobe kurgan, built to commemorate a particularly high-status member of the Saka community, is located at the beginning of a linear group of kurgans, situated at the southernmost tip of the burial ground. The special veneration of elite members of the clan or tribe is reflected in the topography of funerary and commemorative monuments and is, likewise, observed in other memorials of the Saka-Scythian culture. For example, at Ulandryk, monuments commemorating the heads of large families or clan founders are located either at the beginning or in the middle of a kurgan chain and are larger than the others in the group. As V. Kubarev notes, "the funeral rite inevitably reflects the specific social

and economic conditions in which the deceased lived. Therefore, to the tiniest detail, funerary structures model the real conditions in which the ancient nomad lived".[19] To a certain degree, the layout of the burial ground repeats the same spatial organization applied to the dwellings of the living. Yurts belonging to the heads of the *aul*, 'village', were usually placed on the leeward side of the camp, and young members of the community were not permitted to position their own yurt in front of the dwellings of the elders.[20]

One prerequisite for any participant of a Saka funeral was thorough physical purification. T. Talbot Rice describes this bathing procedure, drawing on the writings of Herodotus. The Saka bathed both before and after participation in a funeral rite.[21] The design and principle of Saka baths was very simple. Close to a nearby river or stream, a pile of stones was gathered, over which a large fire was made. Once the stones were piping hot and the fire had burned down to glowing coals, a small, conical-shaped hut consisting of three to six poles with a very small vent at the top was built on top of the stones. The hut was densely insulated on all sides so as to contain the heat inside. Then, steam was made by splashing water onto the stones and the participants bathed in the vapour. During the bathing procedure and afterwards, the bathers would enter a cold mountain stream or river to rinse and refresh themselves. Precisely the same improvised hexapods, covered with felt and animal skins, with a stone cauldron at the centre containing hemp seeds, are entombed in elite kurgans of the Pazyryk culture.[22]

A similar method of vapour-bath purification with exactly the same conical-shaped huts framed with three or more poles fastened at the top and covered with a large piece of dense felt existed among the ancient and medieval Turks and survived up to the ethnographic period. Vapour-baths such as this were still in use among the Kazakhs of East Kazakhstan in the mid-20th century.

According to various sources, both the Saka and the Scythians observed the custom of burying their dead at a set time of year, in early summer or autumn (figs. 4.1, 4.7). This custom is likewise recorded among the population of the Karasuk, Tagar and Pazyryk cultures.[23] Vestiges of this custom survived among the Turks of whom the Chinese chronicles state the following: "[when a person dies] in spring or summer, the deceased is buried when the leaves on the trees and plants begin to yellow and fall; in autumn or winter, the deceased is buried when the flowers start to appear".[24]

This tradition no doubt resulted from climatic conditions as well as the subsistence strategies of the early nomads. Due to the difficulties of digging a grave before the onset of spring, the corpse of a person who had died in winter was preserved using the method *amanat koyu* – after the internal organs were removed, the corpse was temporarily stored in a small cave, sealed at the entrance with a boulder. When the snow

4.7

Eleke Sazy, Group II, Kurgan 4. Humerus
with drilled holes. Possibly part of an
embalming procedure. 8th–6th
century BC

melted and the permafrost thawed, the body was buried in the winter
pasturelands, *kystau*. In summer, the nomads followed the livestock
which wandered far away from the permanent base, the winter camp,
in search of fresh, grassy pasture. Therefore, the custom of temporarily
preserving the body of the deceased, *amanat koyu* was likely practiced
in summertime too. In summer, the internal organs were removed, the
stomach filled with antiseptic herbs and the abdominal cavity sewn up.
The body was then buried temporarily high in the mountains in a small
cist grave on a rocky platform. According to researchers, the embalming
process was intended to preserve the corpse during this stage prior to
burial proper.[25] Then, in autumn, upon returning to the winter pastures
or nearby lands, a permanent burial was arranged.

According to V. Kubarev, the early nomads usually buried their dead
in spring or summer, by which time, another family member might have
passed away. These circumstances may well explain the existence of a
number of paired and collective burials.[26]

The horse burial represents the most stable component of the funeral
rites characteristic of the Altai population during the Scythian period.
The very ancient tradition of the horse burial is tied to the essential role
of the horse in the life of the nomad, and the perception that this role
continued in the other world. This belief is evidenced by the custom
practised by the ancient Turks in the Altai, whereby saddle-bags were
strapped to a packhorse, containing food and other items the deceased
might need while journeying to the other world.[27]

Horse burials are common at Arzhan, Pazyryk, Berel and other
mounds constructed by the Saka-Scythians of Central Asia. In the large
Pazyryk horse burials, there is a preference for chestnut-coloured and
purebred horses. Horse burials, sometimes in large numbers of animals,
are also recorded among the Pontic Scythians.[28]

In the kurgans of the Pazyryk culture, it was custom to line the burial
chamber of a deceased leader with the manes and tails of horses.[29] In
all known Pazyryk representations of the horse, on felt carpets and the
bone overlays on saddle horns, the horse is depicted with a clipped mane.
Some researchers believe that this attribute is simply the mark of a horse
used as a mount.[30] However, it may indicate that the Saka practised the
custom of clipping the manes and tails of horses intended for burial. It
is indeed the case that horses accompanying the deceased had clipped
manes and tails. This same custom was widely practiced among the late
Turkic peoples, and to some degree among the Kazakhs.

According to many pre-revolutionary authors,[31] as well as my elderly interviewees, after death the Kazakhs would cut off the mane and tail (*tuldau*) of the deceased's favourite mount and release the horse back into the herd until the time of the annual memorial rite.[32] During this time, the horse was ridden by no-one. From this taboo, it is possible to realise the echo of the tradition of dedicating the horse's life to the deceased. One year from the day of death, the horse is saddled and laden with the deceased's clothes which are covered with a black blanket. Standing beside the horse, the deceased's closest relatives, his wife, daughter, sons and brothers, take turns to mourn the departed (*korisu*) addressing the horse with the following words: "*Bizdi kimge tapsyryp, kaida tastap ketesin, Iene salem ait*" (For whom are you leaving us? Say hello to the master).[33] After the memorial ceremony, the horse is sacrificed. B. Karmysheva writes about a similar custom among the Uzbek-Lokai people.[34]

Again, according to many pre-revolutionary authors, as well as my informants, the animal bones slaughtered for a memorial feast, especially those of the deceased's personal mount, were never broken or thrown to the dogs.[35] Instead, they were carefully collected and either buried in the ground[36] or burned.[37]

It is interesting to note that versions of this custom are still practised among certain Kazakh groups today, especially among the eastern Kazakhs. At some point during the 1950s, the eastern Kazakhs developed the custom of hanging the head of a sacrificial horse at the corner of a grave, *tortkulak*, or atop an earthen burial mound. The custom of placing horse skulls in a burial was practised among the Scythians and Saka, too, and horse skulls were sometimes buried in the ditch around the circumference of the burial mound. Tolstaya Mogila serves as a clear example of this, where approximately fifty horse skulls were found in the ditch around the mound.[38]

Striking vestiges of the custom of sacrificing a horse to the deceased prevail among the Kazakhs and Ossetians.[39] Elements of the ancient Saka-Scythian cultures seem to have been preserved most among the Turkic-speaking peoples of Eurasia by the Kazakhs, and among the Indo-European peoples by the Ossetians, explained perhaps by historical circumstances not yet clear to us

According to Herodotus, after a year has passed since the burial of a king, funeral rites are performed again.[40] The rites Herodotus refers to were in fact memorial customs. According to ethnographer and archaeologist S. Rudenko, among the Scythian cultures, it was the son who personally arranged the memorial rites on behalf of his father.

Herodotus tells us that, deceased common people among the Scythians were transported for forty days throughout the district, and only then transferred to the burial chamber.[41] The practice of observing commemorative customs on the fortieth day and again one year after death is universal among many Turkic and Slavic peoples. In all

likelihood, this tradition has its roots in the customs of the Saka-Scythian tribes of Eurasia.

In the Saka tradition, cases have been recorded in which the nails and hair of the deceased, collected in life, were placed in the burial to accompany the interred into the other world. For example, in many Ulandryk burials, pouches placed next to the deceased contained teeth, nails and hair gathered during that person's lifetime[42]. Similar pouches containing hair and nails that belonged to the deceased are documented in large Pazyryk kurgans.[43] Rudenko reports the presence of miniature silk purses containing nail cuttings tied to the upper ends of female braids.[44] The tradition of collecting and storing lost teeth, nail cuttings and hair trimmings during a lifetime has been preserved among the Kazakhs of the early ethnographic period. For example, the Kazakhs very carefully kept the foetal hair and nails of a newborn child which are only cut on the fortieth day after birth. The hair and nails were wrapped in clean, white cloth and hidden at the bottom of a chest in the home.

Traditionally, Kazakhs have always been very careful with lost teeth, hair and nail cuttings. Hair and nail cuttings were usually wrapped in green grass or herbs and placed somewhere high up, either in the crevice of a wall or in the rafters of an outbuilding. According to the information collected from some of our most elderly informants during the 1980s, some Kazakh women still had the habit of collecting strands of hair that had fallen out over the years, and, according to the expressed wishes of these women, a large ponytail or clump of *kos* (hair) was laid beneath the women's head during burial.[45]

Cases have been noted in which nail cuttings and hair were burned in the fire each time they were cut. There are many popular explanations for this. Most are associated with black magic and the belief that harm may be brought upon a person via their hair and nails. This belief exists among many peoples of the world and has been documented by several historians and ethnographers of religion and ritual practice: J.G. Frazer, E.B. Tylor, later S.A. Tokarev and others. Several of the most elderly people I interviewed provided the same or very similar explanations for the Kazakh custom of collecting hair, nails and teeth throughout the course of a person's life. Essentially, all the explanations centre on the following notion: when a person journeys to the other world, the sins and good deeds they have committed in life are weighed before the Creator. The individual is placed on one side of a set of scales together with their good deeds, while their sins are placed on the other side of the scales. In the event that the side carrying a person's sins should weigh the most, the Creator calls for all that person's hair, teeth and nails, which have been lost in life, to be brought to the scales, where they are placed on the same side as the individual and all their good deeds to balance the scales. It was for this purpose, our interviewees explained, that the Kazakhs saved and stored strands of hair, nail cuttings and lost teeth.

Despite the archaic nature of this Kazakh tradition, it still does not
fully explain the essence of the Saka custom in which pouches containing
the deceased's hair, teeth and nails are entombed in burials of the
Pazyryk and Ulandryk cultures. What can be said is that the Kazakh
legend connects the origin of this ancient custom to beliefs surrounding
a person's potential sinfulness along with notions of heaven and hell in
the afterlife. Similar ideas may have been reflected in the worldview and
belief system of the Saka-Scythian tribes. What can be said with certainty
is that a connection exists, albeit a distant one in the context of historical
time, between the ancient Saka custom of burying the deceased along
with the hair, teeth and nails collected throughout that person's lifetime,
and the similar custom practised by the modern-day Turkic-speaking
peoples of Central Asia. The explanation for the meaning of the custom
offered by each generation of Kazakhs may differ slightly, but the practice
of the custom and its associated meaning remains unchanged.

Among the ancient Saka-Scythian tribes, women observed the
custom of cutting their hair as a sign of mourning (fig. 4.8). The women
discovered in the Pazyryk kurgans had their braids cut off and their heads
shaved.[46] Over 120 braids were recorded among the three Hun-Xiongnu
kurgans at Noin-Ula. The woman interred at Pazyryk-5 was discovered
with her own cut braid. S.A. Teploukhov has interpreted entombed cut
braids as a sign of mourning.[47] This custom, in slightly modified form,
is found among the Turkic peoples of Central Asia, in particular among
the Kazakhs. As an expression of grievous sorrow and mourning, Kazakh
women were known to scratch their faces, and tear their hair. To some
extent the Kazakh custom of dressing a *tul* (effigy representing the
deceased) during the mourning period sheds light on the more ancient
custom of cutting a widow's hair. One may suppose that the word *tul* once
had a connection with the concept of shortening or cutting. Indeed, one
of the external signs of the *tul* horse (horse belonging to the deceased)
is a clipped mane and tail.[48] To this day, Kazakhs still share the concepts
tulymshak, tulym, which refer to hair cut around the cheek. The mystery
of the braid-cutting custom recorded in antiquity would appear to lie at

4.9

Yurt framework, showing wooden lattice structure, or *kerege*. Altai region. 1870–79. Library of Congress, 2018683630

the root of these concepts. It is intriguing to note that the custom of braid cutting among widows also existed among the Ossetians,[49] whose funeral rites and memorial customs are in many respects similar to those of the Kazakhs.

Another fascinating parallel lies in the fact that, on occasion, the body of the deceased in burials at Pazyryk and Ulandryk was placed on a *kerege* (latticework frame forming the walls of a yurt; fig. 4.9), which closely resembles the Kazakh custom *olikti keregege salu* (to lay the deceased on a kerege). At Pazyryk-5, a lattice artefact was found, which M.P. Gryaznov identified as part of a yurt roof. In one of the kurgans belonging to the Ulandryk culture, V. Kubarev discovered a laittced floor cover beneath the body, closely resembling the frame of a kerege.[50] In the ethnographic present, both Altaians and Kazakhs are known to have transported the deceased to the grave on a kerege. After his death, the great Kazakh poet Abay was transported from his summer base, Shakpaktas, to his winter base, Zhidebay, having been laid on a kerege.

The lattice detail of a yurt roof, *shanyrak*, discovered at Pazyryk-5, appears to have a very close parallel in the ethnography of the present-day nomads, in this case, the Kazakhs (fig. 4.10). In the mid-1970s, during

Modern Kazakh *shanyrak*, the central apex of the roof of a yurt

an ethnographic expedition through East Kazakhstan, my team and I discovered a broken shanyrak in front of the entrance to a grave. Local elderly informants explained that according to one Kazakh custom, when every child in a family had died and the situation was thought hopeless, or in cases where all members of a family suffered a tragic death, a partially broken cradle (*besik*), cauldron (*kazan*) and shanyrak were taken to the cemetery where the family were buried, and left there forever.[51] The Scythians sometimes placed a wagon in the funeral chamber, which was always broken. One might recall that all the bronze cauldrons recorded in Zhetysu dating to the Wusun period were deformed and partially damaged in some way. The custom observed in East Kazakhstan is considered a distant vestige of the Saka custom.

The *Telengits* used to place one or two poles from the upper section of the yurt in the grave of the deceased to help the individual build a home in the other world.[52] Generally speaking, the tradition of arranging a grave in the likeness of a dwelling is characteristic of many peoples throughout the world. First, a house was built for the individual in life and then, the same kind of dwelling was built to house the dead. The external forms of domed mausoleums of the 15th to the 19th century clearly resemble that of a yurt. In this series of ethnographic parallels, the main structural components of the yurt are evident in the funeral rites of the proto-Turks – the Saka, the ancient Turks and the Turkic-speaking peoples of the ethnographic period. In this regard, one must cite the contemporary Kazakh tradition of building a grave from iron rods, frames and strips of cloth in the likeness of the architectural framework of a yurt.

At Chertomlyk, the remains of a bronze funeral stretcher were placed beneath the interred female.[53] The custom of transporting the body of the deceased to the grave on a special stretcher existed during the ethnographic period among the Kazakhs and many Turkic-speaking

peoples of Central Asia. A striking aspect of this tradition among the Kazakhs and some Uzbek groups, is that the funerary stretcher is referred to as *agash at* (wooden horse) – in the context of ritual symbolism, the funerary stretcher is the 'wooden horse' that transported the deceased on their journey to the other world.

According to Herodotus, when swearing an oath, the Libyan tribe the Nasamones, whose customs are similar to those of the Massagetae, "in matters of swearing and divination, lay their hands on the graves of the men reputed to have been the most just and good among them, and by these men they swear. Their practice of divination is to go to the tombs of their ancestors, where after making prayers they lie down to sleep, and take for oracles whatever dreams come to them."[54] We observe the same custom in the ethnography of the ancient and late Turkic peoples. Similar customs of oath-swearing are observed among the Kazakhs and other Turkic-speaking peoples. In the practice of divination and prayers of petition, the Kazakhs also sleep at the graves of their sacred clan ancestors, and a dream seen during the night is considered prophetic and, according to popular belief, will undoubtedly be fulfilled.

Saka-Scythian and Kazakh parallels are also evident in artefacts of material culture found in burials. At Ulandryk-1 Kurgan 2, archaeologists recorded a piece of dried meat and small 'flatbreads' made from coarsely ground grains of wild rye. Kubarev writes, "In shape and size, they resemble the modern Kazakh *baursaky*".[55]

The Saka had the custom of wrapping the handle of a whip with gold or bronze.[56] The 'golden man' from the Issyk mound was also equipped with this type of whip, and in traditional Kazakh life, similar whips bound with copper are common.

According to V.S. Olkhovsky, the Saka and Scythians sometimes placed oval trays for sacrificial meat in the grave to accompany the deceased.[57] Kazakh wooden oval meat trays, *astau, et astau*, are a precise analogy to the ancient artefact in shape, material, manufacturing technology and functional purpose.

Similarities are found in the elements of traditional costume. A felt stocking was found in the Saka monument at Ak-Alakha (*Ak ylak*),[58] perfectly resembling a Kazakh *baipak*. Leather boots with solid soles and a low heel, and a boot shaft that widens at the top and rises above the knee were found in Altai burials of the Bashadar, Ulandryk, Ak-Alakha, and Pazyryk cultures.[59] Saka are also depicted in precisely this kind of footwear.[60] Images of Saka dressed in boots with long shafts occur in representations of Persian reliefs and on gold plaques from the Oxus Treasure (fig. 4.11).[61] Footwear with long boot shafts were discovered in a burial at Karakol, Altai, while in a kurgan at Pazyryk, long felt stockings with decorative cuffs were recorded.[62] It is believed that stockings of this same style were worn inside the leather boots mentioned above. Usually the upper cuff of the felt stocking protruded slightly beyond the top of

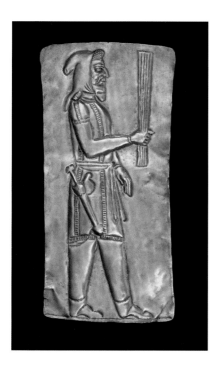

4.11

Rectangular gold plaque with embossed and chased decoration showing a male figure facing right. His tunic is decorated with bands of embroidery or applied material and he wears long boots. He has an *akinakes* by his side. An example of such a costume was found in the Issyk kurgan. 5th–4th century BC. British Museum, BM 123949

the bootleg. In terms of form, fabric and functional purpose, this type of footwear finds striking analogy in the traditional Kazakh footwear *saptama*, a boot with high leg shaft and internal stocking worn all year round. According to Saka-Scythian tradition, the caftan attributed to the Pazyryk culture was wrapped right side over left.[63] Likewise, the ancient Turks and Kazakhs wrapped outer clothing right side over left.

The majority of Saka-Scythian tribes sacralized the cardinal direction East in ritual. This practice is evidenced by features such as the construction of a dromos on the eastern side of the burial tomb.[64] The entrance to a crypt was also built on the eastern side, as were 'entrance-passageways' in deep circular pits surrounding the kurgan. The dromos is widespread among Early Saka and Saka sites of Central Asia, Kazakhstan and the Aral-Ural steppe region. The sacredness of the direction East was evident among the ancient Turkic tribes and, later, among many Turkic-speaking peoples. All rites practised in *Tengrism* were carried out with the practitioner facing eastward. Turkic 'balbals' and Kazakh stone stelae were erected on the eastern side of stone enclosures and burials. The practice of placing small stones in a line extending eastward from the mound is also considered to be an ancient Turkic custom. The ancient Turks and the Kazakhs positioned the door of the yurt so that it faced the sunrise.

On the basis of many years of study dedicated to Saka-Scythian culture, I am of the opinion that the predominant original cultural traits, norms and pivotal characteristics of the Saka culture are more proto-Turkic and Turkic than Indo-Iranian in origin. Without a doubt, with regard to issues of cultural evolutionary development, the connections that exist between the Saka people and the subsequent ancient and medieval Turkic civilizations, rather than being an occasional occurrence, are substantial enough to support systematic analysis.

In future studies on this subject, two possible trajectories are anticipated; one is that the Turkic linguistic and cultural affinities to the Saka-Scythian culture will be proven to a greater degree. The other potential trajectory, one which will no doubt emerge as a clearer reflection of historical reality, is that Saka-Scythian language and culture formed through a natural, historical process of interaction and symbiosis with both Turkic languages and cultures on the one hand, and Indo-Aryan (Indo-Iranian) languages and cultures on the other.

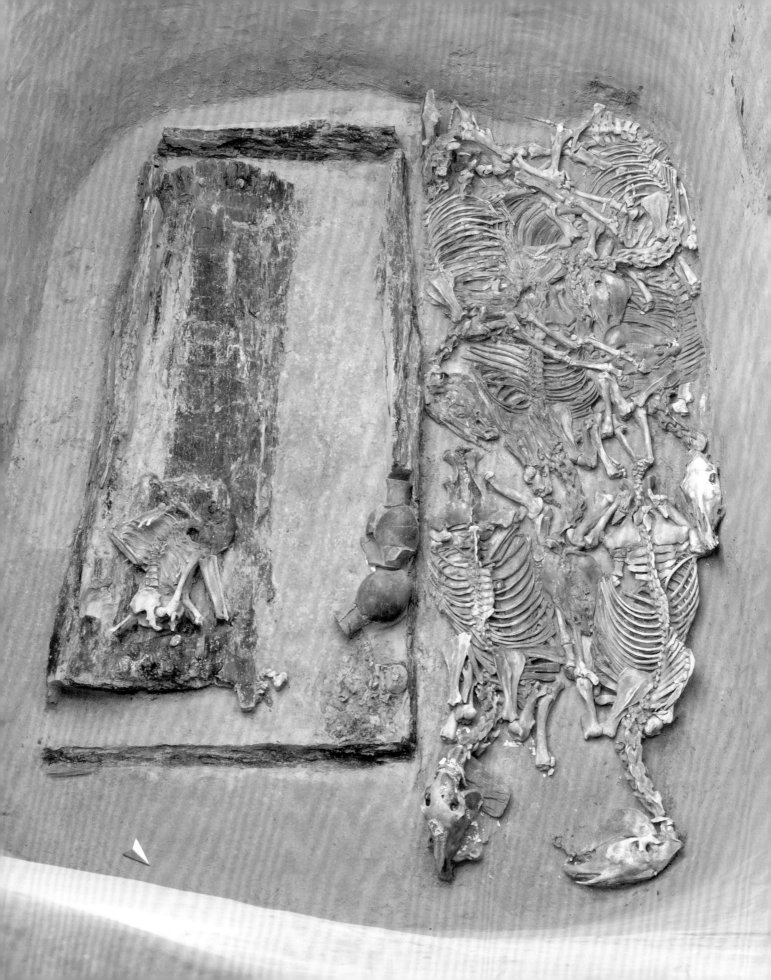

5. MY KINGDOM FOR A HORSE: SAKA-SCYTHIAN HORSE–HUMAN RELATIONS

LAERKE RECHT

EXCAVATION MATERIAL
BY ZAINOLLA SAMASHEV

Without horses, the Scythian world, of which the Saka of Kazakhstan were part, would not be the Scythian world as we know it. Humans and horses lived, worked, fought and died together in a very literal sense. Throughout the Eurasian steppe zone, the Scythians' characteristically highly mobile lifestyle was primarily predicated on horses. While pastoral nomads – as Scythians are generally defined[1] – may base their movement on sheep and goat or even cattle, horses provide a completely different level of mobility and speed, along with the possibility of companionship in military activities.

The relationship between horses and humans was as complex and multi-dimensional as that between humans themselves. Through a lifetime of co-existence and co-dependence, human and horse trained, learned and moved together.[2] They depended on each other for sustenance, with humans ensuring pasture and safety for horses, while horses provided meat and dairy for humans.

The horses of the Altai region, where the burial grounds of Berel, Eleke Sazy, Shilikti and Pazyryk are located, were medium- to large-sized ponies by today's standard. The average withers height of the horses from the Berel kurgans is 136–144 cm (this is measured at the top of the shoulders; for comparison, modern competitive horses are typically 165–170 cm at the withers). Skins and organic matter have been preserved at Berel and Pazyryk. These reveal that the coat colour was typically chestnut (red) or bay (brown/red with black mane and tail), without any white markings.[3]

5.1

Reconstruction of the burial in Berel Kurgan 10. Log-cabin burial chamber containing human burial to the north, and 'horse section' to the south. 4th–3rd century BC

5.2

Log coffin and horse section. Berel Kurgan 2.
4th–3rd century BC

Companions in death

Our knowledge about Saka-Scythian horses, as with most other things
Saka-Scythian, comes mainly from burials in the form of kurgans – large,
circular barrows. Kurgans are found throughout the Eurasian steppes,
but those containing unparalleled archaeological information are the
'frozen tombs' of eastern Kazakhstan and the Altai region, which first
rose to fame when tombs at Pazyryk were excavated in 1947–49 by Sergei
Rudenko[4]. In recent decades, further excavations in eastern Kazakhstan
have substantially added to our knowledge, as demonstrated in this
volume. This chapter will pay particular attention to the kurgans at Berel
(mostly dated to the 4th–3rd century BC), since they have some of the
richest and most complete horse remains.[5]

Kurgans vary in size, with the largest at Berel being Kurgan 11, which
is 33 m in diameter. It is generally believed that the size and complexity
of each kurgan roughly corresponds to social status, although they
all appear to belong to individuals from the higher strata of society
– in other words, all the kurgans belong to 'elite' persons. The typical
construction and elements of kurgans in the Saka period are described in
Chapter 2 of this volume.

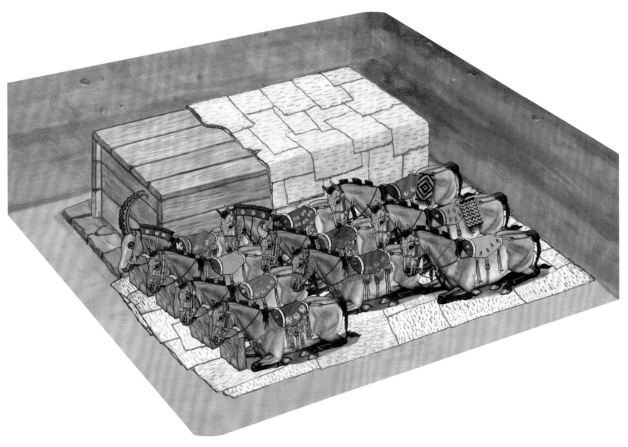

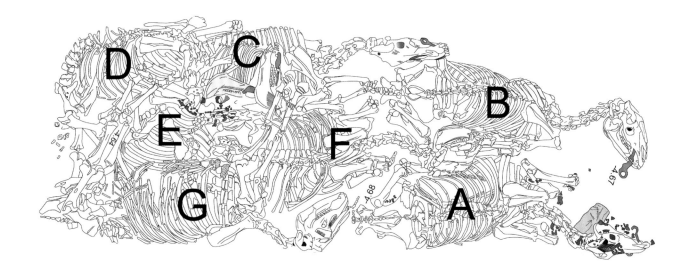

5.3

Kurgan 2 drawing showing position of horses
and associated finds. Berel Kurgan 2. 4th–3rd
century BC

What is of great interest here is the frequent co-burial of horses and
humans, perhaps the most potent testament to the importance of horses
and the honour bestowed on them. Typically, in a kurgan a 'horse section'
is found north of the log chamber containing the human remains (fig.
5.2). This section can contain from one to seventeen horses, as we know
from the examples at Berel.[6] As with their human counterparts, many of
the horses were carefully placed and outfitted for their final journey. We
know this in even more detail than for the humans, because in contrast to
the log chambers, the horse sections are usually intact and unlooted. The
permafrost further means that much more is preserved than elsewhere
in the world, making the finds of this region truly exceptional.

As an example, we can take a closer look at Kurgan 2 at Berel,
excavated by Zainolla Samashev and colleagues.[7] The main log coffin
had been disturbed by robbers, but the remains indicated that a woman
of mature age had been buried there. This is noteworthy insofar as it
demonstrates that horses could also accompany female burials. The
preserved grave goods testify to a wealthy individual, and include many
pieces of gold, a ceramic vessel and a bronze mirror. The 'horse section'
outside the log chamber, however, was undisturbed and contained
the remains of seven horses in all their finery (fig. 5.3). They were all
very carefully placed with their heads to the east, partly in layers, and
subsequently covered, perhaps by a woollen textile. They were buried in
their finest 'outfit'. Many gold bridle and tack pieces were still *in situ* on
the horses' bodies, and metal bits were found in their mouths (fig. 5.4).

From detailed skeletal analysis, we know that many of the horses
did not die of natural causes, but from a blow to the head by a round-
pointed instrument, most likely the kind of axe that is frequently found
in the material culture (fig. 5.5).[8] It is therefore clear that they were

5.4a

Horse A with remaining gold pieces of bridle and bit still in its mouth. Berel Kurgan 2. 4th–3rd century BC

5.4b

Horse A with remaining gold pieces of bridle and bit still in its mouth. Berel Kurgan 2. 4th–3rd century BC

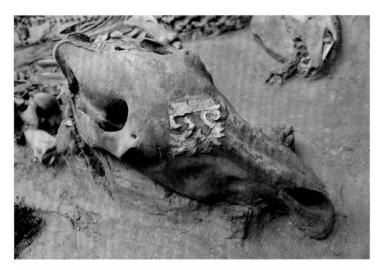

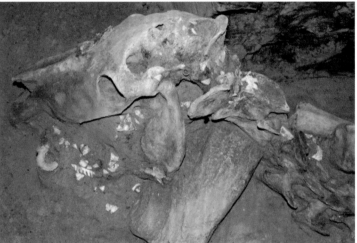

5.5

Petroglyph depicting Saka warriors, one holding an axe (*sagaris*). Kuljabasy, Chu-Ili mountains, Zhetysu. Early Iron Age. Kuljabasy archaeological complex, Zhetysu, south-east Kazakhstan

killed specifically for the purpose of being buried with a human. Horses were thus central to the identity of the deceased, to the extent that they enjoyed pride of place in the funerary ritual. The burials represent mutual, shared deaths, and a close personal relationship between the deceased and their horse(s).

(Out)Fit for a horse

The Scythian peoples of the Eurasian steppe zone were magnificent horse riders, with expert technologies and knowledge of equine gear. The functional elements of the equipment consisted of a bridle with a metal bit and two reins (figs. 5.6, 5.7), and a saddle with girth, crupper, and breast collar to keep it in place (figs 5.8, details of each element

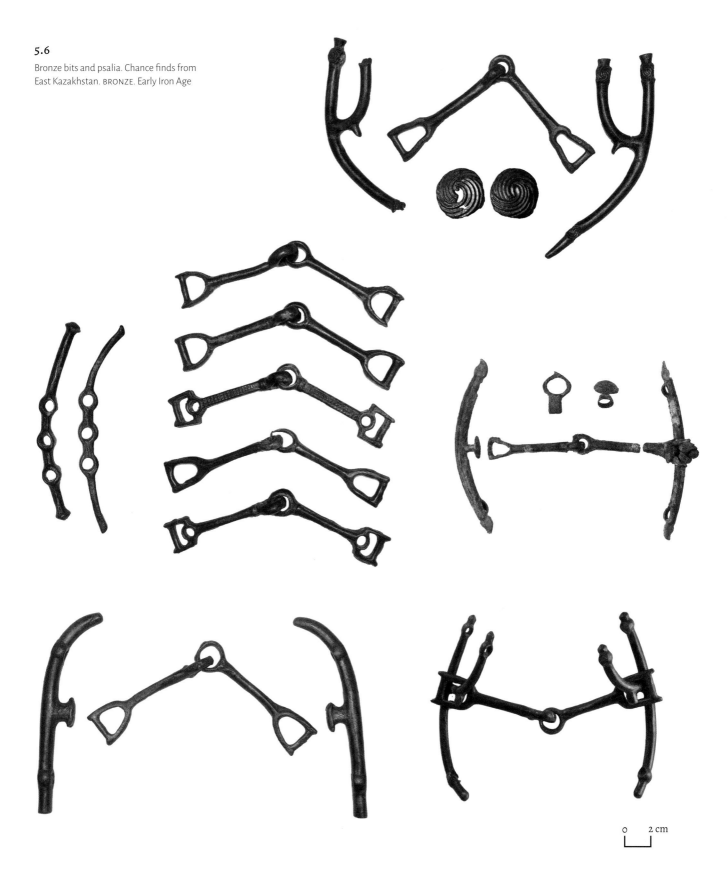

5.6

Bronze bits and psalia. Chance finds from
East Kazakhstan. BRONZE. Early Iron Age

0 2 cm

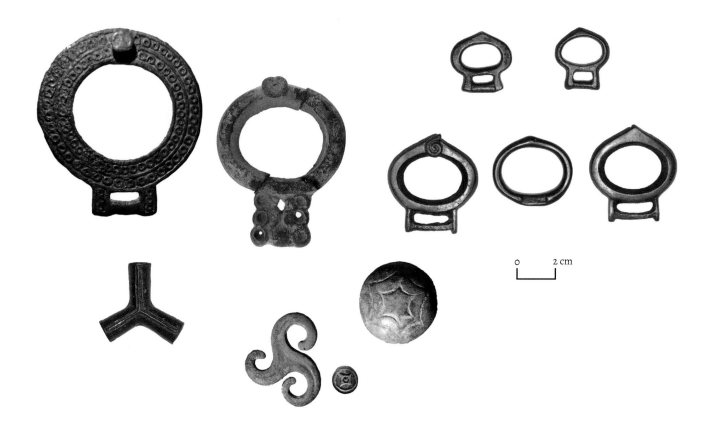

5.7

Annular buckles, strap distributor and ornaments associated with horse tack. Chance finds from East Kazakhstan. BRONZE. Early Iron Age

are given in fig. 5.9). We take these elements for granted today, but in fact they are technologically sophisticated. For example, early riders in ancient Mesopotamia used a single rope attached to a ring in the nose or lip of a donkey or horse, and did not have saddles, but sometimes tucked their knees into a broad band tied around the body of the animal, presumably to help the rider stay seated.[9] The tack elements used by Scythians were much more efficient and suitable for the extremely quick communication between horse and rider that would be necessary for their activities.

Just like the humans, horses wore their finest outfits in death (fig. 5.9). Made of leather, wood, horn/antler, textiles, iron, bronze and gold, these outfits consisted of much more than the basic functional elements mentioned above. Every part could be elaborately decorated in a variety of techniques and materials, usually in lively geometric patterns or the typical 'animal style' (figs. 5.10, 5.11). Decorative wood, horn/antler and gold figures were often added – in Berel Kurgan 2, complete bridles have unfortunately not survived, but we can still see some of the wooden and gold parts in place (fig. 5.4). None of these ornamental parts are necessary for the bridle to function as a means of communication, but they are part of the identity of the individual horse and, by extension, of the deceased.

5.8

Drawing showing reconstruction of
saddle with breast collar and crupper.
The decorative design on the saddle depicts
a deer being attacked by a tiger-griffin.
Berel Kurgan 11. 4th–3rd century BC

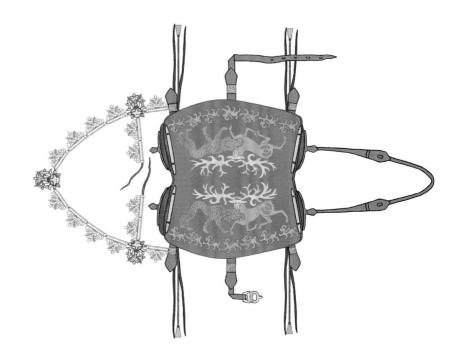

5.9

Drawing showing reconstruction of horse
in full riding tack. Berel Kurgan 36

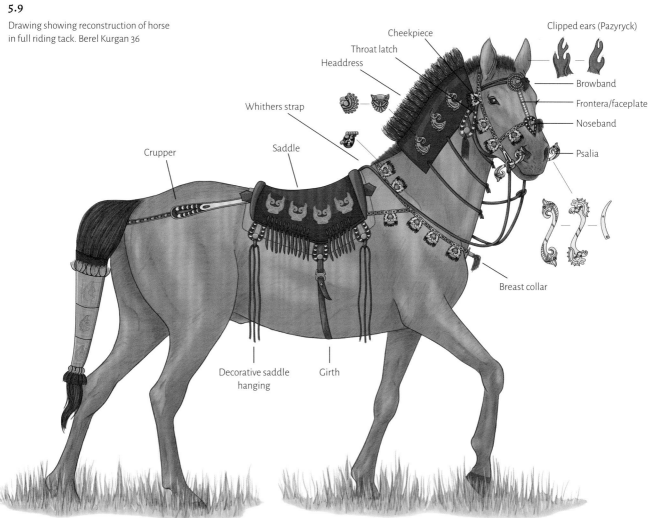

Cheekpiece

Throat latch

Headdress

Clipped ears (Pazyryck)

Browband

Frontera/faceplate

Noseband

Psalia

Whithers strap

Crupper

Saddle

Breast collar

Decorative saddle
hanging

Girth

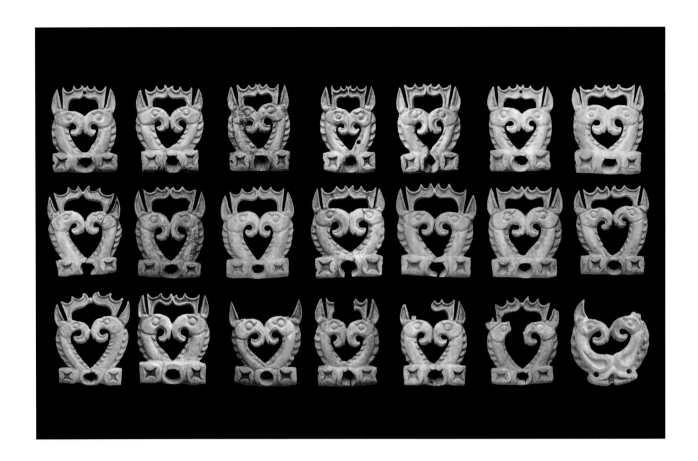

5.10

Decorative plaques from horse harness depicting elk-griffins facing one another. ANTLER (SIBERIAN RED DEER). Berel Kurgan 36. Late 4th–early 3rd century BC

Several other purely decorative and symbolic elements deserve mention, as they must have been a most impressive spectacle. Some horses were outfitted with faceplates or elaborate headdresses which would radically transform their appearance. Several such headdresses were found on horses from Berel Kurgan 2, and a set of wood and gold ibex (mountain goat) horns from such a headdress was found in Berel Kurgan 11 (fig. 5.12). When worn, the headdresses form new, hybrid, fantastical creatures. Similarly, faceplates, when seen from the front, would have been quite a sight (see fig. 5.9). From Pazyryk, where the preservation of the skin was excellent, there are also examples of the ears of the horses being clipped in a distinctive manner (fig. 5.13). It is probably no accident that one type closely resembles the forked antlers of a deer, adding another transformative element.

Extra hangings or textiles could also be added to or placed over the saddle to create a fierce and almost mythical appearance (fig. 5.14), as for example in Pazyryk Kurgan 1, where one of the horses carried a saddle cover that gives the impression of a dead lion slung over its back.[10] Finally, the mane and tail may be plaited and decorative elements added.[11]

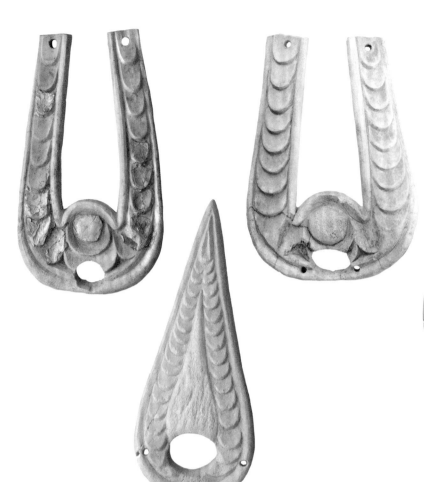

5.11

U-shaped decorative components from throat latch; decorative component of frentera in the shape of a teardrop; disc-shaped decorative component of frentera. ANTLER (SIBERIAN RED DEER). Berel Kurgan 36. Late 4th–early 3rd century BC

5.12

Horse mask detail in the form of ibex horns. WOOD AND GOLD FOIL. Berel Kurgan 11. 4th–3rd century BC

5.13

Drawing of clipped horse ears. Pazyryk,
Kurgans I & V (after Rudenko 1970: fig. 56)

All of these elements, along with each horse's physical attributes
(sex, age, height, coat colour, ears and so on) and temperament reflect
their individual identities as perceived by their human companions.

Companions in war and hunting

In mounted warfare and hunting, both horse and rider need to be highly
skilled and trained, and a bond of trust must be developed between them.
Lacking this could be extremely dangerous for both parties. There is of
course a strong physical aspect to the bond between human and horse,
with close contact and communication through physical and presumably
vocal means. The expertise of both horse and rider would be crucial
during battle, and it is no coincidence that some older horses appear to
have been highly valued and honoured. Immediate and correct responses
to the commands of the rider may mean life or death. Vice versa, the
rider must react quickly and wisely to the subtle messages of the horse,
whose particular flicker of the ear or tensing of a muscle would have
specific meaning and potentially act as warning signs. Horses as well as
humans have individual characteristics, and the more intimate the rider's
knowledge of each horse, the more efficient the communication would be.

The equipment found with the horses in the burials is ideal for use
in fast raids or hunting. The Scythians are of course known as expert
mounted warriors. Weapons are not usually found with the horses,[12]
where the emphasis is rather on their position, outfit and display. But
with the humans, we find weapons and tools, including bow and arrow,
daggers and axes, as seen in Eleke Sazy Kurgan 4. Using a bow and arrow

5.14

Hanging saddle ornament in the shape of a
fish. FELT. Berel Kurgan 11. 4th–3rd century BC

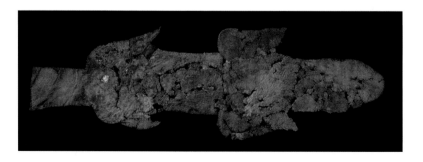

from horseback and at great speed takes a very high level of skill, balance and strength, with a horse completely in tune with the actions of the rider. Stirrups were not in use, making balance even harder, although once the skills had been learnt, this would allow for faster mounting and dismounting.

That horses shared the traumas of violent encounters with their riders is known from detailed analyses of skeletal remains.[13] Fractures were common, and there are examples of bones having healed incorrectly as a result of an injury caused by a strong impact.

Companions in peace

Horses were not just partners in war. They also provided milk, meat, dung, leather and hide, and could be used as beasts of burden and for traction. As yet, our knowledge of the everyday life of the nomadic groups of Saka-Scythians is quite limited, although with new excavations of settlements, we are beginning to form a better picture of those living a more sedentary lifestyle.[14] However, the prevalence of horses, their physical condition and selection, do allow us to make some inferences. Herds of horses would need to be monitored and maintained on a daily basis. The lifestyle required quite a large number of horses, not all of which were ridden. Clearly, the breeding of horses would have been crucial, and mares may have spent most of their time fulfilling this role, along with providing milk. Horses typically do not start their training until around the age of 2 or 3, when they are physically ready to do so. Thus, foals and yearlings could not yet be used for work, and would have to be taken care of and kept safe until ready for training. Around this age, they would likely start their education. The initial breaking in may have been turbulent, if the images on a vase from Chertomlyk are representative (fig. 5.15). If mainly used for riding, the skills may have taken years to perfect.

To keep horses in one place, they may have been tethered using an extra lead rein. Hobbles could also be used to allow a horse to continue to graze without moving too far away or too fast (fig. 5.15). Larger herds would have been moved by herding from horseback.

The horses buried in kurgans are nearly always male (at Berel, only males have been identified so far, based on the presence of canine teeth).[15] They may be stallions or geldings: the bones themselves do not tell us. However, at Pazyryk, where the skins were better preserved, all identifiable horses were in fact geldings.[16] This means two things: first, the Scythians possessed the skill and technology to perform the castration procedure, which comes with a number of risks for the horse; secondly, they were so intimately familiar with horses that they knew very well that geldings make for more trustworthy companions, both in battle and in daily life.

5.15

Scythian amphora from Chertomlyk depicting horses being broken in and the use of a hobble. SILVER, cast, embossing, chasing, engraving, gilding. 4th century BC. The Dnieper Region, near Nikopol, Chertomlyk kurgan. H: 70 cm. The State Hermitage Museum, St. Petersburg, Дн.1863-1/166

Horses led hard lives, but also frequently very long ones. Wear and tear of the bones attest to lifetimes of intense and regular work,[17] but many of the horses reached an age of 20 or even older. This is a fairly advanced age for horses, and suggests that some care was taken even of older individuals that may not have been able to perform as well as in earlier years. That this old age may have been seen as a positive asset is demonstrated by the fact that the older horses are often the ones with the fanciest, most elaborate outfits.[18]

The symbolic power of horses

As with humans, not all horses are equal. Or, more accurately, not all horses are the same. As we have seen, this is reflected in the kurgans, which are the burial grounds of higher levels of society. But just as there are differences in the status of the humans, there are marked differences in the status of the horses. These are partly but not entirely tied to human status.

Only certain horses were considered suitable for burial in a kurgan. Those interred were very carefully selected. The fact that they were nearly always male means that mares must not have been considered appropriate for this, for whatever reason. Our understanding of this is incomplete. It may indeed be because male horses had a higher social, ritual or military status, but it may also be because mares were reserved for other roles, related to breeding and providing milk. Since we do not know if the inhumed horses were stallions or geldings at Berel, it is also possible that a few stallions were reserved for breeding. In any case, Scythian artistic representations of horses rarely explicitly depict the sex of the animal, suggesting that this was not symbolically important. The horses represent a range of ages, from as young as 2 to over 20 years old – but it seems that there was an emphasis and perhaps greater honour bestowed on the older animals.[19] Other factors may have been at play when selecting the horses to be buried, including attributes like size, coat colour and temperament.

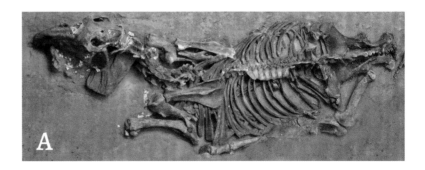

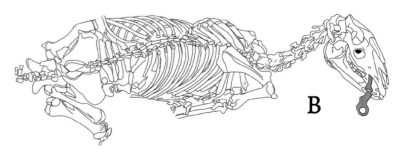

5.16

Horse A *in situ*. Drawing of Horse B. Berel Kurgan 2. 4th–3rd century BC

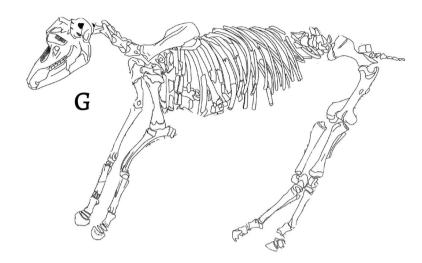

5.17

Horse G. Berel Kurgan 2. 4th–3rd century BC

5.18

Figure of an animal (horse?) 'On tiptoes'. Maykop, Russia. 3rd century BC. British Museum, BM 1923,0716.95

5.19

Horses A and B and associated finds. Berel Kurgan 2. 4th–3rd century BC

G

The way the bodies of the horses were placed is not coincidental or haphazard. They are very carefully and deliberately arranged. Placing horses in symbolically meaningful compositions in death is a practice known at least as far back as the Bronze Age in this region.[20] Returning to our example from Berel Kurgan 2, we can see that at least the front two horses were originally placed on their belly with both front and hind legs folded up under the body (fig. 5.16). The neck and head are stretched out in front, and the importance of this position, and the vertical alignment of the head, are reflected in the frequent placement of a stone below the jaw to hold it up (figs. 5.4, 5.16). A horse's body will not naturally fall into this kind of position, and it would have taken some effort to achieve it.

In fact, this position closely mirrors a well-known motif from the 'animal style' in art (see fig. 6.11). Whether art here imitated death or death imitated art is unclear, but what we can see is that this particular position was indeed symbolically meaningful. The final horse from Berel Kurgan 2 (Horse G) is in a position that at first appears more natural, on the side with all four legs stretched directly outwards, away from the body; it was placed in a layer above all the other horses (fig. 5.17). On closer inspection, the legs are particularly straight, and the tip of the hooves pointing down, as if the horse is 'tip-toeing'. This also, is reflected in the art in a typical image of an animal on its toes (fig. 5.18).

The inclusion of horses in wealthy and large tombs illustrates the pride of place assigned to these animals. However, there is an asymmetry in the relation with humans in that although they are in close physical proximity to the human deceased, they are still in the separate 'horse section' outside the log coffin or chamber itself. We thus have a situation where the horses are as close to the human(s) as possible without quite being included in the same space, and at the same level. We have seen this arrangement for Berel Kurgan 2, and it is commonly found in many other kurgans.

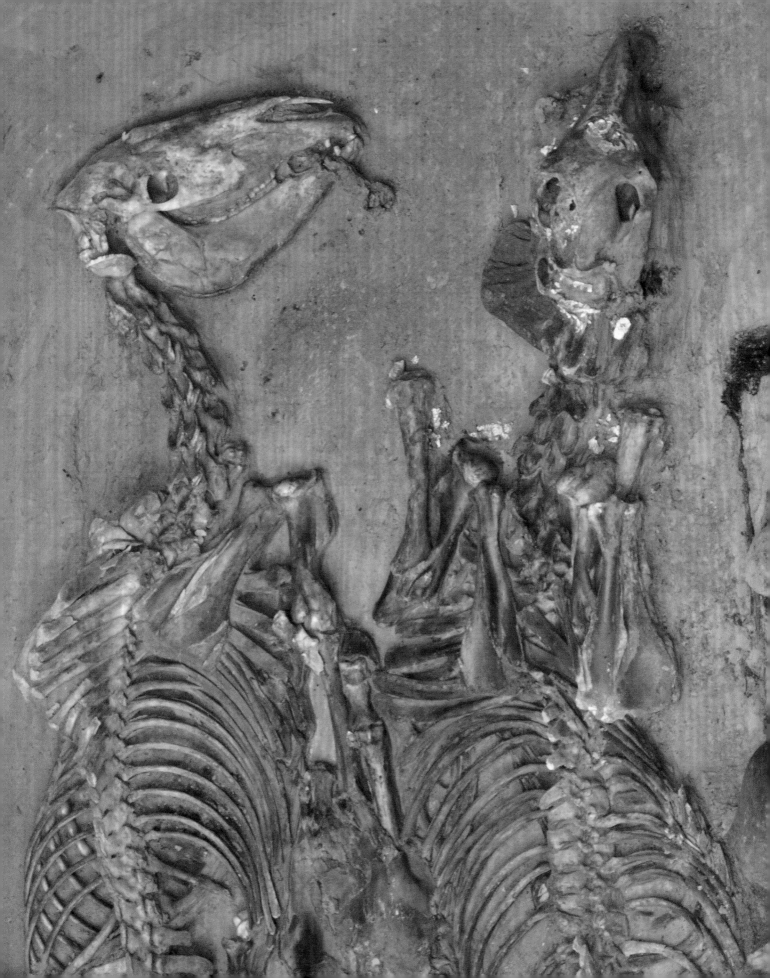

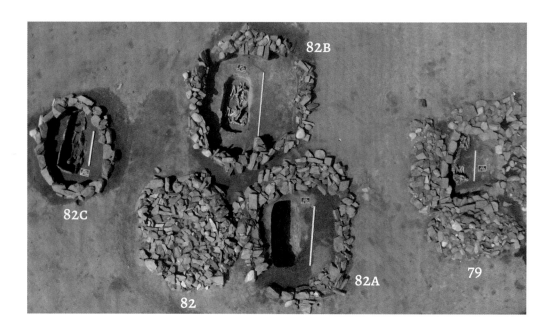

Berel Kurgan 82, with surrounding
kurgans 82A–C. 2nd–5th century AD

The central role of the horse extended much beyond the Scythian
period, and the landscape had a strong hold on human memory and
imagination. Horses continued to be buried in kurgans at Berel at least
into the first millennium AD.[21] They also illustrate that the relationship
between human and horse is not always simple or clearly hierarchical.
For example, Berel Kurgans 82 and 82A–C form a cluster or complex of
small barrows (interpreted by Z. Samashev as dating to the 2nd–5th
century AD; fig. 5.20).[22] No. 82 was empty – possibly a cenotaph or ritual
structure; 82A and 82C each contained the remains of an adult person,
and 82B contained a single horse skeleton with a bit in its mouth. The
barrows are of almost equal size, and there is little differentiation in
terms of grave goods in each. There is a much greater symmetry here
between human and equine individuals, and the horse received its own
separate structure for burial.[23] The horse was placed once again with its
legs folded up under the body, but on its side and with its head forcefully
turned backwards (fig. 5.21) – yet another image familiar from the earlier
'animal style' art.

5.21

Berel Kurgan 82B. Burial containing a horse.
2nd–5th century AD

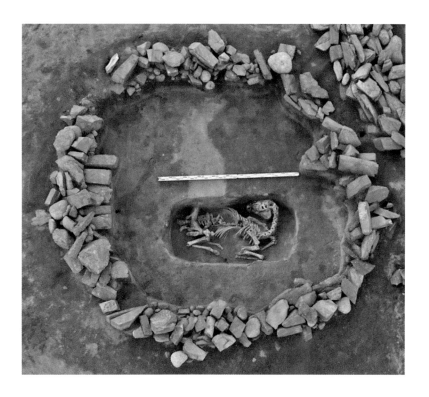

Conclusion

Close parallels can be noted between horses and humans in burials. They are both dressed in fine outfits that are tantamount to costumes. These outfits mark individual and social identities of both horses and humans. Further, masks, wigs and headdresses are worn, and the body carefully placed, sometimes with the aid of a stone or headrest to keep the head where intended. Both horses and humans were killed by blows to the head,[24] with axes wielded by humans, although likely as part of very different events – humans as part of battle, horses as part of sacrifices. The kurgans are an incredibly rich source of information about the ancient Saka-Scythians. In particular, they provide an unprecedented view into the many aspects of human–horse relations, and associated knowledge and technology. The impact of horses on the Saka-Scythian lifestyle can hardly be overstated.

0.5 mm

6. GOLDWORKING OF THE GREAT STEPPE: TECHNICAL ANALYSIS OF GOLD ARTEFACTS FROM ELEKE SAZY

SALTANAT AMIR AND
MARCOS MARTINÓN-TORRES

The frequency and cultural importance of gold artefacts among Bronze and Iron Age societies in the Great Steppe, the vast territory of modern Kazakhstan and western Siberia, is unsurprising considering the relative abundance of metalliferous resources in general, and of gold in particular, across the region. Gold deposits are common across Kazakhstan (fig. 6.2), with as much as 40% of the deposits concentrated in the most gold-rich region, East Kazakhstan.[1] The earliest gold artefacts found in the region date to the beginning of the second millennium BC and are associated with the Bronze Age Fedorovo culture, part of the broader Andronovo horizon.[2]

Most East Kazakhstan gold-bearing deposits are confined to the Altai mountains, specifically at the Kalba and Naryn ridges and Kandy Altai (Rudnyi Altai) (fig. 6.3). Geologically they can be roughly divided into two types – primary and secondary (*placer*) gold deposits. Primary gold deposits – those under the surface and requiring mining and smelting – include the auriferous quartz veins in the Kalba and Naryn ridges as well as polymetallic ores in the Kandy Altai (fig. 6.2).[3] Their chemical composition varies substantially from deposit to deposit, with those differences potentially providing diagnostic markers for the sourcing of archaeological artefacts to particular geological regions through chemical analyses.[4]

There is both direct and indirect archaeological evidence for ancient gold mining at the polymetallic deposits in the region (fig. 6.3). For example, in the late 18th century Russian Imperial mining officer Hans Michael Renovantz[5] reported finding the remains of a prehistoric miner with mining tools and a leather bag "full of gold and silver rich oxide

6.1

Shoe decoration gold beads. Notice the folding technique. GOLD. КПО93-38630/1-1781. Eleke Sazy, Group II, Kurgan 4. 8th–6th century BC

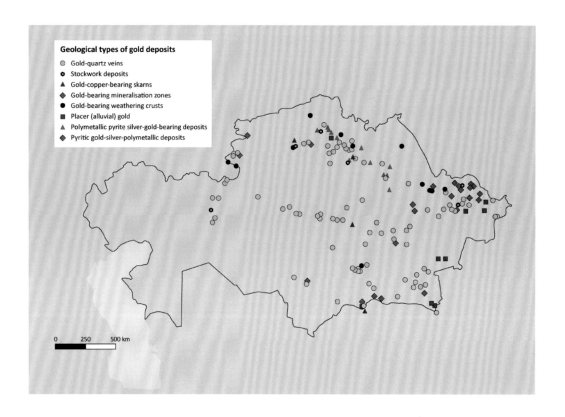

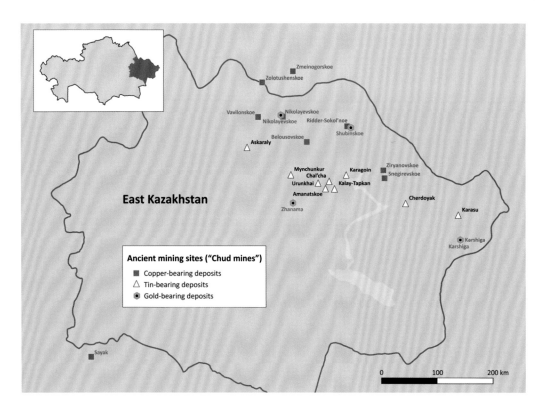

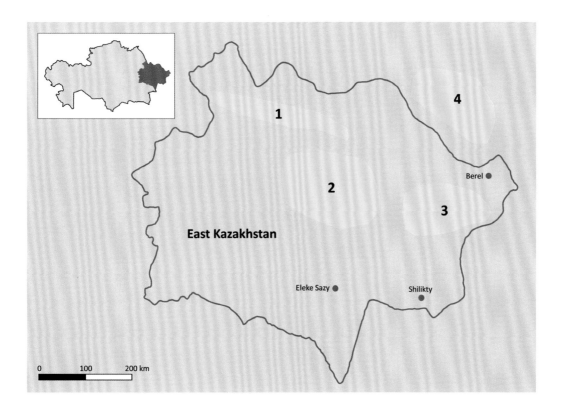

East Kazakhstan

Berel ●

Eleke Sazy ●

Shilikty ●

0 100 200 km

6.2

Map of gold deposits on the territory of Kazakhstan (after Bespayev et al., 1997, p. 10)

6.3

Map of geological resources of the Altai mountains (East Kazakhstan) (after Vaulin, 2016, p. 12)

6.4

East Kazakhstan placer gold zones: (1) Semey-Irtysh (2) West Kalba (3) South Altai (Kazakhstani Altai) and (4) Sinjukhinskoye, Soloneshskoye, Kumirskje and others (Russian Altai) (after Bespayev et al., 1999, p. 131)

ores" inside an ancient mine at the polymetallic field of Zmeinogorsk.[6] Further archaeological evidence of gold mining, such as bronze and stone mining tools, tailings from *beneficiation* activities and miners' settlements have been found in the Altai mountains.[7]

The presence of mountains with their extensive water systems favoured the weathering of primary deposits and the formation of secondary, alluvial gold, where gold nuggets can be collected without mining or smelting. There are three main placer gold fields in East Kazakhstan, corresponding to the location of the primary gold deposits – Semey-Irtysh, West Kalba and the South Altai areas (fig. 6.4).[8] Additional gold placer fields are found in the Russian Altai.[9]

It is worth mentioning that, besides gold, the Altai mountains have been a pivotal location for the exploitation of other metals as far back as the Bronze Age. In particular, tin mining, smelting and bronze production in this region contributed substantially to the spread of tin bronze metallurgy across the entirety of Central Asia, as well as of west and east Siberia (fig. 6.3).[10]

Gold in Early Saka and Saka-Scythian kurgans

Modern remote sensing and survey technologies have allowed the identification of thousands of prehistoric kurgans across the Eurasian steppe zone. Unfortunately, many mounds have been looted throughout their history up until the present day, including many Early Saka and Saka-Scythian kurgans in Kazakhstan and Siberia. However, even in looted kurgans a small number of undisturbed burials have been excavated by archaeologists, such as the Saka-Scythian Issyk kurgan (c. 400–300 BC) in south-east Kazakhstan, and the Early Saka-Scythian Arzhan-2 kurgan in western Siberia (Tuva).[11] One of the most remarkable features of these kurgans is the presence of numerous gold objects. For example, over 20 kg of gold were recovered in Arzhan-2, with over 5000 gold objects, not counting hundreds of thousands of microscopic gold beads. This evidence illustrates the material and symbolic importance of gold among the prehistoric social groups of the Eurasian steppe.[12]

Despite the extensive looting, recent archaeological discoveries and excavations have recovered human remains, structures, gold and other artefacts in undisturbed contexts. The Eleke Sazy Iron Age kurgan complex provides an excellent example of the materials and information we can obtain using modern archaeological and scientific methods. The recovery of relatively complete gold assemblages *in situ* allows us to better understand the particular contexts and uses of specific artefacts, as well as providing insight into their production methods and life-histories. For example, we can examine whether one or more geological sources of gold are represented in a single kurgan, investigate the mass production of a series of identical objects, or identify different technical traditions or skills by reverse-engineering individual items made of gold or other materials; we can also investigate whether the objects were specifically made for the burial or whether, instead, they were used previously before they were deposited with the dead.

We have recently initiated a research project that addresses the above questions through a science-based investigation of the materials excavated at the Eleke Sazy complex, which includes several burials with rich goldwork assemblages. This chapter presents the initial results of our study of the goldwork from two kurgans in Group II of the Eleke Sazy cemetery, Kurgan 4, with a special focus on the artefacts associated with the male burial, and Kurgan 7. The individual in Kurgan 4 was found undisturbed with all objects *in situ*, allowing a more solid basis for reconstructive interpretations, whereas Kurgan 7 had been looted. The presence of gold objects fashioned using different goldsmithing techniques allows a glimpse into the technical repertoire of the artisans. From these initial investigations, we plan to expand our comparative study of goldwork at other kurgans at Eleke Sazy and beyond.

Kurgan 4 is a double inhumation burial of a young man and woman. Although the female burial had been looted, the male burial was practically

intact, and includes a large number of gold objects decorating the body and associated weaponry, described in Chapter 3 of this volume (fig. 3.16a). The burial is a unique example of the very few undisturbed Saka-Scythian inhumations excavated in modern times, and thus allows us to reconstruct the clothing, weaponry and other attributes of an Early Saka male. In addition to the burial, a hoard was found under a crepidoma stone of the kurgan, consisting of different gold plaques, gold beads and microbeads, gold spirals, a gold pendant, stone beads, and a bronze mirror (fig. 3.9).

Kurgan 7 is an inhumation burial located near Kurgan 4. It was looted in antiquity; however six gold deer plaques, six gold ribbed tubes, eight bronze socketed arrowheads and a few gold clothing decoration plaques were discovered in the burial chamber and dromos of the kurgan (figs. 6.10, 6.21). The six gold ribbed tubes were found in close proximity to the arrowheads. Both the arrowheads and gold tubes had remnants of wood adhering to their inner surfaces, and it is therefore likely that the tubes were overlays on the wooden arrow shafts.[13]

We employed two portable, non-invasive analytical techniques. A digital microscope Dino-Lite Edge 3.0 was used to examine the artefacts under high magnification, in order to identify technological features and/or marks of use. We also carried out chemical analyses by portable X-ray fluorescence (XRF) using an Olympus Vanta VMR handheld analyser. All the elemental results reported here are averages of three measurements carried out directly on the artefact surfaces, with analytical spots of ~3 mm diameter.

Gold working techniques

There are a few peculiarities of the Eleke Sazy Kurgan 4 gold objects, compared to those from other Early Saka-Scythian kurgans. First, very few garment adornment plaques were found among the burial gold objects. There are only a few exceptions, among them two small feline plaques, two headdress decoration plaques and six deer plaques that could be either part of the gorytos decoration or garment adornments. As such, the assemblage differs substantially from those in other kurgans, such as Arzhan-2, Issyk, Baigetobe and Shilikti 5 where numerous gold outfit adornments as well as belt plaques were excavated.[14]

Secondly, most of the Eleke Sazy gold objects were manufactured using pressed sheet techniques, rather than casting. Similar contemporaneous artefacts from Arzhan-2 were shaped using a variety of techniques including casting, sheet work, and pressed sheet techniques, and the majority of artefacts from Baigetobe were cast.[15] The predominance of mechanical shaping techniques is not exclusive to Eleke Sazy, but it does provide some pointers for future comparative researches of technological traditions across the Steppe.

6.5a

Great torc. GOLD. КПО93-38626. Eleke Sazy, Group II, Kurgan 4. 8th–6th century BC

6.5b,c

(b) Spiral surface of the torc; (c) part of the terminal of the torc (internal surface)

6.5d,e

(d) Torsion and stress lines on the surface of the torc due to the intensive deformation of the metal; (e) indentations on the surface of the torc that could be signs of wear and tear or manufacturing defects

THE GREAT TORC

The torc from Kurgan 4 with a weight of 335.5 g, found around the neck of the deceased, is by far the largest gold artefact in the Eleke Sazy gold assemblage (fig. 6.5a). This object was hammered out of a single metal rod. The central part was extensively twisted, resulting in its spiral form, while the terminals were left in their original, rectangular shape (figs. 6.5b,c). Torsion and stress lines are visible on the surface of the torc, some developing into cracks, clearly caused by the intense deformation of the metal (fig. 6.5d). It is unclear whether the torc was worn during the lifetime of the individual. However, the presence of smoothed edges might indicate that it was (fig. 6.5e). Additionally, there are small indentations on the surface, which could be the result of slight damage caused during manufacture, use, deposition or recovery. According to Chugunov and colleagues, the Arzhan-2 torc has worn edges, and their presence was interpreted by the authors as signs of the torc's long-term usage.[16]

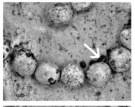
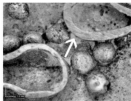
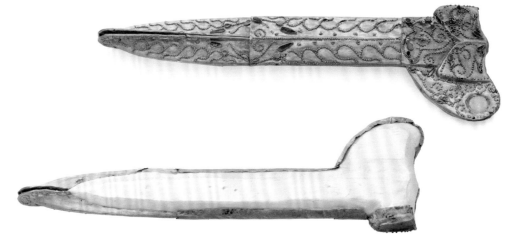

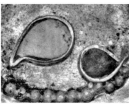

6.6a,b

Sheath (a) general view; (b) reverse side of the sheath gold overlay. The modern plastic is a substitute of the original wooden pad. GOLD, TURQUOISE, LAPIS LAZULI. КПО93-38628. Eleke Sazy, Group II, Kurgan 4. 8th–6th century BC

6.6c,d

Black (c) and white (d) substances between the granules, possible remnants of the material used for a high-temperature join.

6.6e,f

(e) Polishing marks on the surface of the inlay; (f) Turquoise (light green) and lapis lazuli (dark blue) inlays. Polishing marks are visible on the turquoise surface.

THE SHEATH

The next largest gold object of the collection by weight is a sheath covered by gold, which consists of four separate parts (total gold weight 66.8 g) (fig. 6.6a). Each part was made of gold sheet and decorated using granulation and inlaying. The gold was wrapped around a wooden base, partly preserved *in situ* (fig. 6.6b). The granulation generally takes the form of curved lines or small clusters of three granules. Granule diameter varies but is typically around 1 mm, which makes these granules relatively large compared to those from granulated goldwork of other cultures.[17] They also vary in the degree of sphericity as well as the extent to which the metal 'necks' in the joints are visible (figs. 6.6c–f). It is interesting to note that the quality of the granulation technique is particularly poorly executed in the upper right part. Here, the spacings between granules are inconsistent, and some are partially fused. It is conceivable that this part of the sheath was decorated by a less skilled artisan, or alternatively, excess heating was accidentally applied to this particular area during manufacture. The relative irregularity in shapes and sizes of the granules suggests that the granules could have been formed by 'freezing' molten metal upon contact with water.[18] Remnants of both black and whitish substances at the interface between some granules and the substrate are suggestive of the use of copper salts to bond the granules directly to the surface, rather than soldering with an additional metal (fig. 6.6c,d).[19] However, these hypotheses can only be verified with additional microanalyses.

The cells for inlaying are made of thin gold strips (0.2–0.4 mm thickness), joined to the sheath surface using high temperature and superficially polished, as inferred from the subparallel marks on their surfaces (fig. 6.6e,f). Some of the surviving inlays are identified as turquoise and lapis lazuli stones, which were cut and polished before

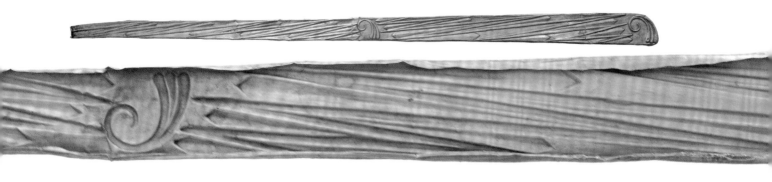

6.7a,b

(a) Gorytos decoration long plaque; (b) detail of reverse side showing the wrapped edges. GOLD. КПО93 38632. Eleke Sazy, Group II, Kurgan 4. 8th–6th century BC

6.7c,d

(c) Gold decoration of the gorytos from the Arzhan-2 kurgan; (d) the wooden part of the gorytos which was used as a model for embossing. 7th century (Chugunov et al., 2017, p. 381). Aldan-Maadyr National Museum of the Republic of Tuva. НМРТ КП 11195/571/1, 1195/572 (ТК РФ 11528648)

inlaying.[20] Often, it is possible to see remnants of white stains on the edges of the inlaid cells; this may constitute remains of a backing paste or glue, possibly an organic material, employed to facilitate the setting of the inlays. The identification of this material should be a focus of future analysis.

GORYTOS ADORNMENTS

The gorytos or bow-case of the male individual, although made of leather, included three types of gold decorations: a long plaque, a pear-shaped end decoration plaque, and deer plaques (three found in close proximity to the gorytos, and five others associated with the burial) (figs. 3.16, 6.7a).

The long plaque is made of a thin gold sheet that was most probably embossed using a wooden model likely left inside after shaping (fig. 6.7b). The wooden part of the gorytos has not survived, but the gorytos decoration from the Arzhan-2 kurgan gives us a hint about its production technology (figs. 6.7c,d):[21] here, the decoration patterns are clearly visible on the wooden part , which was used as a substrate or matrix for embossing an identical pattern on the golden decorative sheet

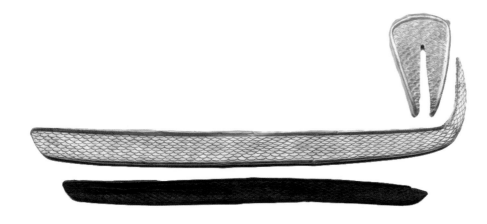

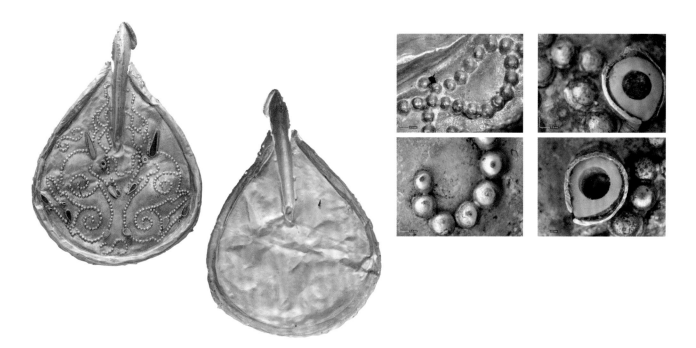

6.8a,b

(a) Gorytos end plaque; (b) reverse side. Perforations from nailing or sewing are visible on the side edges. GOLD, TURQUOISE, LAPIS LAZULI. КПО93-38629. Eleke Sazy, Group II, Kurgan 4. 8th–6th century BC

6.8c,d

(c) Granulation of the gorytos end plaque; (d) partially fused granulation at the edge of the gorytos end plaque

6.8e,f

(e) Deer's 'eye' with lapis lazuli as the pupil. Possible remnants of the glue are indicated; (f) the drilled hole with the lapis lazuli inlay missing

and afterwards was left inside the plaque. The stylistic and technological similarities between the Arzhan-2 and Kurgan 4 gorytos decorations are quite obvious.

The pear-shaped plaque (13.5 g), placed at the bottom of the gorytos, was crafted from a gold sheet 0.05–0.08 mm thick (figs. 6.8a,b). Like the longer plaque, it was likely shaped around a thicker die; this plaque probably covered an inside pad of leather, to which it was attached. Perforations from nailing or sewing are visible on the edges of the gold object (fig. 6.8b). Like the sheath, this object was decorated using granulation and stone inlays (figs. 6.8c,d). One remarkable feature of the plaque is the combination of different inlaying materials for highlighting the deer's eyes: the eyeball, made of turquoise, was drilled to leave a 1.4 mm diameter hole where a lapis lazuli pupil was set (fig. 6.8e,f). Remnants of the possible glue are still visible in the small gaps between the stones, as well as in the hole left where one of these pupils was lost.

DEER PLAQUES

The deer plaques from Kurgan 4 and Kurgan 7 are made of sheet gold; eight plaques from Kurgan 4 and six from Kurgan 7 were excavated in total (figs. 6.9a–c, 6.10). Of these, the six plaques from Kurgan 7 and the single stag from Kurgan 4 were analysed here. They are shining examples of the pan-Scythian 'animal style', defined by Rudenko as a style where "depiction of animals or their parts are reproduced in a preselected form that corresponds with the functionality of an object".[22] These kinds of

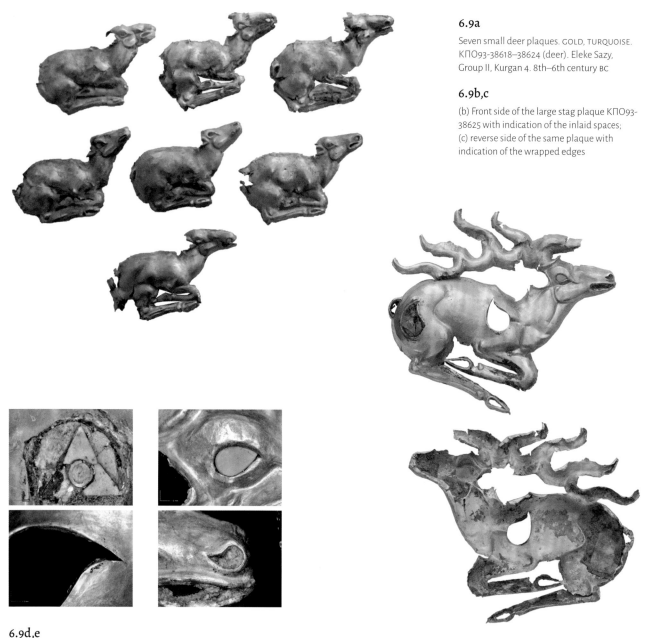

6.9a

Seven small deer plaques. GOLD, TURQUOISE. КПО93-38618–38624 (deer). Eleke Sazy, Group II, Kurgan 4. 8th–6th century BC

6.9b,c

(b) Front side of the large stag plaque КПО93-38625 with indication of the inlaid spaces; (c) reverse side of the same plaque with indication of the wrapped edges

6.9d,e

(d) Stag plaque inlays of the hip joint; (e) the shoulder joint notch

6.9f,g

(f) Eye inlaid by turquoise and empty space (or cell) on the back of the head; (g) horn or bone inlay of the nostril and corroded material in the mouth.

plaques in the Eurasian steppe region were formed using a stone, wood or metal die on top of which a gold sheet was placed before embossing, stamping or chasing the plaques.[23]

The deer plaques were most probably embossed with wooden dies left inside, although they have not survived; this is suggested by the curved plaque edges which would have wrapped around the back of the wooden die. Most interesting among these plaques is the large stag (13.4 g) from Kurgan 4, with branching horns and three large decorative notches:

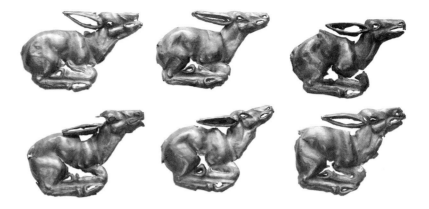

6.10

Six deer plaques. GOLD, TURQUOISE.
КПО92-37974–37979. Eleke Sazy
Kurgan 7. 8th–6th century BC

two of them on the hip and shoulder joints and one at the back of the head (figs. 6.9b,c). At the hip joint notch is a complex, preserved inlay of turquoise and lapis lazuli, with a central core probably made of horn and enclosed in a strip of gold sheet (fig. 6.9d). The hollow cell at the shoulder joint is empty, but it possibly included an inlay that was lost (fig. 6.9e). The notch on the back of the head was either inlaid by a stone or most probably left open, as no remnants of glue are visible (fig. 6.9f). Other inlay cells include an eye hole, mouth, hooves, tail and nostril of the deer, but only two of them survived: a turquoise eye, and the inlay material of the nostril possibly of horn or bone (figs. 6.9f,g). The other notches contain corroded material that should be investigated to see if it is a backing paste or glue, or perhaps enamel.

The presence of glass enamelling is plausible, even if not yet confirmed without additional analyses. Glass enamels have been found at Early Saka-Scythian burials, for example, in Shilikti 5[24] and Arzhan-2 (fig. 6.11).[25] However, not much is known about glass production in the Steppe region, and future work should target chemical composition and production techniques.

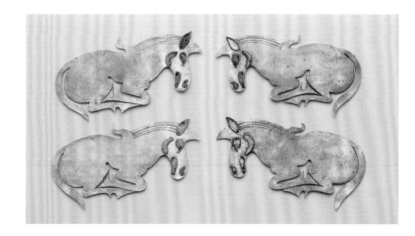

6.11

Head dress adornment plaques decorated with white enamel, from Arzhan-2 kurgan. 7th century BC (Chugunov et al., 2017, p. 371). Aldan-Maadyr National Museum of the Republic of Tuva. НМРТ КП 11195/525-528 (ТК РФ 11267044, 11267038, 11267001, 11266999)

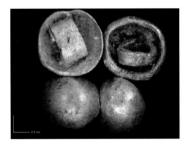

6.12

Some of the thousands of 'button' beads from Baigetobe kurgan, Shilikti. c. 730-690 BC

6.13

Gold beads *in situ*. They decorated the shoes of a deceased male

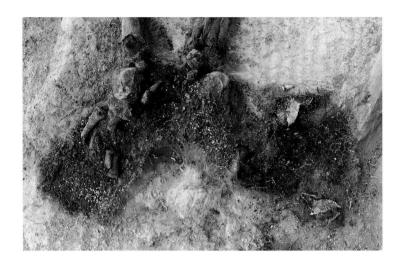

Microscopic gold beads (*monshak*)

Archaeological evidence indicates that microscopic gold beads were an important component of funerary garment decoration during the Saka-Scythian period.[26] However, remarkably little attention has hitherto been devoted to these astonishing examples of goldsmithing craftsmanship, and little is known about their manufacturing technologies. Meanwhile, comparing the total number of gold beads with other gold artefacts from the undisturbed Saka-Scythian kurgans, there is an overwhelming prevalence of gold beads. For example, in the main burial at Arzhan-2 more than 250,000 microscopic gold beads decorated the trousers and shoes of the male and the female's skirt and shoes. Another important point is the variety of their types and manufacturing technologies they display, and the astonishingly small size of 1–2 mm. In Arzhan-2 three different types of these beads were recovered, and classified as annular, tubular elongated, and tubular short-cut.[27] In the Baigetobe kurgan (Shilikti) at least three different types of gold beads were found: cylindrical 'buttons' and 'pendants' (fig. 6.12).[28]

The assemblage from Kurgan 4 includes two sets of tiny beads which are most remarkable in their abundance and, most particularly, their extremely small size.

The first group comprises a set of 1,781 beads (total weight of about 21 g) that decorated the shoes of the deceased person (fig. 6.13). Barely 1.6–2.2 mm across and with an average weight of 11.6 mg (0.0116 g), these were made of gold sheet 0.07–0.12 mm thin (figs. 6.14a,b). Their peculiar cross-section suggests that the gold beads were manufactured at one time following the same method: a gold sheet was cut into long strips 5–7 mm wide, and folded longitudinally twice; the resulting 'roll' was then cut transversely to create the individual beads. Very small circular indentations near the cut edge of many of the beads are probably

6.14a,b

(a) Shoe decoration gold beads. Notice the folding technique; (b) impressions on the beads suggesting the use of a needle to help the folding or cutting. GOLD. КПО93-38630/1-1781. Eleke Sazy, Group II, Kurgan 4. 8th–6th century BC

6.15a,b

Detail of some of the cylindrical 'barrel-shaped' gold beads. КПО93-38631/1-10358, Eleke Sazy, Group II, Kurgan 4, hoard

impressions left by a needle that was used to aid folding the strip, or perhaps to hold it in place while cutting (figs. 6.24a,b).

The second group (10,358 pieces with a total weight about 37 g) is made of even smaller beads, and reconstructing how they were manufactured is more challenging. The exact purpose of these beads is not clear as they were part of the hoard rather than being associated with an individual, though they were probably used to decorate shoes or other garment (see Chapter 3). These cylindrical beads weigh on average as little as 3.6 mg (0.0036 g); their walls are 0.05–0.06 mm thin, their diameter is around 1.0 mm and average length is 0.5–1.0 mm (figs. 6.15a,b). The beads bear no discernible seams or joints, which, together with the textured appearance of their surfaces, is consistent with high-temperature, individual manufacture. Many of them show a layer of metal smear on the inside, and one of their ends is more rounded than the other. The specific manufacture method for these beads remains enigmatic, and it will require additional microanalyses under higher magnification.

Chemical analyses

Gold is never naturally pure. The main geological impurity in gold is silver, with concentrations in gold that typically range between 1 and 30%, followed by copper in much lower amounts, generally less than 1%. Other elements may be detected too, but more rarely and in much lower concentrations. Given that the natural composition of gold shows some variability between geological deposits, the elemental analysis of archaeological gold materials can in principle help us discern artefacts that originally came from different deposits, or at least from different batches of metal. Yet, at the same time, prehistoric humans have artificially modified the composition of gold by alloying it with other metals, frequently including silver and/or copper, in order to adjust the colour, hardness or other properties of the resulting objects. Geological signatures as to original deposits can overlap with one another, and such results may be further distorted through re-melting or mixed recycling of scrap, which pose additional difficulties when attempting to match artefacts to specific geological deposits. Notwithstanding these challenges, the elemental analysis of archaeological goldwork is a very useful starting point for investigating possible sources of metals, alloying and recycling practices, and other aspects of past technologies. Even when it is difficult to separate natural from cultural effects on the metal chemical composition, when there are sufficiently large sample sizes of archaeological objects, we can make inferences about spatial and temporal changes, the preference for specific alloys, the existence of standardized compositions or other factors. Such inferences may inform us about metallurgical craftsmanship, especially technical knowledge, raw material availability, and cultural preferences

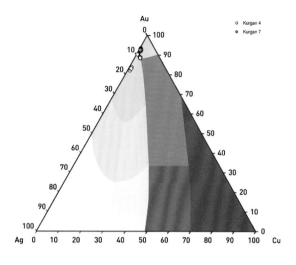

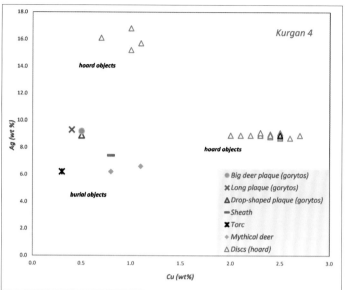

6.16

Ternary colour diagram showing the composition of the goldwork from Kurgan 4 and Kurgan 7. Note the clustering of the artefacts in the gold-rich corner of the triangle, corresponding to lemon yellow colours

6.17

Scatterplot of the average copper and silver levels of the gold artefacts from Kurgan 4. Note the presence of three distinct compositional clusters, one corresponding to burial objects and the other two to the collection of discs from the hoard

KURGAN 4

The elemental compositions of the analysed artefacts from Kurgan 4 and Kurgan 7 fall in a relatively narrow range, with silver levels spanning between 6 and 17%, and copper values only rarely exceeding 2.5%. These compositions correspond to the lemon yellow colours that are typical of high purity gold, as opposed to the warmer shades of goldwork that is copper-rich, or the paler colour of silver-rich gold (fig. 6.16).

There is, however, some variability behind this apparent uniformity, and upon closer examination it is possible to distinguish three compositional clusters that correspond, respectively, to the artefacts associated with the burial and to two subsets of artefacts from the hoard (fig. 6.17).

The composition of the objects found in direct proximity to the deceased person (burial objects) shows the highest purity levels of gold, with correspondingly low silver and copper levels (with averages of 7% and 0.6%, respectively). The decorative elements of the gorytos form a tight chemical cluster, most probably indicating that they were all manufactured simultaneously from a single batch of gold. The torc stands out as the artefact with the highest gold content among all objects, together with the lowest copper content.

Of the hoard objects, only a series of identical gold discs was analysed, each with four hoops on the back, but interestingly these form two distinct clusters that do not overlap with the burial group (figs. 6.17, 6.19). One shows similar average silver to that of the burial cluster but slightly higher copper levels, always exceeding 2%; the other one stands out in its much higher silver concentrations, averaging around 16%.

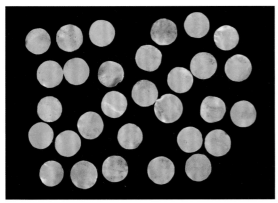

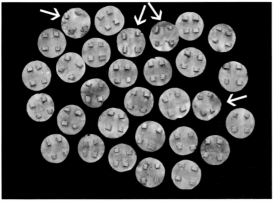

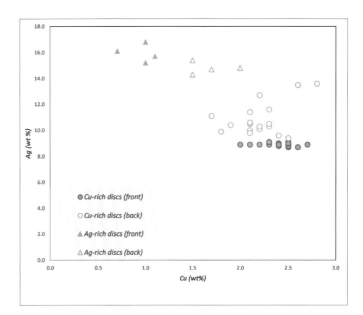

6.19

Scatterplot comparing the copper and silver levels of the front and back of the two groups of gold discs recovered in the hoard

6.18a,b

(a) Gold discs; (b) reverse side of gold discs. The arrows are pointing to the more Ag-rich discs. КПО93-38577/3 – 101. Eleke Sazy, Group II, Kurgan 4, hoard

Without more extensive investigations of the composition of archaeological and geological gold, ideally including trace elements, we can only offer some tentative conjectures as to the extent to which these compositional groups are a result of different geological sources or a result of cultural practices in metallurgical production (e.g. remixing, alloying, etc.). In essence, any of these compositions is potentially consistent with those of natural, unalloyed gold – with the different clusters perhaps suggestive of the use of gold from different sources. The copper levels of the larger hoard cluster appear to be plausibly at the higher end of the compositional spectrum typical of natural gold (fig. 6.19). At the same time, the group with the high silver content could reflect the artificial addition of silver to gold in the 'burial group'. Silver was in use during the Early Saka-Scythian period, as apparent from the silver objects found in the Arzhan-2 kurgan;[29] it is thus possible that, together with gold, copper and tin, the Early Saka-Scythian population practised silver metallurgy and artificially added silver to gold alloys.

Nevertheless, the presence of three chemical groups with no overlap appears to indicate that there are three different metal batches, perhaps

6.20

Scatterplot of the average copper and silver levels of the gold artefacts from Kurgan 7. Note the presence of a single very tight compositional cluster

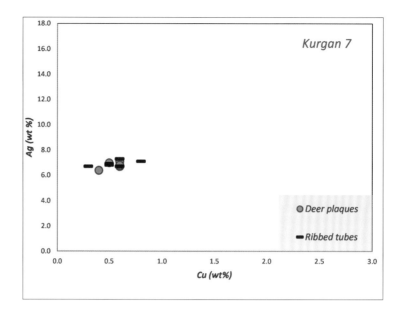

from distinct sources, with no recycling or mixing among them. We need additional data on the other gold artefacts from the hoard to verify these findings, but the information currently available supports the hypothesis that the burial objects were made at the same workshop and in a single manufacture event, separate from that of the hoard objects.

Chemical analyses provide information about further technical aspects such as joining techniques. The relatively large diameter of the X-ray beam (~3 mm) does not allow a focused analysis of the joints, but by comparing the composition of the areas around the joints to those on the body of the objects we can obtain qualitative data about enrichments created from the joining process. In the two groups of discs from the hoard, comparison of the analyses of the back surfaces (where the fastening hoops are joined) and the undecorated front surfaces reveals a peculiar pattern: the backs of silver-rich discs show an enrichment in copper, whereas the backs of copper-rich discs are predominantly enriched in silver (figs. 6.18b, 6.23). This peculiar result could indicate the use of different joining techniques in each case, but this point requires further investigation.

KURGAN 7

The elemental composition of the gold deer plaques and the ribbed tubes from Kurgan 7 revealed their identical chemical association, forming a tight elemental group that is consistent with manufacture from a single batch of gold (fig. 6.20). It is possible that their recovery in different parts of the kurgan (burial chamber and dromos) is due to their having been dropped by the robbers when making off with their loot.

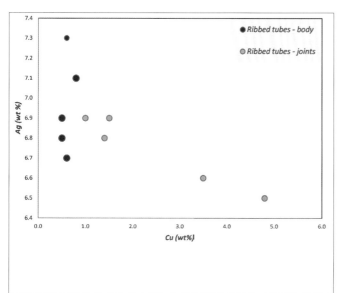

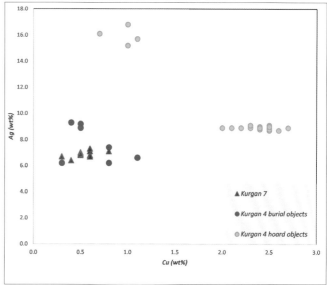

6.21

Scatterplot comparing the composition of the body of the ribbed tubes decorating the arrow shafts and the areas at the joint, showing a clear copper enrichment. Note that the pXRF detector window is larger than the joints, and hence 'joint' analyses include part of the surrounding metal sheet

6.22a,b

(a) Ribbed tube on the bronze arrow (front side); (b) reverse side of the tube with indication of a joint. КПО92-37981–37985, Eleke Sazy, Group II, Kurgan 7

6.23

Scatterplot comparing the composition of gold objects from Kurgans 4 and 7. Note the presence of a chemical cluster including the burial objects from Kurgans 4 and 7

In close parallel, the decorative pieces of the Kurgan 4 gorytos, including the deer plaques that are almost identical in form to those from Kurgan 7, were also likely made from a single batch of gold. Considering that the ribbed tubes and the deer plaques from Kurgan 7 are identical in composition and were found near the arrowheads, we hypothesize that these artefacts from Kurgan 7 were initially part of a gorytos.

The ribbed tubes that decorate the arrow shafts are made of gold sheet. The area of the joints is clearly enriched in copper, which suggests the use of copper-rich salts to lower the melting temperature and facilitate the joint (figs. 6.21, 6.22a,b).

Plotting together the gold objects from Kurgans 4 and 7 reveals the close chemical proximity of the gold objects associated with the burials from both kurgans (fig. 6.23). Moreover, the stylistic identity of certain objects (i.e. the deer plaques) in both kurgans provides the grounds to hypothesize that at least some of the artefacts in both kurgans could have been made by the same goldsmiths, using gold from the same source.

Conclusions

The initial analysis of the gold assemblages recovered in Kurgans 4 and 7 has allowed a number of technological and behavioural observations that should be investigated further, while also prompting research avenues for future comparison to the goldwork found in other kurgans at Eleke Sazy and beyond.

The artefacts associated with the burials reveal the use of compositionally homogeneous metal, consistent with a single batch of

unalloyed gold containing only natural impurities. The predominant use of mechanical transformation (hammering, twisting, bending, embossing) for shaping, as well as granulation and inlays as the main decorative techniques, indicate a degree of technological homogeneity too. This homogeneity is supported by similarities in the size, morphology and arrangement of the gold granules, together with the very similar inlays of lapis lazuli and turquoise.

Additional analyses of a larger sample of gold artefacts from the Kurgan 4 hoard will be required, but so far the available evidence suggests that the hoard objects were fashioned from different gold, and possibly at a different time. If a larger sample of objects confirms that this deposit was likely made at a later time, this could add an interesting dimension to our understanding of the life-history of the kurgan, as suggested by Samashev in Chapter 3 above.

More detailed specialized analyses of the microscopic beads should clarify how they compare chemically, and in terms of technique, to the rest of the assemblage. In any case, their very presence highlights an important dimension of the value of the gold among those who made and deposited these artefacts: these thousands of beads require an extraordinary investment of skill and labour, and their value clearly went beyond that of the value of the raw material. These tiny beads, barely visible to the naked eye, represent a significant investment of time and effort in their manufacture. Their materiality stands in stark contrast to the manufacture and massive weight of the great torc. The bulk weight of this torc would have provided sufficient metal for over 400 deer plaques, or as many as 100,000 microscopic beads. Thus, the gold objects emphasize the many aspects of gold as a material that held economic value, and justified the investment of ingenuity and skill, conferred social prestige, and served a purpose in the afterlife.

Our research on the gold from Eleke Sazy Kurgans 4 and 7 illustrates some of the potential avenues for a scientific understanding of the gold produced, used and deposited by the prehistoric societies of the Great Steppe. It is possible to put forth questions about ancient metallurgy and craft production when the gold artefacts are found in rich burial and hoard contexts such as those found at Eleke Sazy. Many more research avenues remain to be explored, including the specific techniques employed for granulation and joining of gold, and for the cutting, drilling and setting of stone inlays, in addition to the technology and composition of enamel decoration. The organic components of the artefacts, from the wood and leather substrates to the smaller elements such as horn inlays and glues, present another strand of rich evidence to be scrutinised with the power of modern science.

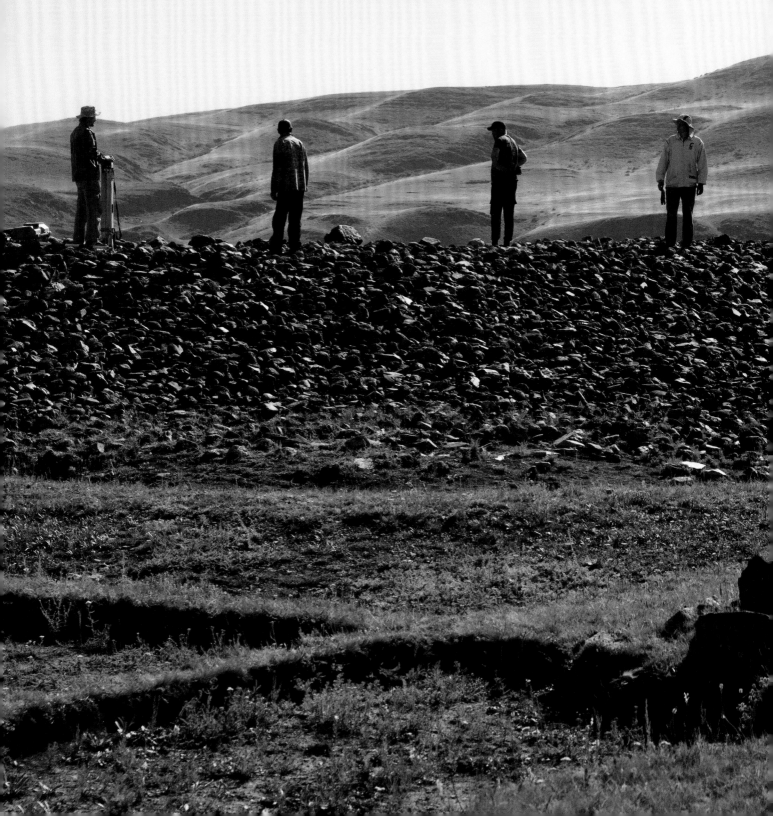

NOTES, APPENDICES,
GLOSSARY, BIBLIOGRAPHY

NOTES

1. Introduction CLAUDIA CHANG AND REBECCA ROBERTS

1 Samashev, Chapter 2, this volume.
2 Salzman 2004.
3 See Toleubayev, Chapter 4, this volume.
4 Khazanov 1984.
5 Chapter 3, this volume.
6 Andreeva 2018.
7 Chapter 2, this volume.
8 Klejn 2013.
9 Tylor 1871.
10 Currie 2015.
11 Toleubayev, Chapter 4, this volume.
12 Herodotus, *Histories*, IV, p. 13.

2. The Illustrious Culture of the Early Nomads in the Kazakh Altai ZAINOLLA SAMASHEV

1 Ермолаева, 2012; Молодин, Кожин, Комиссаров, 2015, pp. 5–12.
2 Бочкарев, Кашуба, 2018, pp. 55–76.
3 Кулькова, Боковенко, 2018, pp. 154, 160.
4 Жауымбаев, 2018, pp. 47–49.
5 Акишев, 1959, p. 204.
6 Грач, 1980, p. 6.
7 The region of Zhetysu, located in south-east Kazakhstan, is also known by its Russian name Semirechye. It means 'land of seven rivers'.
8 Геродот, История, I, p. 106
9 Самашев, 2011, pp. 202, 203.
10 English translation from Luckenbill 1927, p. 328.
11 Латышев, 1992, p. 26.
12 Ibid.
13 *Haoma* is a plant with stimulant properties, possibly Ephedra, that was made into a drink. It is considered sacred in Zoroastrianism. *Haoma* is the Avestan form of the Sanskrit *soma*..
14 Kohler, 1995.
15 For example, Черников, 1960; Максимова, 1959, pp. 85–161; Ткачев, Ткачева, 2008; Ермолаева, Ермоленко, 2016, pp. 654–72; Бейсенов, Шульга, Ломан, 2017.
16 Максимова, 1959, pp. 104–15; Черников, 1960, pp. 52–62.
17 Ермолаева, Ермоленко, 2016, pp. 654–72.
18 Сорокин, 1966, pp. 42, 44, 47.
19 Самашев, 2019, pp. 37–60.
20 Шульга, 2008, pp. 63–66.
21 Грязнов, 1980.
22 Чугунов, 2000, pp. 213–37.
23 Самашев, 2018a, pp. 109–17; 2019, pp. 37–60.
24 Бейсенов, 2012.
25 Арсланова, 1974b, pp. 46–60.
26 Ермолаева, 2012.
27 Грязнов, 1947, pp. 9–17.
28 Самашев, Жумабекова, Омаров, 1998, pp. 155–60.
29 Черников, 1965; Толеубаев, 2018.
30 Арсланова, 1974a, pp. 77–83.
31 Бейсенов, 2012, p. 232, fig.7; Чугунов, Парцингер, Наглер, 2017, 389, table 51.
32 Толеубаев, 2018, pp. 232, 233.
33 Акишев, Акишев, 1978, pp. 60–63.
34 See, for example, Шульга, 2008.
35 Чугунов, Парцингер, Наглер, 2017, pp. 164–65.
36 Самашев, 2011; 2018.
37 Зеймаль, 1979, p. 34; Museum Miho, Japan, 2002, 48 a,b,73 b,c.
38 Самашев, Кариев, Ерболатов, 2019, pp. 385–93.
39 Самашев, 2018c, pp. 56–72.
40 Грязнов, 1961.

3. Eleke Sazy, Kurgan 4 ZAINOLLA SAMASHEV

1 Samashev, 2018b.
2 Кадырбаев, 1966, p. 398, fig. 63.
3 Чугунов, Парцингер, Наглер, 2017.
4 Китов, Китова, 2018, p. 310.
5 Китов, Китова, 2018, pp. 309–14.
6 Джансугурова, Самашев, Нуржибек, Альберто, Джеонг, Бекманов, Хусаинова, Краус, 2019, pp. 103, 106.
7 Черненко, 1980, 11.
8 Ворошилов, 2009, pp. 40–42.
9 Иванов, 2005, pp. 72–76.
10 Волков, 2002, p. 245, table 130.
11 Оралбай, Кариев, 2016, pp. 161–71.
12 Черников, 1965; Толеубаев 2018

4. Parallels in Kazakh and Saka-Scythian Funerary Rites and Memorial Customs ABDESH TOLEUBAYEV

This article was first published in Russian. Толеубаев А.Т. 2019, available here: http://edu.e-history.kz/ru/publications/view/1270 (accessed 14th June 2020)

1 Бонгард-Левин and Грантовский, 1983, p. 96.
2 Author's field observations: Semipalatinsk region, 1977, 1978; East Kazakhstan and Pavlodar regions, 1979; Turgay and Kostanay regions 1980.
3 Толеубаев, 1991, pp. 88–89.
4 Полосьмак, 1994, p. 14.
5 Руденко, 1952, p. 9.
6 Кубарев, 1987, p. 124.
7 Радлов, 1989, p. 139.
8 Сапожников and Монгольский, 1911, p. 53.
9 Акишев and Кушаев, 1963, p. 80.
10 Толеубаев, Т.1a, p. 329.
11 Толеубаев 2007.
12 Руденко, 1953, p. 28.
13 Руденко, 1953, pp. 86–87, fig. 37–39, 89, fig. 42; Полосьмак, 1994, p. 25.
14 Кенин-Лопсан, 1987, p. 88.
15 Кубарев, 1987, p. 26.
16 Руденко, 1953, p. 85.
17 Потапов, 1953, p. 293; Кубарев, 1987, pp. 125–27.
18 Толеубаев, Т.2, p. 323–24.

19 Кубарев, 1987, p. 123.
20 Вяткин, 1960, p. 182; Сорокин, 1981, p. 30.
21 Геродот, История, IV, 73.
22 Райс, 2004, pp. 92–93.
23 Киселев, 1951, ро. 106–07; Руденко, 1953, p. 326; Райс, 2004, p. 90; Кубарев, 1987, p. 128.
24 Бичурин, 1950, p. 230.
25 Райс, 2004, p. 90.
26 Кубарев, 1992, p. 26.
27 Кубарев, 1987, p. 130.
28 These issues have already been well covered in the works of M.P. Gryaznov, S.I. Rudenko, S.V. Kiseleva, V.D. Kubareva, V.I. Molodina, A.A. Tishkina, N.V. Polosmak, Z.S. Samashev and others.
29 Грязнов , 1982, p. 46.
30 Ковалевская, 1977, p. 64; Витт, 1952, p. 178; Полосьмак, 1994, p. 80.
31 Диваев, 1889, p. 6; Рычков, 1772, p. 154; Ауэзов, 1960, p. 205.
32 Толеубаев, 1984, pp. 35–40.
33 Author's field observations: Semipalatinsk region, 1977, 1978; East Kazakhstan and Pavlodar regions, 1979; Turgay and Kostanay regions 1980.
34 Кармышева, 1954, p. 103.
35 Кастанье, 1911, pp. 91–92.
36 Кастанье, 1894, pp. 132–33; Author's field notes, 1976, no. 36:41; 1977, no. 23, p. 54.
37 Ходыров Л. 1916, pp. 9–10; Левшин, 1932, p. 111.
38 Ольховский, 1978, p. 130.
39 Калоев, 1964.
40 Геродот, История, IV, pp. 71,72.
41 Ibid.
42 Кубарев, 1987, pp. 90,129.
43 Руденко, 1953, pp. 91–98.
44 Руденко, 1962, p. 90, tab. 1, 1–4.
45 Author's field observations.
46 Руденко, 1953, pp. 128–29.
47 Теплоухов, 1925, p. 20.
48 Диваев, 1889, p. 6.
49 Калоев, 1964, p. 3.
50 Кубарев, 1987, p. 127.
51 Author's field observations: East Kazakhstan and Pavlodar regions, 1979.
52 Тощакова, 1978, p. 132.
53 Райс, 2004, p. 96.
54 Геродот, История, IV, p. 172.
55 Кубарев, 1987, p. 30.
56 Ольховский, 1978, p. 117.
57 Ольховский, 1978, p. 157.
58 Полосьмак, 1994, p. 40.
59 Яценко, 2006, p. 95, figs. 46, 28–31, 32.
60 Зеймаль, 1979, p. 54, fig. 59.
61 Клочко, 1992, p. 26.
62 Руденко, 1953, pp. 111–12.
63 Руденко, 1952, p. 92.
64 Толеубаев, Т.1b, p. 204–12.

5. My Kingdom for a Horse: Saka-Scythian Horse-Human Relations LAERKE RECHT

1. The Scythian were not all or only nomads: at least some segments of the population were sedentary or semi-sedentary, and there was extensive contact with agriculturally based populations (see e.g. Chang et al., 2003; Chang, 2012).

2. Argent has written several papers emphasizing the two-way learning and relationship between horse and human (Argent, 2010; 2013). Humans teach and learn; horses teach and learn. They are not passive objects which humans act upon, but actively engage in the encounter.

3. Kosintzev and Samashev, 2014, p. 146; Lepetz 2013, p. 318.

4. Published in English in 1970; see Rudenko, 1970.

5. For reports with English text or sections, see e.g. Samashev 2011; 2012.

6. Earlier kurgans sometimes contain even more: in Arzhan-1 (dated 9th–7th century BC) 160 horses were buried (Bokovenko and Samashev 2012).

7. Samashev, 2016.

8. Kashkinbayev, 2013, pp. 50–63; Kosintzev and Samashev, 2014, pp. 166–205.

9. Moorey, 1970.

10. Argent, 2010, fig. 3.

11. See also Toleubayev, Chapter 4 in this volume, for the possibility of clipped mane being either a signature of riding horses or the horse being marked for burial.

12. There are, however, a few examples of shields buried with them (Shamashev, 2011: pp. 142–43.).

13. Kashkinbayev 2013; Kosintzev and Samashev, 2014.

14. For example, the newly excavated settlement Akbauyr, described by Samashev in Chapter 1 of this volume.

15. Kosintzev and Samashev, 2014, p. 201. Mares are rare, but have been recorded elsewhere (Lepetz, 2013, p. 319). The horses of Berel and elsewhere are sexed based on the presence of canines – these are typically a feature of male horses, but mares can also have them (usually smaller and less developed).

16. Rudenko, 1970, p. 118.

17. Kosintzev and Samashev, 2014, pp. 166–205.

18. Argent, 2010.

19. Argent, 2010; Lepetz, 2013.

20. Usmanova et al., 2021; it also occurred in the Near East and Aegean (Recht, 2018).

21. See Samashev, Chapter 1, this volume.

22. Samashev, 2016.

23. In Chapter 4 of this volume, Toleubayev discusses the Kazakh practice of horse sacrifice, where the deceased's favourite mount is sacrificed one year after the death of its master in a ceremony as part of continued mourning rites. The mourning family pass greetings to the deceased through the horse, who is then sacrificed.

24. For injury to human skulls very like that on horses, see https://blog.britishmuseum.org/mummies-and-log-houses-of-the-dead-scythian-life-and-death/ (accessed 7 April 2020).

6. Goldworking of the Great Steppe: Technical Analysis of Gold Artefacts from Eleke Sazy SALTANAT AMIROVA AND MARCOS MARTINÓN-TORRES

1. Беспаев et al., 1999; Ваулин, 2016.

2. Хаврин и Папин, 2006; Кузнецова и Мадина, 1990; Маргулан, 1998.

3. Ваулин, 2016.

4. Шербаков и Рослякова, 2000; Зайков et al., 2016.

5. Ренованц, 1792, p. 157.

6. According to the Mining Dictionary of Spasskii, (1841, p. 36): "Ochre is a watery oxide of certain metals of earthy colour, which sometimes used as pigments. For example, iron or lead ochre"; Renovants, 1792, p. 157: "... кожаный мешок, наполненный изобилующими серебром и золотом охрами" is "... a leather bag full of gold and silver rich oxide ores".

7. Черников, 1960, 1948; Ренованц, 1792; Шербаков и Рослякова, 2000.

8. Беспаев et al., 1999.

9. Зайков et al., 2016.

10. Черных, 2008, 1978; Stollner et al., 2011; Stollner and Samashev, 2013.

11. Акишев, 1978; Чугунов et al., 2017.

12. Артамонов, 1973; Bunker, 2002; Chang and Guroff, 2007; Чугунов et al., 2017; Пиотровский, 2004; Руденко, 1961; Руденко и Руденко, 1949; Simpson and Pankova, 2017; So and Bunker, 1995; Stark et al., 2012; Яблонский, 2013.

13. Оралбай and Кариев, 2016.

14. Акишев и Акишев, 1983; Акишев, 1978; Черников, 1965; Чугунов et al., 2017; Пиотровский, 2004; Толеубаев, 2018.

15. Armbruster 2009; Черников, 1960; Толеубаев, 2018.

16. Чугунов et al., 2017, p.39.

17. Carroll, 1974.

18. Wolters, 1981.

19. Scrivano et al., 2017.

20. Samashev et al., 2019.

21. Чугунов et al., 2017.

22. Руденко и Руденко 1949, p. 25.

23. Чугунов et al, 2017; Молодин et al., 2000; Minasyan, 2004; Черников, 1965.

24. Черников,1965; Marsadolov et al. 2013.

25. Чугунов et al., 2017.

26. Черников, 1965; Чугунов et al., 2017; Толеубаев, 2018.

27. Чугунов et al., 2017.

28. Толеубаев, 2018.

29. Чугунов et al, 2017.

APPENDIX I: THE NEXT CHAPTER

ABDESH TOLEUBAYEV, ZAINOLLA SAMASHEV, REBECCA ROBERTS

1. Ongoing archaeological work at the Eleke Sazy burial complex

Excavations are ongoing in East Kazakhstan, and new discoveries are being made every year. Archaeologists are working against the threat of looters, who have severely damaged some kurgans at Eleke Sazy, and dedicated teams worked throughout the COVID-19 pandemic to document and protect endangered heritage. This has led to sensational discoveries since this book was first conceived in March 2020. Summarized here, they are deserving of their own volume in future. Fortunately, many of the most freshly unearthed objects will be included in the exhibition at the Fitzwiliam Museum.

At Eleke Sazy, in the summer of 2020, excavations at Kurgan 7 of Group IV revealed many new insights into the construction and ritual use of this kurgan dating to the 5th–4th century BC. The central grave pit was found to be completely plundered. It had a stone-covered dromos 9 metres in length leading from it, and, in a construction never seen before, the capping stones of the dromos were found to have been placed in two rows over 4 metres above the lowest point. During excavation of the lower boundaries of the stone shell, 830 spectacular gold artefacts belonging to a horse harness were found (figs. 2, 3). Unlike horse tack decorations from Berel and Pazyryk, which were based on carved wooden moulds with gold leaf, the decorations from Kurgan 7 were made of bronze with thick gold foil overlays. Their sturdy construction and remnants of leather found in brackets and other fastenings on the back indicate that these items were worn as ceremonial adornment by living horses, rather than as funerary props for burial. Undoubtedly, this was a funeral and memorial gift-offering to the deceased ruler, possibly from the tribal divisions or associations subject to him. Other such Saka-Scythian horse harnesses of thick plate gold and foil are rarely found, displaying as they do such a diverse and rich mythological canon and array of forms, and intended for ceremonial rather than as funerary use.

2. The hoard discovered during excavations in summer 2020, Eleke Sazy IV, Kurgan 7.

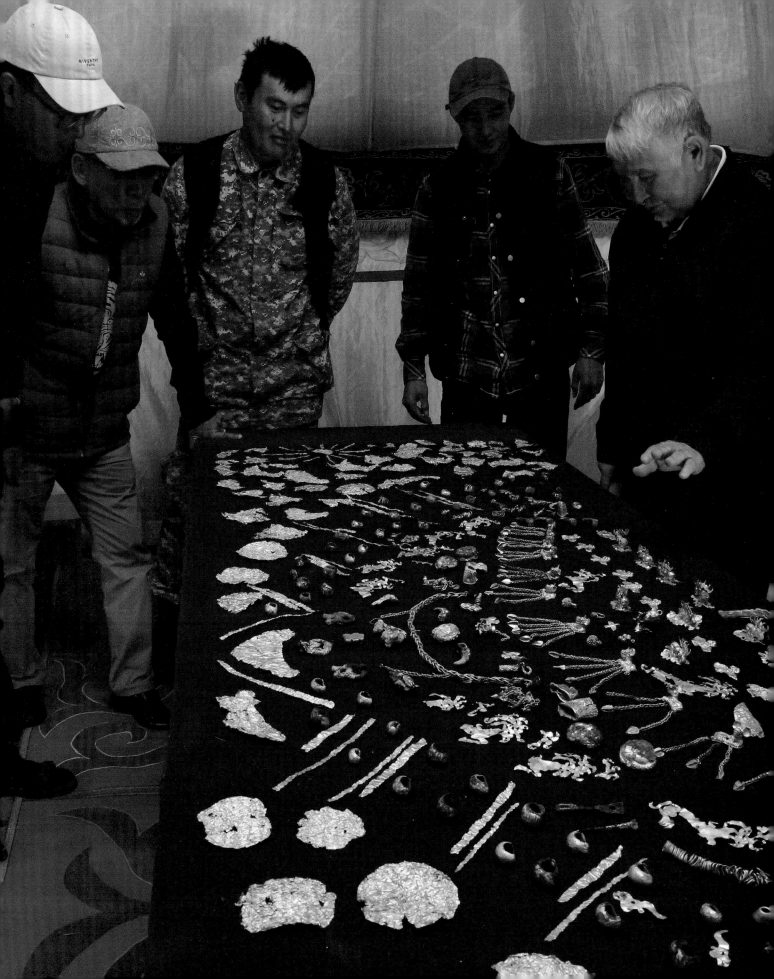

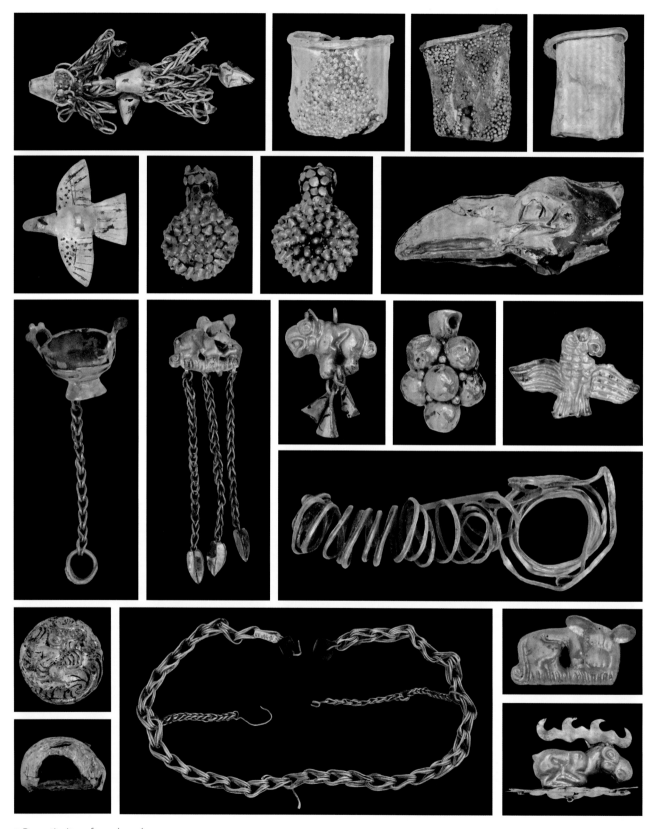

3. Decorative items from a horse harness
deposited as a hoard at Eleke Sazy IV,
Kurgan 7. GOLD, BRONZE. 5th–4th century BC

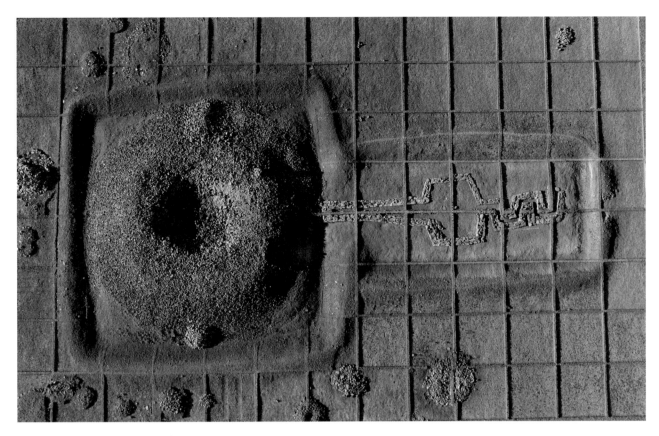

4. Aerial view of the Turkic period temple complex at Eleke Sazy, 7th century AD

The burial ground of Eleke Sazy continued to be a sacred place long after the Saka era. Beginning in 2019, excavations have been conducted at a temple complex dating from around the 7th century AD, 1500 years later than the archer's burial in Kurgan 4 of Group II. The complex consists of two parts – the central structure of the temple, and the labyrinth adjoining it from the eastern side (fig. 4). Both components are erected on stone and earthen platforms and are surrounded by loess ramparts. Religious structures of this kind are known in Central Asia. They marked sacred places of the ancient Turkic people, and are associated with the deification of the image of a deceased Qagan (emperor). Items of weaponry, horse harnesses and ceremonial costumes have been found. At the base of the structure in 2021, among artefacts such as stirrups, a bronze dish, a lamp, and a bowl, an outstanding find was made of a belt made up of gold plaques depicting a Turkic Qagan sitting on a throne with horse-head arm rests, his features clearly visible as Central Asian (fig. 5). At his feet attendants kneel to serve him from saucers. Such a find has the potential to study the religious and memorial rites of the ancient Turkic people, opening the next chapter in the rich history of East Kazakhstan.

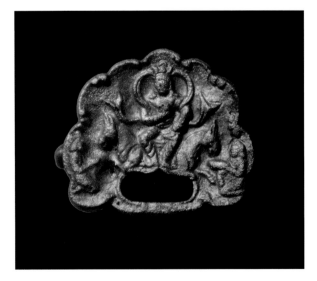

5. Gold belt plaque featuring a Turkic Qagan (emperor) seated on a throne with horse-head arm rests. At his feet attendants kneel to serve him from saucers.

APPENDIX II: RECONSTRUCTION OF KURGAN 4, ELEKE SAZY II

An artist's impression of Kurgan 4 in cross-section, showing the
different architectural elements and layers of construction

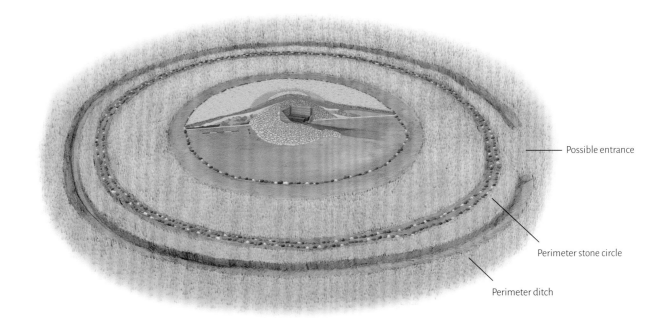

Possible entrance

Perimeter stone circle

Perimeter ditch

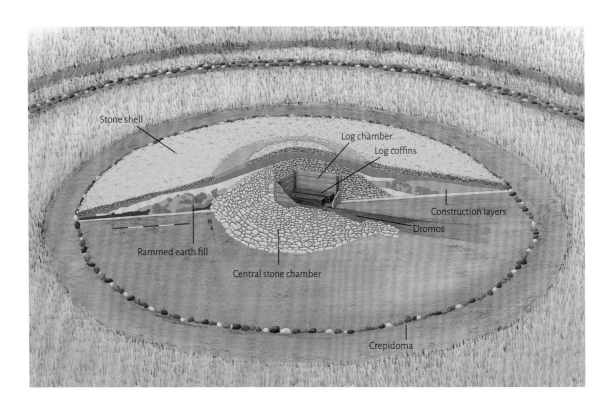

Stone shell

Log chamber

Log coffins

Construction layers

Dromos

Rammed earth fill

Central stone chamber

Crepidoma

APPENDIX III: ANIMALS OF THE GREAT STEPPE

Animals of the Great Steppe depicted in Saka art,
and their current conservation status

Altai argali (*Ovis ammon ammon*).
Vulnerable

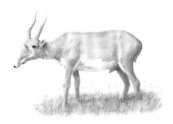

Saiga antelope (*Saiga tatarica
tartarica*). Critically endangered

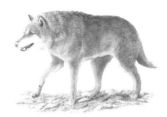

Wolf (*Canis lupus*). Least concern

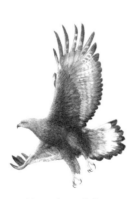

Golden eagle (*Aquila chrysaetos*).
Least concern

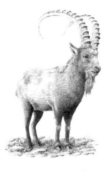

Siberian ibex (*Capra sibirica*).
Near threatened

Brown bear (*Ursus arctos*). Least concern

Snow leopard (*Panthera uncia*).
Vulnerable

Caspian tiger (*Panthera tigris virgata*).
Extinct, 2003

Siberian red deer (*Cervus elaphus
sibiricus*). Least concern

GLOSSARY OF TERMS

Agropastoralism A subsistence strategy widely adopted across central Eurasia during the Iron Age, combining livestock rearing (pastoralism) and growing crops (agriculture). The system is highly flexible and adaptable to settled, nomadic, and transhumant (moving between summer and winter territories) patterns of land use, all of which are found on the territory of Kazakhstan during the Iron Age.

Akinakes A type of short sword, generally around 40 cm in length. They are thought to have been of Saka-Scythian origin, however the akinakes was adopted by the Medes and Persians from at least the 7th century BC. The akinakes found at Eleke Sazy Kurgan 4 displays the belt fastening attachment typical of this weapon.

Animal style The pan-Scythian animal style is a type of artistic form found across the Scythian world, including among the Saka-Scythians of East Kazakhstan. As the name suggests, the animal style depicts animals, both real and imagined, in complex compositions, often with limbs either folded or stiffly extended, with heads and torsos twisted. More than one creature might be depicted in a single design, for example an intricate intertwining of predator and prey, which changes appearance depending on the angle of viewing, or parts of one creature creating the form of another.

Arzhan Located in the Republic of Tuva, Russian Federation, the necropolis of Arzhan consists of several hundred kurgans arranged in parallel chains. Arzhan-2 was excavated in 1997–2003, and was discovered to contain an unlooted burial of Early Saka-Scythian date (7th–6th century BC), consisting of an elite man and woman in a central chamber (actually built off-centre, perhaps to fool looters), and the accompanying burials of 14 horses, and 33 other human individuals. Over 20 kg of gold artefacts in the animal style were recovered, including the gold decorative parts of a gorytos and thousands of tiny gold beads, analogous to those from Eleke Sazy Kurgan 4.

Baipak A Kazakh felt stocking worn under boots.

Balbal Stone anthropomorphic stele associated with funerary monuments. Balbals are found across the Eurasian steppe in great numbers, and were produced my many different peoples across millennia, from the 4th millennium BC to the Middle Ages.

Baursak (pl. baursaky) Kazakh fried bread, usually shaped into small rhomboids or spheres. They are made to be shared with friends and family, and are served at significant events such as weddings and memorials. It is said that the smell of the frying dough floats up to deceased loved ones, who can then share in their consumption.

Beneficiation The process of improving ore through removal of undesirable minerals prior to smelting. The waste products from this process are known as tailings.

Berel Necropolis located in the Altai mountains of East Kazakhstan. The majority of the burial mounds date to the 4th–2nd century BC and are attributed to the Scythian Pazyryk culture, however recent research by Z. Samashev has identified later burials of the 2nd/3rd–5th century AD clustered around some of these earlier kurgans. Due to the formation of permafrost in the kurgans, the burials from Berel display exceptional levels of preservation of organic materials such as wood, leather, textiles, hair and fur, allowing for the reconstruction of the burial outfits of both people and horses.

Bit The bit is usually made of iron, bronze or copper in a fairly simple design. The mouth piece consists of joined pieces, at the end of which is a ring to attach the reins and through which to place the cheekpieces.

Bogatyr An epic hero, akin to the knight-errant of Medieval Arthurian legend.

Breast collar and withers strap The breast collar runs from each side of the front of the saddle around the chest of the horse. It prevents the saddle from sliding backwards over the croup of the horse. It can be either directly attached to the saddle or divided into straps attaching to the withers and girth. It can be used for ornamental elements, and a special plaque or carving may be placed in the centre of the breast, complimenting the bridle.

Bridle The bridle – sometimes called a headstall – is the composite element that goes on the horse's head and helps the rider communicate with and steer the horse.

Cheek straps Cheek straps run along the side of the horse's head and attach to the crownpiece at the top, and the psalia at the bottom. In the attachment to the psalia, they divide into two in an inverted v-shape, which serves to hold the psalia in the correct position, so that they work as intended. The cheek straps are usually made of leather or rope, but can have added carved or engraved elements in other material.

Crepidoma a term borrowed from Ancient Greek architecture, and is used to describe the platform on which the superstructure of a building is constructed. The crepidoma of Eleke Sazy Kurgan 4 is composed of large round stones.

Crupper The crupper runs from each side of the back of the saddle around the buttocks of the horse, below the tail. It prevents the saddle from gliding too far forward. Ornamental elements can be added to it. Crupper and breast collar are particularly useful when navigating terrain that is not flat, since travelling up or down steep slopes is likely to make the saddle slide out of place.

Dromos An entrance passageway into a kurgan, which is usually built from the outside perimeter into the central grave shaft. It is believed that the dromos was used as part of the funerary rites to take the deceased into the burial chamber.

Eleke Sazy Necropolis located on the northern slope of the Tarbagatay mountains. It consists of over 300 funerary monuments arranged in groups that are presumed to date to the first half of the first millennium BC. Excavations conducted by Z. Samashev in 2018 on Kurgan 4, Group II, uncovered the intact burial of a 17–18 year old young man, thought to date between the 8th and 7th centuries BC, who was buried with numerous gold artefacts including a large torc, a gorytos with gold detailing, a bronze dagger with gold sheath, the gold decorations of a hat or headdress, and other clothing decorations including thousands of tiny gold beads which would have adorned his shoes.

Frentera Also called a frontlet or faceplate, a frentera runs down the front of a horse's head. It is usually attached to the headband and noseband, and can thus be seen as an extension of decoration found on those parts. The frentera is usually carved in detail, often using heraldic and merging animal compositions. Although it may be partly protective, the frentera's main function is to make the horse even more imposing. Along with or instead of the headdress, it transforms the horse into a fantastic or semi-mythical being.

Girth The girth wraps around the stomach of the horse and keeps the saddle in place. Decorative parts may be added, and the buckles used can also be carefully carved.

Gorytos A combined bow case and quiver of Scythian invention. They were worn on the left side, attached to a belt, with the opening facing backwards. Found across the pan-Scythian world, gorytoi are made of leather and often highly decorated, as in the case of the gorytos from Eleke Sazy Kurgan 4.

Headband and noseband As with the throat latch, these bands running across the forehead and the lower nose ridge of the horse, the headband and noseband help keep the bridle in place. They are also often decorated to create a stunning frontal view.

Headdress / mask Some high-status horses wore elaborate headdresses or 'masks' that would significantly change their appearance. They were worn on the crown of the head, thereby also increasing the overall height of the horse. Such headdresses could be made of leather, horn, wood and textiles, and decorated with gold. They have been found in a variety of shapes, but as with other elements, there is a focus on animals, for example goats and deer. Horses were buried wearing these masks, and they were likely using for ritual practices; it is less certain whether they were also used to impress or scare enemies during warfare.

Kerege The wooden lattice framework which forms the walls of a yurt.

Kurgan The Russian word for a tumulus – a mound raised above ground level, which usually contains at least one burial. Kurgans can be constructed using a variety of materials including stone, wood, turf and soil.

Legs and hooves No equipment or items of adornment have been found on the legs and hooves of horses, nor are such depicted in the art. The legs were likely kept free in order to ensure smooth and easy movement.

Mane and tail The mane of riding horses would be clipped and could also be decorated with a textile cover; similarly, the top part of the tail might be clipped, and the rest either plaited or tied in a knot. A leather strap with gold was sometimes included in the plait. The short mane may prevent it from getting in the way of the rider (especially while using a weapon or tool), and the tied tail may prevent it from getting caught in bushes or other obstacles.

Necropolis (pl. necropoles) A necropolis is a burial ground or cemetery containing multiple funerary monuments.

Oxus Treasure This is a hoard of 180 artefacts of precious metal, dated to the Achaemenid Empire (c. 550–330 BC), which were discovered on the north bank of the Oxus (modern-day Amu Darya) River near the town of Takht-i Sangin in Tajikistan between 1876–1880 AD. The bulk of the collection is presently housed in the British Museum, London.

Pazyryk The frozen burial mounds of Pazyryk in the Altai region were first excavated by S. Rudenko in the 1930s. Part of the Scythian world, the exceptionally well preserved artefacts uncovered in the burial mounds have been used to define the Pazyryk culture, which dates between the 6th and 2nd centuries BC. Artefacts from the Berel necropolis are considered to be part of the Pazyryk culture.

Placer deposit Gold deposits found in the sands and gravels of streams. Placer deposits result from the weathering and disintegration of primary gold-bearing rocks, and subsequently accumulate through further weathering and mechanical concentration.

Protome A term in art history used to describe the front half of an animal, including head and forelegs.

Psalia Cheek pieces, or psalia, are fitted through the rings of the bit. Psalia are often made of wood, metal, horn or bone, with elaborately carved ends in animal shapes. They have an important function during riding, especially in very active situations. They prevent the rings of the bit from being pulled into the horse's mouth when one rein is pulled urgently (the modern equivalent is either bit guards or a full cheek snaffle bit). This greatly aids in the fast turning of a horse, which would have been vital during battle.

Reins The reins were directly attached to the bit, tied to the rings. The Scythians used two reins, allowing for very effective and direct steering. The reins do not appear to have been used for decorative elements. Sometimes an extra 'lead rein' (also called a *chumbur*) would be added to the left rein. This would most likely be used when the horse had to be tied in a hurry.

Saddle hangings Various ornamental hangings, strings and fringes can be attached to the saddle or the saddle cover, usually made of leather or textile. These can be as simple as a few short strings or as elaborate as an imitation of an entire lion skin slung over the back of the horse.

Saddle Saddles were composite objects, and several different types were made. Two hair or grass-filled 'cushions' would align each side of the horse's back, supported by arched at the front and back, and sewn together using large pieces of leather and sinew thread. Some types would have wooden reinforcements. A sweat cloth would be directly against the horse's back, and a saddle cloth, often with woven figural decoration, would cover the saddle.

Sagaris This is a type of war axe. It has a long shaft and metal head, with a pick-like point on one side and either a sharp or blunt edge on the other side. Much like the akinakes, the sagaris has Saka-Scythian origins, but was adopted by other Western Asian peoples including the Medes and the Persians. The sagaris is found deposited in pan-Scythian burials and is depicted in petroglyphs on the territory of Kazakhstan. It was also used to sacrifice people and horses, for example at Berel, where horses show blunt force trauma to the skull.

Saka/Saka-Scythian The term Saka is used to denote the easten Scythian tribes, and the first written record of the term is found in contemporaneous Persian historical sources, as detailed in Chapter 1 of this volume. The authors in this volume use the term Saka-Scythian to highlight both the regional and cultural attribution of these eastern steppe peoples, although in Kazakhstani academic literature the term Saka is more commonly used in isolation, where its meaning is more readily understood.

Scythian The term Scythian is commonly used in two ways by archaeologists. 'The Scythians' as a people are considered to be those nomadic tribes occupying the Pontic steppe in the first millennium BC, whereas 'Scythian culture' is used to describe the pan-Eurasian cultural phenomenon witnessed in the first millennium BC whereby the Eurasian steppe zone, from the Black Sea in the West to the Altai region in the East, was occupied by largely nomadic tribes who produced decorative gold and other metal work in the 'animal style', engaged in mounted warfare, buried their dead in kurgans, and were skilled stock breeders and horse riders. The Saka and Pazyryk cultures referenced in this volume were part of the pan-Scythian world.

Shanyrak The central apex of the roof of a yurt. Circular in form with crossed struts at the centre, it holds the structure together and allows smoke to escape. The cultural importance of the shanyrak in Kazakh culture cannot be overstated. Shanyraks are family heirlooms, and they are symbols of home, family, ancestors, and nomadic lifeways which are central to Kazakh identity. The shanyrak forms the central part of the national emblem of Kazakhstan.

Shilikti Necropolis located in the Zaysan region of East Kazakhstan, in a valley surrounded by the Tarbagatay, Manrak and Sauir-Saikhan mountain ranges. It consists of over 200 burial mounds constructed between the 8th and 1st centuries BC, of which 120 are Saka-Scythian. First excavated in the 1960s by S.S. Chernikov, the most recent excavations have been conducted by A. Toleubayev. In 2003 excavations of the Baigetobe kurgan uncovered over 4,000 spectacular gold artefacts in the Saka-Scythian 'animal style' dating between the 8th and 7th centuries BC, as well as fragments of leather and wood.

Telengits A Turkic-speaking group who live in the Altai region, with the majority of the population now found in the Altai Republic, Russian Federation. They are livestock breeders, and their dwellings include felt yurts and a conical tent, called an *alanchik*, which is covered in either bark (larch or birch), or felt.

Tengrism An ancient Turko-Mongolian religion revering the sky and sky deities. It dates back to at least the 4th century BC, and has had an ideological pan-Turkic revival in the post-Soviet space.

Throat latch The throat latch attaches at the join of the cheek straps and crownpiece, and runs underneath the neck of the horse. It is frequently a decorated piece, but also helps keep the bridle in place and not fall off during the frenzy of battle.

Toreutics A term used to refer to artistic metalworking, in this case goldworking.

Tuyere This is a tube through which air is blown into a furnace or hearth, usually for the purpose of achieving the kinds of high temperatures required for metal extraction and working.

Xianbei A confederation of nomadic tribes that inhabited the Eastern Eurasian steppe region, who rose to power in the 2nd–3rd century AD as the Xiongnu empire collapsed.

Xiongnu A confederation of nomadic tribes who rose to power during the 3rd century BC, controlling a large territory, including southern Siberia, Mongolia, and East Kazakhstan.

Yurt The word used to denote a portable, dome-shaped dwelling used by many nomadic groups across central Eurasia. The word yurt in English is borrowed from the Russian 'yurta', which has Turkic origins. The Kazakh word for yurt is *kiiz úy*, meaning 'felt house'. Although variations are found between ethnic groups, the main elements include a wooden framed structure, which can be dismantled for transport, and felt coverings. Among the Kazakhs, yurts tend to be used in summer pastures.

BIBLIOGRAPHY

Andreeva, P. 2018 *Fantastic Beasts of the Eurasian Steppes: Toward a Revisionist Approach to Animal-Style Art*, Publicly Accessible Penn Dissertations, 2963, https://repository.upenn.edu/edissertations/2963 (Accessed 25 May 2020)

Argent, G. 2010 'Do the clothes make a horse? Relationality, roles and statuses in Iron Age Inner Asia', *World Archaeology*, 42.2, pp. 157–74

Argent, G. 2013 'Inked: Human-horse apprenticeship, tattoos, and time in the Pazyryk world', *Society & Animals*, 21, pp. 178–93

Armbruster, B. 2009 'Gold technology of the ancient Scythians: Gold from the kurgan Arzhan-2, Tuva', *Archeosciences*, 33, pp. 187–93

Bokovenko, N.A. & Samashev, Z. 2012 'The roots of Iron Age pastoral nomadic culture', in Stark, S. & Rubinson, K.S. (eds.), *Nomads and Networks: The Art and Culture of Kazakhstan*, Princeton & New York: ISAW and Princeton University Press, pp. 20–29

Bunker, E.C. 2002 *Nomadic Art of the Eastern Eurasian Steppes. The Eugene V. Thaw and Other Notable New York Collections*, New York: The Metropolitan Museum of Art

Carroll, D. 1974 'A Classification for Granulation in Ancient Metalwork', *American Journal of Archaeology*, 78 (1), pp. 33–39

Chang, C., Benecke, N., Grigoriev, F.G., Rosen, A.M. & Tourtellotte, P.T. 2013 'Iron Age society and chronology in south-east Kazakhstan', *Antiquity*, 77 (296), pp. 298–312

Chang, C. 2012 'Cycles of Iron Age mobility and sedentism: Climate, landscape, and material culture in south-eastern Kazakhstan', in Stark, S. & Rubinson, K.S. (eds.), *Nomads and Networks: The Art and Culture of Kazakhstan*, Princeton & New York: ISAW and Princeton University Press, pp. 140–51

Currie, A. 2016. 'Ethnographic analogy, the comparative method, and archaeological special pleading', *Studies in History and Philosophy of Science, Part A (55)*, pp. 84–94.

Frachetti, M.D. 2008 *Pastoralist Landscapes and Social Interaction in Bronze Age Eurasia*, Berkeley: University of California Press

Hanks, B.K., Epimakhov, A. V., & Renfrew, A.C. 2007 'Towards a refined chronology for the Bronze Age of the southern Urals, Russia', *Antiquity*, 81 (312), pp.353–67

Herodotus *The Histories*. English translation: Herodotus, The Histories, 2003 trans. De Selincourt, A., revised with an introduction and notes by Marincola, J., London: Penguin

Kashkinbayev, K. 2013 *Berel Horses: Paleopathologycal Dimension Research*, Astana: Ministry of Education and Science of the Republic of Kazakhstan

Khazanov, A.M. 1984 *Nomads and the Outside World*, Cambridge: Cambridge University Press

Klejn, L.S. 2013 *Soviet Archaeology: Trends, Schools, and History*, Oxford: Oxford University Press

Kohler, E.L. 1995 *The Gordion excavations (1950- 1973), Final Reports, Volume II, The Lesser Phrygian Tumuli, Part 1: The Inhumations*, Pennsylvania: University of Pennsylvania Museum

Kosintzev, P. & Samashev, Z. 2014 *Berel Horses: Morphological Research*. Astana: Ministry of Education and Science of the Republic of Kazakhstan

Lepetz, S. 2013 'Horse sacrifice in a Pazyryk culture kurgan: The princely tomb of Berel' (Kazakhstan). Selection criteria and slaughter procedures', *Anthropozoologica*, 48 (2), pp. 309–21

Luckenbill, D.D. 1925 *Ancient Records of Assyria and Babylonia Volume 2: Historical Records of Assyria From Sargon to the End*, Chicago: University of Chicago Press

Moorey, P.R.S. 1970 'Pictorial evidence for the history of horse-riding in Iraq before the Kassite period', *Iraq*, 32 (1), pp. 36–50

Museum Miho, Japan, Inagaki, H., Green, A., & Yamazaki, K. 2002 *Treasures of ancient Bactria: [Miho Museum exhibition catalogue]*. Miho, Japan: Museum Miho.

Recht, L. 2018 '"Asses were buried with him": Equids as markers of sacred space in the third and second millennia BE in the eastern Mediterranean', in Nebelsick, L., Wawrzeniuk, J. & Zeman-Wisniewska, K. (eds.), *Sacred Space: Contributions to the Archaeology of Belief*, Warsaw: Institute of Archaeology of the Cardinal Stefan Wyszynski in Warsaw, pp. 65–94

Rudenko, S.I. 1970 *Frozen Tombs of Siberia: The Pazyryk Burials of Iron-Age Horsemen*. London: J.M. Dent & Sons Ltd

Salzman, P.C. 2004 *Pastoralists: Equality, Hierarchy and the State*, Boulder: Westview Press

Samashev Z. & Ongar A. 2013 'Die Nomaden der kasachischen Steppe in der Früheisenzei' in Stöllner, T. & Samašev, Z. *Unbekanntes Kasachstan. Archäologie im Herzen Asiens*, Exhibition catalogue, Bochum: Deutsches Bergbau-Museum, pp. 555–72

Samashev, Z., Kurganov, N.S., Pankin, D.V., Povolotskaya, A., & Kurochkin, A. 2019 'Incrustation of ancient Saka scabbard: material studies by Raman and FTIR spectroscopy', in *SPIE Optics for Arts, Architecture, and Archaeology VII*, Conference report Paper 11058–62, Munich

Samashev, Z. 2011 *Berel*. Astana: Ministry of Education and Science of the Republic of Kazakhstan.

Samashev, Z. 2012 'The Berel kurgans: Some results of investigation', in Stark, S. & Rubinson, K.S. (eds.), *Nomads and Networks: The Art and Culture of Kazakhstan*, Princeton & New York: ISAW and Princeton University Press, pp. 30–49

Scrivano, S., Gómez Tubío, B., Ortega-Feliu, I., Ager, F. J., Paul, A., and Respaldiza, M. A. 2017 'Compositional and microstructural study of joining methods in archaeological gold objects', *X-Ray Spectrometry*, 46, pp. 123–30

Simpson, J., & Pankova, S. 2017 *Scythians: Warriors of Ancient Siberia*, London: Thames & Hudson

So, J.F., & Bunker, E.C. 1995 *Traders and Raisers on China's Northern Frontier*, Washington, D.C.: The Arthur M. Sackler Gallery, Smithsonian Institution

Stöllner, T., Samaschev, Z., Berdenov, S., Cierny, J., Doll, M., Garner, J., Gontscharov, A., Gorelik, A., Hauptmann, A., Rainer, H., Kusch, G.A., Merz, V., Riese, T., Sikorski, B. & Zickgraf, B. 2011 'Tin from Kazakhstan—steppe tin for the West?', in Yalçin, U. (ed.) *Anatolian Metal V*, Bochum: Deutsches Bergbau-Museum, pp. 231–51

Stollner, T., & Samashev, Z. (eds.) 2013 *Unbekanntes Kasachstan Archäologie im herzen Asiens.* Bochum: Deutsches Bergbau-Museum

Tylor, E. B. 1871 *Primitive Culture: Researches into the Development of Mythology, Philosophy, Religion, Art, and Custom*, vol. 2. London: J. Murray

Usmanova, E., Gumirova, O. & Chechushkov, I. 2021 (forthc.) 'The "flying gallop" iconography and its representation in the burial rites of the Eurasian Bronze Age'. In Recht, L. & Zeman-Wisniewska, K. (eds.), *Animal Iconography in the Archaeological Record: New Approaches, New Dimensions*. Sheffield: Equinox.

Wolters, J. 1981 'The ancient craft of granulation – A re-assessment of established concepts', *Gold Bulletin*, 14 (3), pp.119–29

Акишев К.А. 1959 'Саки Семиречья (По материалам Илийской экспедиции 1954, 1957 гг.)', Труды Института истории, археологии и этнографии АН КазССР. – Т. 7. Алма-Ата, с. 204–214

Акишев К.А. 1978. *Курган Иссык*. Москва: Искусство

Акишев, К.А. & Акишев, А.К. 1978 'Проблема хронологии раннего этапа сакской культуры', в *Археологические памятники Казахстана*, Алма-Ата, стр. 38–63

Акишев, К. & Акишев, А.К. 1983 *Қазақстанның көне алтыны*, Алма-Ата: Өнер

Акишев, К.А., & Кушаев, Г.А. 1963 *Древняя культура саков и усуней долины реки Или*, Алма-Ата: Издат. АН Казахской ССР

Арсланова, Ф.Х. 1974а 'Новые материалы VII-VI вв. из Восточного Казахстана', в *Бронзовый и железный век Сибири*, стр. 77–83

Арсланова, Ф.Х. 1974b 'Погребальный комплекс VIII-VII веков до нашей эры из Восточного Казахстана' в *В глубь веков*, Алма-Ата, стр. 46–60

Артамонов, М.И. 1973 *Сокровища саков. Амударьинский клад, Алтайские курганы, Минусинские бронзы, Сибирское золото*, Москва: Искусство

Ауэзов, М.О. 1960 *Путь Абая*, Алма-Ата, т. 1

Бейсенов А., Шульга, П.И., & Ломан, В.Г. 2017 *Поселения сакской эпохи*, Алматы: НИЦИА «Бегазы-Тасмола»

Бейсенов, А.З. 2012 'Сарыарқа сақтары мәдениетінің жаңа деректері', *Археология и империя Сарыарки*, Сб. науч. Ст. Караганда, стр. 223–241

Беспаев, Х.А., Аубекеров, Б.Ж., Абишев, В.М., Жаутиков, Т.М., Степаненко, Н.И., Гуськова ,А.И., Жакупова, Ш.А. 1999 *Россыпи золота Казахстана. Справочник*, Алматы

Бичурин, Н.Я. 1950 *Собрание: сведении о народах, обитавших в Средней Азии в древние времена*, Москва-Ленинград, Т.1

Боковенко, Н.А. 2011 'Эпохи бронзы и раннего железа южной Сибири: критерии выделения', *Переход от эпохи бронзы к эпохе железа в Северной Евразии. Материалы Круглого стола, 23–24 июня 2011года*, СПб., стр.16–18

Бонгард-Левин, Г.М., Грантовский, Э.А. 1983 *От скифии до Индии*, Москва

Бочкарев, В.С. 2018 'Кашуба М.Т. Между бронзой и железом', *Принципы и методы датирования в археологии (неолит — средние века)*, Спб.

Ваулин, О.В. 2016 *Восточно-Казахстанская область. Золото. Справочник*, Усть-Каменогорск и Бишкек: Рокизол

Витт, В.О. 1952 'Лошади пазырыкских курганов', *Советская археология*, №16

Волков, В.В. 2002 *Оленные камни Монголии*, Москва: Научный мир

Ворошилов, А.Н. 2009 'О серии акинаков келермесского типа', *Древность: Историческое знание и специфика источника. Выпуск IV. Материалы международной научной конференции, посвященной памяти Эдвина Арвидовича Грантовского и Дмитрия Сергеевича Раевского, 14–16 декабря 2009 года*, Москва, стр. 40 –42

Вяткин, К. 1960 *Монголы Монгольской Народной Республики// Восточно-Азиятский этнографический сборник*, Москва-Ленинград, Т.10

Геродот *История*, Перевод Г.А. Стратановского. 2004 – Москва: ОЛМА-ПРЕСС Инвест

Грач А.Д. 1980 *Древние кочевники в центре Азии*, Москва: Наука

Грязнов М.П. 1980 *Аржан – царский курган раннескифского времени*, Ленинград: Наука

Грязнов, М.П. 1961 'Древнейшие памятники героического эпоса народов Южной Сибири', *АСГЭ*, Вып. 3, стр. 7–31

Грязнов, М.П. 1947 'Памятники майэмирского этапа эпохи ранних кочевников: Доклад в секторе бронзы и раннего железа ИИМК 05.07.1945', *КСИИМК*, Вып. 18, Ленинград, стр. 9–17

Джансугурова, Л.Б., Самашев З.С., Нуржибек, Альберто Г., Джеонг Ч., Бекманов Б. О., Хусаинова Э.М., Краус, Й. 2019 Анализ отцовских и материнских линий древних объектов из пантеона Елеке сазы, *Алтай - түркі әлкмінің алтын бесігі*, Өскемен, стр. 100–109

Диваев, А. 1889 'Древнекиргизские похоронные обычаи', *Отд. оттиск из т. XV Известий общества арх., ист. и этногр. при Казанском ун-те*

Ермолаева, А.С. 2008а 'Измайловский погребально-поминальной комплекс начала эпохи ранних кочевников из Восточного Казахстана', *Известия НАН РК, Сер. обществ. Наук*, №1, стр. 83–100

Ермолаева, А.С. 2008b 'Погребально-поминальные комплексы первой половины I тыс. до н.э. на Измайловском могильнике из Восточного Казахстана и проблема трансформации культурных традиций', *Номады казахских степей: этносоциокультурные процессы и контакты в Евразии скифо-сакской эпохи*, Астана, стр. 310–337

Ермолаева, А.С. 2012 *Памятники предгорной зоны Казахского Алтая (эпоха бронзы – раннее железо)*, Алматы: Институт археологии им. А.Х. Маргулана МОН РК

Ермолаева, А.С., Ермоленко, Л.Н. 2016 Поселение эпохи ранних кочевников на Иртыше, *Мир Большого Алтая международный научный журнал*, 2 (4.1), стр. 654 –672

Жауымбаев, С.У. 2019 'Из истории изучения металлургического комплекса Алат', *Древние технологии. Каталог выставки – Великая степь: история и культура*, Том VI, Древние технологии, Нур-Султан, стр. 45–49

Зайков, В.В., Гусев, А.И. & Зайкова, Е.В. 2016 'Сопоставление состава золота из месторождений Саяно-Алтайского региона', в Зайков, В. (ред.) *Геоархеология и археологическая минералогия – 2016. Материалы III всероссийской молодежной научной школы*, Миасс, стр. 137–143

Зеймаль, Е.В. 1979 *Амударьинский клад. Каталог выставки*, Ленинград

Иванов, Г.Е. 2006 'Два бронзовых кинжала раннескифского времени из степного Алтая', *Западная и Южная Сибирь в древности. Сборник научных трудов, посвященный 60-летию со дня рождения Юрия Федоровича Кирюшина*, Барнаул, стр. 72–76

Кадырбаев, М.К. 1965 'Памятники тасмолинской культуры', в Маргулан, А.Х., Акишев, К.А., Кадырбаев, М.Е., Оразбаев, А. М. *Древняя культура Центрального Казахстана*, Алма-Ата: Наука

Калоев, Б.А. 1964 'Обряд посвящения коня у осетин', *VII международный конгресс антропологических и этнографических наук*. Москва

Кармышева, Б.Х. 1954 'Узбеки-локайцы Южного Таджикистана, вып. 1: Историко-этнографические очерки животноводства в дореволюционный период', *ТИИАЭ АН ТаджССР*, т. 28, вып. 1

Кастанье, И.А. 1911 'Надгробные сооружения киргизских степей', *Труды Оренбургской учебно-архивной комиссии*, вып. 26

Кастанье, И.А. 1894 'О погребальных обрядах тюркских племен с древнейших времен до наших дней', *Известия об-ва арх., ист. и этногр. при Казанском ун-те, 1894, т. 12, вып. 2.*

Кенин-Лопсан, М.Б. 1987 *Обрядовая практика и фольклор тувинского шаманства*, Новосибирск

Киселев, С.В. 1951 *Древняя история Южной Сибири*, Москва-Ленинград

Китов, Е.П., Китова, А. О., Оралбай, Е. 2016 'Посмертная манипуляция с костями человека (данные о мумификации) у населения Центральной Азии в раннем железном веке', *Stratum plus*, № 3, стр. 369–379

Китов, Е.П., Китова, А.О. 2018 'Могильник Елеке сазы II в Восточном Казахстане (Анализ искусственных повреждений костей погребенных)', *Материалы XV международного Евразийского научного форума "Актуальные вопросы изучения историко-культурного наследия народов Евразии"*, Астана, стр. 309–317

Клочко, Л.С. 1992 'Скифская обувь', *СА*, №1

Ковалевская, В.Е. 1977 *Конь и всадник*, Москва

Кубарев, В.Д. 1987 *Курганы Уландрыка*, Новосибирск

Кубарев, В.Д. 1991 *Курганы Юстыда*, Новосибирск

Кубарев, В.Д. 1992 *Курганы Сайлюгема*, Новосибирск

Кузнецова, Е.Ф., Мадина, С.С. 1990 'Исследования древнего золота Казахстана', *Советская археология*, 2, стр. 136–148

Кулькова, М.А., Боковенко, Н.А. 2018 'Абсолютная и относительная хронология памятников бронзового - раннего железного веков Южной Сибири по данным геохимических методов исследования', *Принципы и методы датирования в археологии (неолит — средние века)*, СПб., стр. 141–170

Латышев, В.В. 1992 *Известия древних писателей о Скифии и Кавказе. Вып. I*, СПб.: Фарн

Латышев, В.В. 1993 *Известия древних писателей о Скифии и Кавказе. Том. II*, СПб.: Фарн

Левшин, А.И. 1832 *Описание киргиз-казачьих или киргиз-кайсацких орд и Степей*, СПБ.: Ч.3

Максимова, А.Г. 1959 'Эпоха бронзы Восточного Казахстана', *Труды Института истории, археологии и этнографии АН КазССР*, Т.VII, Алма-Ата, стр. 86–161

Маргулан, А.К. 1998 *Бегазы-Дандыбаевская культура Центрального Казахстана*, Алматы: Атамура

Марсадолов, Л.В., Хаврин, С.В., Гук, Д.Ю. 2013 'Проба древнего золота Казахстана', *Теория и практика археологических исследований*, 2 (8), стр. 129–141

Минасян, Р.С., Шаблавина, Е.А., 2009 'Тунны, готы и сарматы между Волгой и Дунаем. Сборник научных статей', *Санкт-Петербург, Факультет филологии и искусств СПбГУ*, стр. 236–261

Молодин, В.И., Кожин, П.М., Комиссаров, С.А. 2015 'Особенности перехода к раннему железному веку на территории Северного Китая', *Вестн. Новосиб. гос. ун-та, Серия: История, филология*, Т. 14, вып. 4: Востоковедение, стр. 5–12

Ольховский, В. С. 1978 *Погребальные обряды населения степной Скифии (VII—V вв. до н. э.)*, Москва: МГУ

Оралбай, Е.К. & Кариев, Е.М. 2016 'Предварительные результаты исследований раннесакских памятников ха плато Елеке Сазы в Тарбагагтайском районе Восточно-Казахстанской области', в Онгарулы, А., Хасенова, Б.М., Айдарбекова, А.Б. 2016 Қазақ даласындағы сақтар мен савроматтар: мәдени байланыстар. Археолог Бекен Нұрмұханбетовты еске алуға арналған ғылыми мақалалар жинағы. – Саки и савроматы Казахских степей: контакт культур: Сборник научных статей, посвященный памяти археолога Бекена Нурмуханбетова, Алматы, стр. 161–172

Пиотровский, М.Б., Piotrovskiy, M.B. (Ed.), 2004 *Аржан Источник в Долине царей: Археологические открытия в Туве*, **Государственного Эрмитаж СПб: Славия**

Полосьмак, Н.В. 1994 *Стерегущие золото грифы (Ак-алахинские курганы)*, Новосибирск

Потапов, Л.П. 1953 *Очерки по истории алтайцев*, Москва-Ленинград

Радлов, В.В. 1989 *Из Сибири. Страницы дневника*, Москва

Реновaнц, И.М. 1792 *Минералогические, географические и другие смешанные известия о Алтайских горах, принадлежащих к Российскому владению*, Санкт Петербург: при Императорской Академии наук.

Руденко, С.И. 1961 *Искусство Алтая и Передней Азии (середина I тысячелетия до н.э.)*, Москва: Издательство Восточной литературы

Руденко, С.И. 1952 *Горно-алтайские находки и скифы*, Москва-Ленинград

Руденко, С.И. 1953 *Культура населения Горного Алтая в скифское время*, Москва-Ленинград

Руденко, С.И. 1962 *Культура хуннов и Ноинулинские курганы*, Москва-Ленинград

Руденко, С.И. и Руденко Н.М. 1949 *Искусство скифов Алтая*, Москва: ГМИИ

Рычков, И. 1772 *Дневные записки путешествия капитана Николая Рычкова в киргиз-кайсацкую степь в 1771 г.*, СПб.

Самашев З. 2011 *Берел*, Алматы: Таймас

Самашев, З. 2016 *Отчет об археологических работах в рамках "Программы развития научно-исследовательских работ в сфере археологии в Восточно-Казахстанской области на 2016–2018 годы по теме Археологические работы на курганах № 2, 19 Берел, Катон-Карагайский район"*, unpublished field report

Самашев, З. 2018а 'К изучению культуры ранних саков Восточного Казахстана', *Древние и средневековые общества Евразии; перекресток культур . Материалы Международного научного симпозиума, посвященного памяти Н.А. Мажитова в г. Уфа, 6–7 декабря 2018г, Сборник материалов*, Уфа, стр. 109–117

Самашев, З. 2018b 'Курганы Елеке сазы на Тарбагатае', *Материалы XV международного научного форума "Актуальные вопросы изучения историко-культурного наследия народов Евразии"*, Астана, стр. 5–11

Самашев, З. 2018с 'Оружейный комплекс сяньбэй в контексте культуры по материалам некрополя Берел в Казахском Алтае', *Великая степь: военное наследие.- Астана*, стр. 56–72

Самашев, З. 2019 'К вопросу о формировании раннесакского культурного комплекса в Восточном Казахстане', *Turkic Studies Journal*, № 1 (1), Нур-Султан, стр. 37–60

Самашев, З.С., Боковенко, Н., Чотбаев, А., Кариев, Е.М. 2016 'Культура саков и скифов Великого Пояса Евразийких степей', *Мир Большого Алтая Международный журнал*, 2 (4.1), стр. 719–735

Самашев, З., Кариев Е.М., Ерболатов С. Е. 2019 'Сюнну-сяньбэйский культурно-хронологический горизонт Береля', *Маргулановские чтения–2019*, Нур-Султан, стр. 385–393

Самашев, З. & Кадырбаев, М.К. 2012 'Некоторые вопросы археологии раннего железного века Казахстана', *Материалы III Международной научной конференции "Кадырбаевские чтения–2012", 14–15 ноября 2012 года*, Актобе, стр. 6–20

Самашев, З. С, Жумабекова, Г.С., Омаров, Г.К. 1998 Раннесакские наконечники стрел из Казахстанского Алтая, *Военная археология*, Спб. 1998, стр. 155–160

Сапожников, В.В. 1911 *Монгольский Алтай в истоках Иртыша и Кобдо: Путешествия 1905–1909гг.*, Томск

Сорокин, С.С. 1981 'К вопросу о толковании внекурганных памятников', *АСГЭ*, Вып. 22

Сорокин, С.С. 1966 'Памятники ранних кочевников в верховьях Бухтармы', *Археологический сборник Государственного Эрмитажа*, Вып. 8 – Эпоха бронзы и раннего железа. Москва-Ленинград: Славяне, стр. 39–60

Райс, Т.Т. 2004 *Скифы. Строители степных пирамид*, Москва

Теплоухов, С.А. 1925 'Раскопки курганов в горах Ноин-Улы', в Козлова, П.К. *Краткие отчеты экспедиции по исследждению Северной Монголии в связи с Монголо-Тибетской экспедицией П.К.Козлова*, Ленинград

Ткачев, Н.А., Ткачев, А.А. 2006 *Эпоха бронзы Верхнего Прииртышья*, Новосибирск: Наука

Толеубаев, А.Т. 1991 *Реликты доисламских верований в семейной обрядности казахов*, Алма-Ата: Гылым

Толеубаев, А. 2007 'Шілікті жазығы – сақтардың алғашқы мемлекетінің ту тіккен ордасы', *Қазақ әдебиеті*, №26

Толеубаев, А.Т. 2018 *Раннесакская Шиликтинская культура*, Алматы: ИП Садвакасов А.К

Толеубаев, А.Т. 2019 'Сако-скифские и казахские параллели в похоронно-поминальных обычаях', *Электронный научный журнал "edu.e-history.kz"*, № 3 (19)

Толеубаев, А.Т. Т.1а 'Результаты многолетних мультидисциплинарных исследований царских некрополей Шиликтинской долины', в Толеубаев А.Т. *Проблемы эпохи бронзы раннего железного века Казахстана. Избранные труды и статьи.*

Толеубаев, А.Т. Т.1b. 'Дромосы элитарных курганов предгорий Тарбагатая', в Толеубаев, А.Т. *Проблемы эпохи бронзы и раннего железного века Казахстана. Избранные труды и статьи.*

Толеубаев А.Т. Т.2 Жилище в представлениях, верованиях и обрядах казахов, в Толеубаев, А.Т. *Проблемы этнографии казахов. Избранные труды и статьи*

Толеубаев А.Т. 1984 'Происхождение и сущность казахского обычая посвящения умершему коня', *Изв. АН КазССР, Сер. общ. Наук*, №2

Толеубаев, А.Т. 2018 *Раннесакская шиликтинская культура*, Алматы: ИП Садвакасов А.К.

Тощакова, Е.М. 1978 *Традиционные черты народной культуры алтайцев (XIX - начало XX в.)*, Новосибирск

Федосеенко О.А. (ред.). 2004 *Аржан Источник в Долине царей. Археологические открытия в Туве*, Санкт-Петербург: АО Славия

Хаврин, С.В. & Папин, Д.В. 2006 'Исследования состава золотых андроновских украшений Алтая', *Современные проблемы археологии России*, Новосибирск: Издательство Института археологии этнографии СО РАН, стр. 388–390

Ходыров, Л. 1916 'Из киргизских поверий', *Труды Оренбургской ученой архивной комиссии*, 337 Оренбург, стр. 3–17

Черненко, Е.В. 1980 'Древнейшие скифские парадные мечи (Мельгунов и Келермесс)', *Скифия и Кавказ*, Киев, стр. 7–30

Черников, С.С. 1948 'Древняя металлургия и горное дело Западного Алтая', *Кратких сообщениях о докладах и полевых исследованиях Института истории материальной культуры*, XXIII, Москва: Академия наук СССР, стр. 96–100

Черников, С.С. 1960. *Восточный Казахстан в эпоху бронзы*, Москва-Ленинград: Издательство Академии наук СССР.

Черников, С.С. 1965 *Загадка золотого кургана. Где и когда зародилось «скифское искусство»*, Москва: Наука

Черных, Е.Н. 1978 'Металлургические провинции и периодизация эпохи раннего металла на территории СССР', *Советская археология*, 4, стр. 53–82.

Черных, Е.Н. 2008 'Формирование Евразийского степного пояса скотоводческих культур: взгляд сквозь призму археометаллургии и радиоуглеродной хронологии'. *Археология, этнография и антропология Евразии*, 3 (35), стр. 36–53

Чугунов, К.В. 2000 'Бронзовые наконечники стрел скифского времени Тувы', в Никитин А., Панкова С. *Мировоззрение. Археология. Ритуал. Культура. Сборник статей к 60-летию Марка Лазаревича Подольского*, СПб: Мир книги, стр. 213–238

Чугунов, К.В. 2011 'Дата кургана Аржан и хронология начала эпохи ранних кочевников', Переход от эпохи бронзы к эпохе раннего железа в Северной Евразии. Материалы Круглого стола, 23–24 июня 2011г., стр. 69–75

Чугунов, К.В., Парцингер Г., Наглер А. 2017 *Царский курган скифского времени Аржан–2 в Туве*, Новосибирск: Изд-во ИАЭТ СО РАН

Шербаков, Ю.Г. & Рослякова Н.В. 2000 'Состав золотых и бронзовых изделий, источники металлов и способы их обработки', в *Феномен алтайских мумий*, Новосибирск: Издательство Института археологии и этнографии СО РАН, стр. 179–187.

Шульга, П.И. 2008 *Снаряжение верховой лошади и воинские пояса на Алтае. Часть I. Раннескифское время*, Барнаул: Азбука

Яблонский, Л.Т. 2013 *Золото сарматских вождей. Элитный некрополь Филипповка 1 (по материалам раскопок 2004–2009 гг.)*, Книга 1, Москва: ИА РАН

Яценко, С.А. 2006 *Костюм древней Евразии*, Москва

PHOTOGRAPHIC CREDITS

Unless otherwise stated, all object photography © Fitzwilliam Museum/East Kazakhstan Regional Museum of Local History

Unless otherwise stated, all objects in this volume are held in the East Kazakhstan Regional Museum of Local History. Accession numbers are provided where known

Unless otherwise stated, all landscape photography © Yevgeniy Domashev

Maps 1–3
Ayshea Carter, © Fitzwilliam Museum

Chapter 1
Fig. 1. © Zainolla Samashev

Chapter 2
Fig. 2.2 © Mauro Gambini; fig. 2.3 © Bart van Eijden; fig. 2.4 © Courtesy of the Oriental Institute of the University of Chicago; fig. 2.5 Ayshea Carter, Fitzwilliam Museum, after Akishev 1978; figs. 2.6–15; 2.18; 2.22–25; 2.27, 2.28; 2.30–48; 2.57–62; 2.64–65; 2.76–81 © Zainolla Samashev; fig. 2.21 Ayshea Carter, Fitzwilliam Museum, after Gryaznov; fig. 2.29 © The State Hermitage Museum /photo by Vladimir Terebenin; figs. 2.69–71 © The Trustees of the British Museum

Chapter 3
Figs. 3.1–9; 3.15–17; 3.19–20; 3.24b; 3.25a © Zainolla Samashev; fig. 3.24d Ayshea Carter, Fitzwilliam Museum, after Z. Samashev; fig. 3.28 Vicki Herring, © Fitzwilliam Museum

Chapter 4
Fig. 4.2 Photograph © 2021 Museum of Fine Arts, Boston; figs. 4.3–4 Photos © Abdesh Toleubayev; fig. 4.5 Library of Congress, Meeting of Frontiers/ photo by Sergei Ivanovich Borisov; fig. 4.9 Library of Congress, Meeting of Frontiers/ photo by L.K. Poltoratskaia; fig. 4.10 Photograph © Perry Tourtellotte; fig. 4.11 Photograph © The Trustees of the British Museum

Chapter 5
Figs. 5.1–4; 5.6–8; 5.12; 5.16–17; 5.20–21 © Zainolla Samashev; fig. 5.5 © R.Sala, Laboratory of Geoarchaeology, Kazakhstan; fig. 5.9 Vicki Herring, © Fitzwilliam Museum; fig. 5.13 Ayshea Carter, Fitzwilliam Museum, after Rudenko 1970; fig. 5.15 © The State Hermitage Museum /photo by Vladimir Terebenin; fig. 5.18 Photograph © The Trustees of the British Museum

Chapter 6
Figs. 6.2–4 Ayshea Carter, © Fitzwilliam Museum; figs. 6.7c,d © Aldan-Maadyr National Museum of the Republic of Tuva/ photo by Vladimir Terebenin; fig. 6.11 © Aldan-Maadyr National Museum of the Republic of Tuva/ photo by Vladimir Terebenin; fig. 6.13 © Zainolla Samashev

Appendix I
Fig. 2 © Abdesh Toleubayev; fig. 3 © East Kazakhstan Regional Museum of Local History/ photography by Yevgeniy Domashev; figs. 4, 5 © Zainolla Samashev

Appendix II
Vicki Herring, based on excavation reports by Z. Samashev © Fitzwilliam Museum

Appendix III
Alan Duncan © Fitzwilliam Museum